THE COMPLETE GUIDE TO
OUTDOOR
Photography

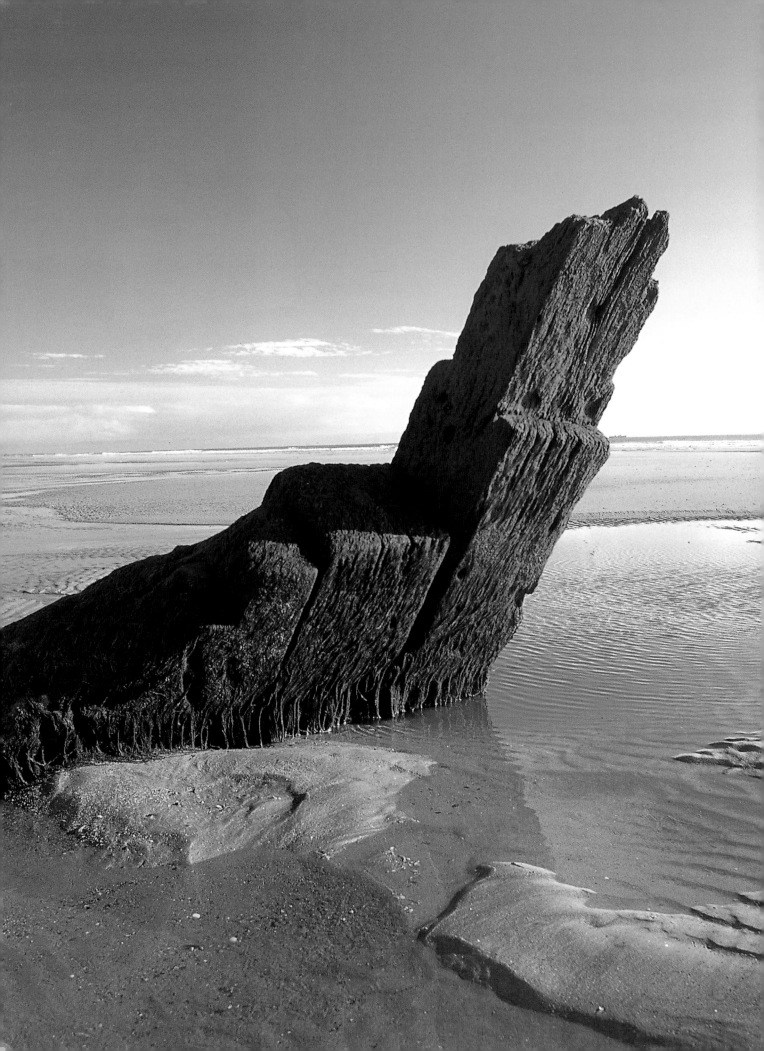

THE COMPLETE GUIDE TO
OUTDOOR
Photography

Paul Harcourt Davies

David & Charles

DEDICATION

To Lois, Hannah and Rhodri

A DAVID & CHARLES BOOK

First published in the UK in 2002

A catalogue record for this book is available from the British Library.

ISBN 0 7153 1304 5 (hardback)
ISBN 0 7153 1447 5 (paperback)

Printed in Singapore
by KHL Printing Co Pte Ltd
for David & Charles
Brunel House Newton Abbot Devon

Commissioning Editor: Sarah Hoggett
Senior Editor: Freya Dangerfield
Design: Paul Cooper Design
Production Controller: Kelly Smith

page 2

SHIPWRECK TIMBERS

Nikon F4, 24mm f/2.8 AF with circular polarizer, 1/60 sec. at f/8,
Fujichrome Velvia

CONTENTS

INTRODUCTION

How many of us start out with a camera bought to capture holiday memories, or to take snaps of friends, and subsequently become seduced by the whole business of capturing images on film? This appeal doesn't dull, for after taking hundreds of thousands of pictures I still, like every photographer I know, find the whole business magical!

A certain way of improving your picture-taking skills is to have interests that require pictures. In my case it was a fascination with the natural world, with others it can be sport, travelling or portraiture . . . However, although you may start in one area, your photography will doubtless begin to take on a life of its own, and you will end up taking pictures of anything that makes an interesting image. With thought you can encourage the development of your photographer's 'eye' and produce good pictures of all sorts of things exactly as you want them.

Which brings me to the reason for this book – another photography book, you might say. Well, this one has grown out of a conviction, through running courses and photographic holidays, that anyone who wants to can learn how to take pictures of outdoor subjects with impact. It's not just a question of what you photograph but of how much you fill the frame, where you place the subject in the frame, the lighting, and so on. At first this seems like a long list to remember, but with a little practice you won't need to think about these things any more. You will just take what looks and feels right – and sometimes you will get it spot on,and sometimes you won't. The great thing about photography is that you never stop learning or finding new areas to explore.

What I hope you will do on reading through this book is say, 'yes, I know that', and then 'interesting, didn't know that – I'll try it', also, 'I've taken better shots than that!'. And this is fine, because most people can take good pictures. The bulk of published pictures are *good*, but only a few are *great* pictures. My attitude is that if I can do this, then so can you.

I have deliberately not made a great fuss about digital cameras – they are marvellous but, after all, they are just cameras and this book is about taking pictures of all kinds of subjects, regardless of the equipment you use. I have found that many people want recipes: they want to know what equipment to use, the film, the exposure and exactly where to stand. What I like to do is to encourage people to think for themselves and fly solo – yes, all the pointers are in this book, but please feel free to take the good bits and then put something of yourself into every shot. Good photography is something personal and deeply satisfying, and your pictures will start to improve out of all recognition as you practise and discover the myriad of opportunities in the great outdoors for picture-taking.

▶ **COAST NEAR GIGLIO PORTO, GIGLIO ISLAND, ITALY**
At first there seems to be a big difference between what you see through the viewfinder, and what actually appears on film – this gap will close with practice. Through photographs we bring happy memories flooding back – to many people this picture will seem like just another attractive piece of coast. However, by looking at it, I can almost feel the breeze on the headland and the warmth of the air when it was taken.
Mamiya 645 Super, 45mm f/2.8 with circular polarizer, 1/60 sec. at f/16, Fujichrome Provia 100F

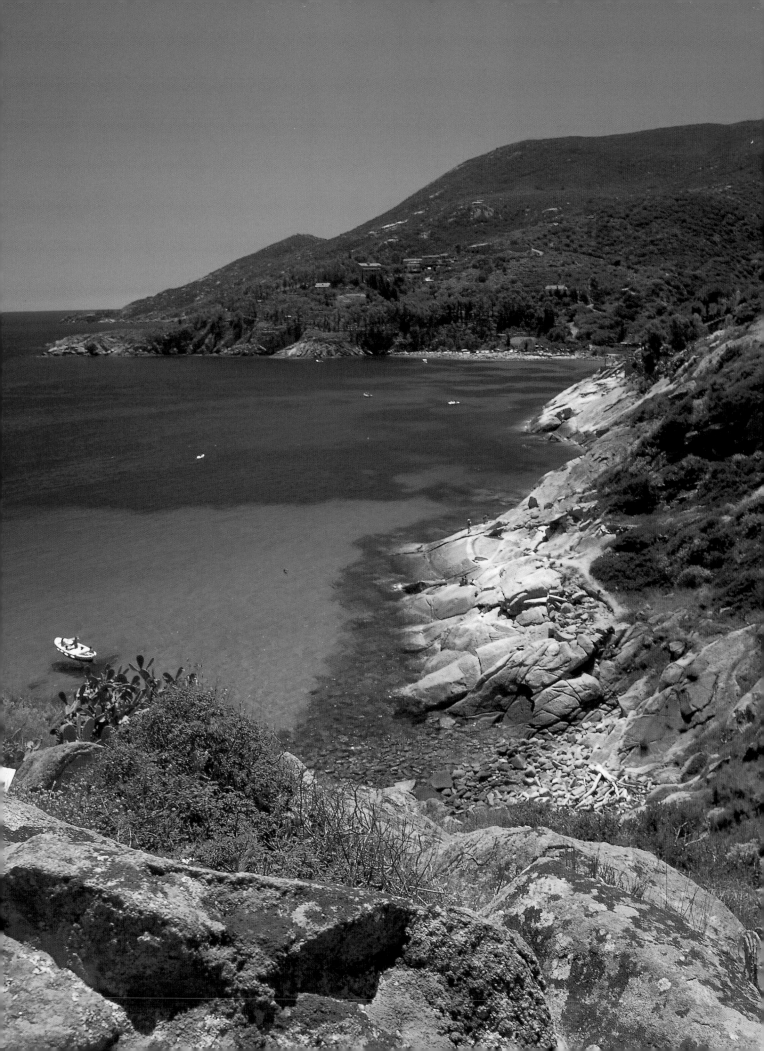

CHAPTER 1
EQUIPMENT

There is a bewildering choice facing photographers when it comes to purchasing equipment. This chapter provides an overview that will enable you to make an informed choice depending on the type of subjects you favour and the approaches you are most likely to take.

Buy the best equipment you can afford when you need it. You will probably find that a camera body with a good zoom lens that has a close-up facility will cover a great proportion of what you need to do. But don't get bogged down too much in the technical merits of one brand over another. The truth is that competent photographers can take good pictures with most equipment because they have developed an 'eye' for what makes a composition with impact.

▶ **FLORENCE: VIEW FROM THE DUOMO**
Any modern camera, whether compact or SLR, is capable of capturing astonishing detail. A camera fitted with a zoom lens was braced against a balustrade for support to capture this winter view of Florence all the way to the snow-capped Appenine Mountains.
NIKON F60, 28–80MM F2.8 AF ZOOM WITH CIRCULAR POLARIZER, 1/30 SEC. AT F/16, FUJICHROME PROVIA 100F

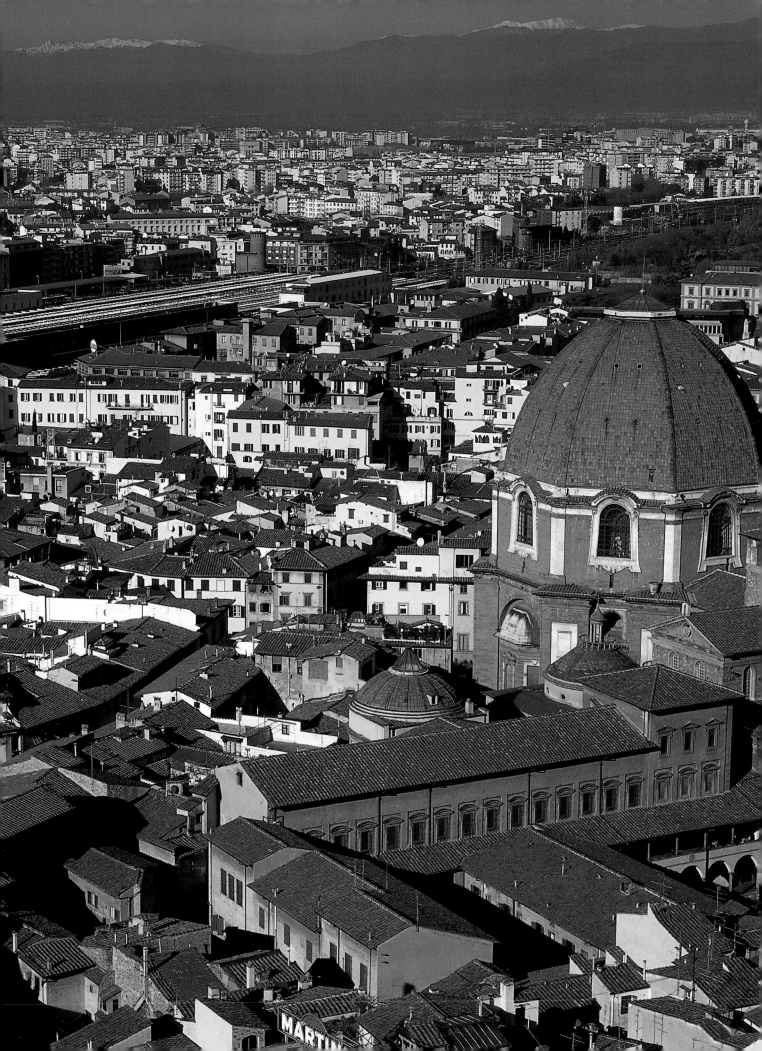

Cameras that are suitable for outdoor photography come in several formats. By far the most popular is 35mm, which is easy to carry and extremely versatile. A huge range of accessories is available to suit most pockets, and the format is suitable for all but the most exacting professional use. It has reigned supreme for around half a century, and several types of camera are available in this format.

ADVANCED PHOTO SYSTEM

Three different picture formats are available for each shot using Advanced Photo System (APS) cameras: 'classic' (with an aspect ratio of 2:3), 'HDTV' (9:16) and 'panoramic' (1:3). But picture quality is not as high as in conventional 35mm systems – the panoramic mode uses only the central portion of the frame and negatives will not take big enlargement – and most APS cameras do not have interchangeable lenses, so the system is not really good enough for serious photography.

COMPACT CAMERAS

For speed and ease of use, it is hard to beat a modern compact camera with its built-in exposure meter and zoom lens with autofocus (AF). It is worth carrying one even if you also have a more sophisticated outfit. In a situation such as a crowded market, when you don't want to draw attention to yourself, this type of camera is my first choice.

SINGLE LENS REFLEX

In addition to the flexibility of interchangeable lenses, the beauty of single lens reflex (SLR) is that you see through the viewfinder exactly what will appear on film. A mirror and pentaprism enable you to look directly through the lens, then the mirror flips up out of the way while the film is exposed. For close-up and most wildlife photography, this is the only type of camera to choose.

Unfortunately, with some makes it is difficult to take control without some pre-programmed mode interfering. As this book

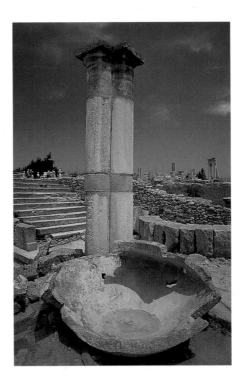

◀ **TEMPLE OF APOLLO HYLATES, CYPRUS**
With an SLR camera you see exactly what will appear on film. The camera was carefully positioned to include both columns and foreground. A polarizer emphasized the blue of the sky and the rich tones on the columns.
Nikon F4, 24mm f/2.8 AF with circular polarizer, 1/30 sec. at f/16, Fujichrome Velvia

▼ **POPPIES NEAR HENLEY-ON-THAMES, ENGLAND**
Most people use their camera without a tripod or other support, and on a sunny day this works perfectly. Keeping your arms at your sides helps to brace the camera against body movements. Wait until any breeze moving the subject dies down.
Nikon F100, 28–80mm f/2.8 AF with circular polarizer, 1/125 sec. at f/8, Fujichrome Velvia

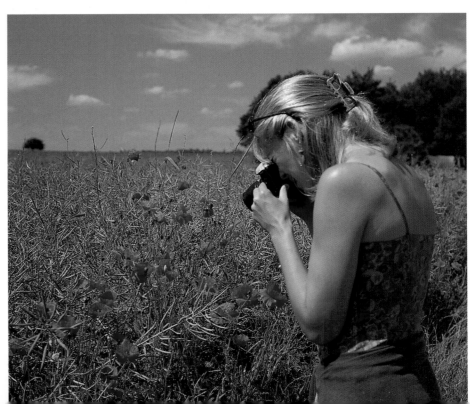

will make clear, getting great pictures is often a matter of taking control of exposure as well as composition and lighting.

SLRs do have their drawbacks: because of their complexity, repairs tend to be expensive, and you cannot see through the viewfinder while the picture is being taken – a disadvantage with the long exposures needed for low-light work.

RANGEFINDER CAMERAS

Rangefinders have a direct viewfinder which uses a binocular arrangement of lenses, mirrors and prisms to measure distance. One part is coupled to the camera lens, and correct focus is achieved when the two versions of the image coincide.

These cameras can be made compact, light and reliable because of the simplicity of the mechanism. The fact that there is no need to incorporate a mirror box means that the lens can be nearer the film. In theory at least, this gives sharper results than an SLR, but at close quarters the slight difference in position of viewfinder and lens creates parallax, which means that what appears on film is slightly different from what you see.

35MM PANORAMIC CAMERAS

The panoramic format is now becoming increasingly popular and really comes into its own for landscape photography. Hasselblad have developed the XPan,

a 35mm camera that uses the whole width of the film – unlike the APS panoramic mode – to generate 24 x 65mm transparencies in addition to the conventional 24 x 36mm format. Several 6 x 7cm cameras can be fitted with a panoramic film mask that allows you to use 35mm film in the same way.

DIGITAL CAMERAS

With every year that passes, the quality gap between digitally generated images and film narrows. For my work, however, film still just has the edge. Also, a 35mm transparency is an excellent 'data storage' device, and you don't need a computer to look at it: you need only hold it up to a window.

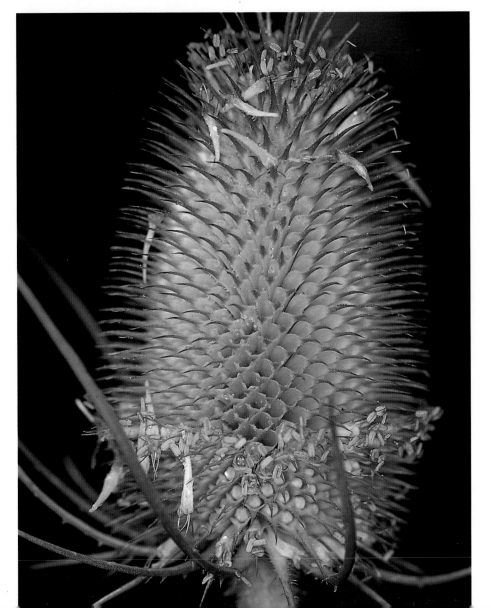

◀ TEASEL HEAD

The intriguing part of a teasel is its flowerhead and an SLR camera allows you to move in close or to use a zoom lens and fill the frame. With rangefinder cameras a certain amount of guesswork is needed because of the slight difference between what you see in the viewfinder and what the film records, and they do not have the same close-focus facility.
NIKON F60, 28–80MM F/2.8 AF, CAMERA'S INTERNAL FLASH, 1/60 SEC. AT F/16, FUJICHROME VELVIA

Roll-film cameras offer a larger negative size than 35mm and therefore record greater detail. They are favoured by many amateurs and professionals but the equipment is costly and there is nowhere near the choice available in 35mm. Sheet-film cameras, in 5 x 4in and larger formats, are for *aficionados* of the ultimate quality, who will take time over shots and don't mind the expense.

In medium format cameras, six different negative and transparency formats are currently made possible by employing the same 120 roll film in different ways. These are 6 x 4.5cm, 6 x 6cm, 6 x 7cm, 6 x 8cm, 6 x 9cm and the panoramic format 6 x 17cm. Using a roll film of standard length, you get 15, 12, 10, 9, 8 and 4 frames per film respectively. If your camera will take 220 roll film, you will get twice as many frames per film.

Many outdoor photographers who run both 35mm and roll-film outfits favour the 6 x 4.5cm format, because it handles much like 35mm and lenses and accessories are not prohibitively expensive. Others would not be parted from square-format 6 x 6cm outfits. Each roll-film format has its enthusiasts, but the larger the area of film, the heavier the equipment and the more expensive the lenses.

RANGEFINDER CAMERAS

Roll-film rangefinder cameras are available in a number of formats. Many travel photographers use 6 x 4.5cm cameras with autofocus or 6 x 7cm – both are quick to set up, quiet and unobtrusive, and produce a large negative or transparency with a lot of detail. If you are used to SLR cameras, rangefinder focusing takes a little getting used to.

I have used a Mamiya 7 II rangefinder camera for over two years. The 43mm wide-angle lens almost touches the film plane and gives astoundingly sharp results. The camera can be hand-held but it is better supported.

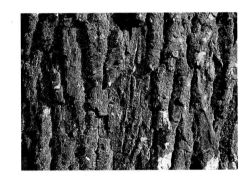

▲ **BARK OF BLACK PINE (*PINUS NIGRA*)**
A macro lens focusing to half life-size recorded bark detail: for magnifications greater than life-size you can use 35mm macro lenses with adaptors on roll film.
MAMIYA 645 SUPER, 80MM F/4 MACRO, 1/30 SEC. AT F/11, FUJICHROME PROVIA 100F

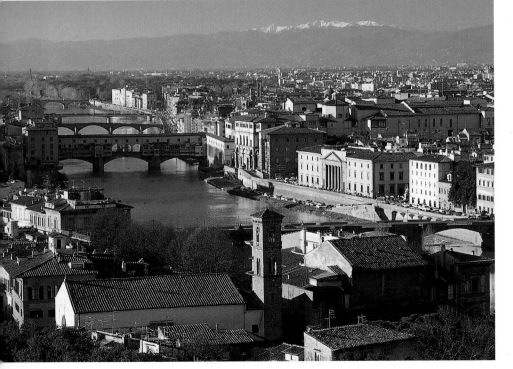

◀ **BRIDGES ALONG THE ARNO RIVER, FLORENCE, ITALY**
Roll film is an ideal choice when a scene contains a great deal of fine detail and a wide tonal range. The viewpoint on a nearby hill was chosen to get as many of the Arno's bridges as possible in the same frame.
MAMIYA 645 SUPER, 150MM F/3.5 WITH 81B WARM-UP FILTER, 1/30 SEC. AT F/16, FUJICHROME PROVIA 100F

PANORAMIC CAMERAS

The panoramic format has become very popular in recent years. For the highest quality, cameras such as Fuji's 617 and those from Horseman have won many enthusiasts, in spite of the high price of the lenses. The detail obtained in a 6 x 17cm transparency has to be seen to be believed.

It is very difficult to design lenses that cover this width yet are still a sensible size. In the widest-angled lenses, the centre is brighter than the edges, and a special circular graduated filter is fitted to make sure the frame is uniformly exposed. Some cameras, such as the Noblex, tackle the problem of coverage by moving the film during exposure.

CAMERAS WITH MOVEMENTS

Outfits such as Hasselblad's FlexBody and Fuji's 680 allow you to use camera movements – tilting the plane of focus by moving the camera back and front – to control and correct perspective distortion. For outdoor photographers who specialize in architectural work, it can be worth purchasing a 5 x 4in camera with a full range of movements. The high price of sheet film means you become extremely careful about using the correct exposure every time, and these cameras have to be used on a solid tripod.

It takes time to master the Scheimpflug principle governing the movements: the film plane, lens board and subject plane must all meet at a point to achieve optimum overall sharpness.

It is important to get to grips with one or two of the movements before attempting to cope with all of them. In much outdoor work you can do a great deal simply using movements of the lens panel: the rise and fall movements offset converging verticals in the composition, while swing and tilt can create a greater depth of field.

▼ **POPPIES NEAR HENLEY-ON-THAMES, ENGLAND**
Roll-film rangefinder cameras can be used quickly, without a tripod, for shots which can be cropped to panoramic format, while the Mamiya 7 II can be fitted with an adaptor to take 24 x 65mm transparencies on 35mm film.
Mamiya 7 II, 80mm f/2.8, 35mm panoramic adaptor, 1/30 sec. at f/16, Fujichrome Provia 100F

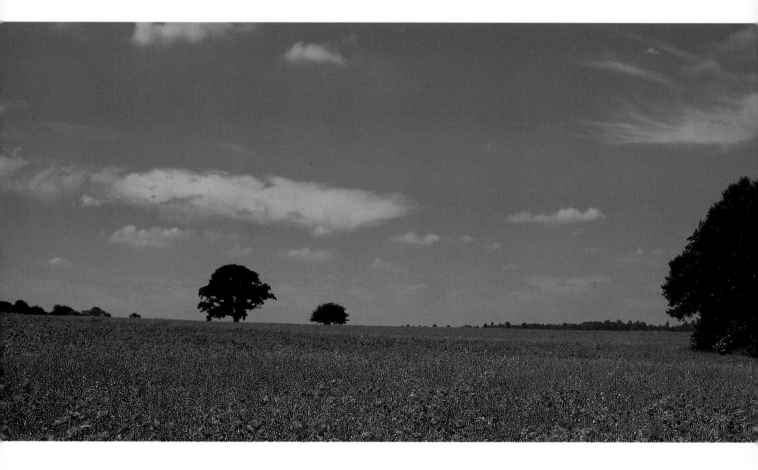

Lenses

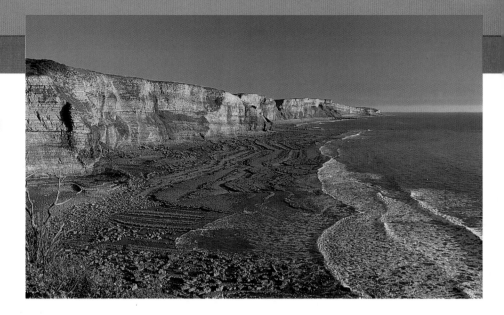

Every lens has to be a compromise and the skill in lens design is to balance lens corrections and costs. Today, you get a great deal for your money. Whatever lens test charts in magazines say, there is little or no discernible difference in performance between the camera manufacturers' own lenses and those of the top independent manufacturers. In some cases, however, the independents come out on top when it is a case of providing good value.

An appreciation of the way lenses cope with perspective – the spatial relationship between elements in a picture – is essential for any photographer. Try the following exercises: they can be done with either a zoom lens or a series of fixed-focus lenses.

Exercise 1: How depth of field changes with magnification

Find a scene that contains objects in both the foreground and the distance and then, without changing your position, take a series of shots from wide angle to telephoto, keeping the same object – perhaps a tree or a building – at the centre of each picture. There is no change in perspective, because you stay at the same distance from all the objects. Magnification does change, however, and with it depth of field (see page 30). The more powerful the telephoto, the shallower will be the depth of field at a particular aperture – a factor that allows you to isolate a subject.

Exercise 2: How perspective changes with different focal lengths

With a series of lenses or a zoom lens, change your position so that your subject stays exactly the same size in the viewfinder at each different focal length. You could try doubling focal length each time, from 24mm to 50mm, 100mm and 200mm. Because your position changes, so does the perspective: the spatial relationship between the elements in the frame. This is particularly noticeable with wide-angle lenses.

WIDE-ANGLE LENSES

In 35mm format a lens of 35mm focal length is wide angled, lenses of 24–28mm are ultra-wide and those of 14–20mm extreme wide angles. Extreme lenses are great fun to use but they distort perspective. For general outdoor photography, 24mm and 28mm lenses (and their equivalents in roll-film formats) are the most useful. The corresponding focal length in 6 x 4.5cm format is 45mm. These lenses provide wide vistas without too much distortion of perspective and can also be useful in creating close-ups that show subjects in the context of the landscape.

ZOOM LENSES

There was a time when all photographers were warned against depending on zooms because they were not of high quality. Those days are passed and some excellent wide-angle zooms, or zooms with a good wide-angle end, are available. The 28–80mm zoom has become the standard lens for most cameras. The only disadvantage of this, and the reason I still hang on to some manual focus lenses, is that designers are not generous with close focus, which is a very useful feature of wide-angle lenses (see page 146).

▲ **DUNRAVEN BAY, SOUTH WALES**
Using a wide-angle lens to record a scene requires some thought, such as where to put the horizon to let either sky or, in this case, beach and cliff dominate. Roll film comes into its own for scenes like this and a magnifier allows astonishing detail to be recorded. Dunraven Bay, where the pounding of the sea has reduced the cliffs to wave-cut platforms and revealed numerous fossils, has been a favourite haunt since childhood.
MAMIYA 645 SUPER, 45MM F/2.8, LINEAR POLARIZER, 1/15 SEC. AT F/16, FUJICHROME PROVIA 100F

▶ **ALHAMBRA PALACE, GRANADA, SPAIN**
Wide-angle lenses certainly do not have to be used in landscape format: an upright shot suits a magazine page, and a frame – such as an arch – creates a 'window' effect. The day was overcast so a position was chosen to keep the featureless sky to a minimum.
MAMIYA 7 II, 43MM F/4.5, 1/15 SEC. AT F/16, FUJICHROME PROVIA 100F

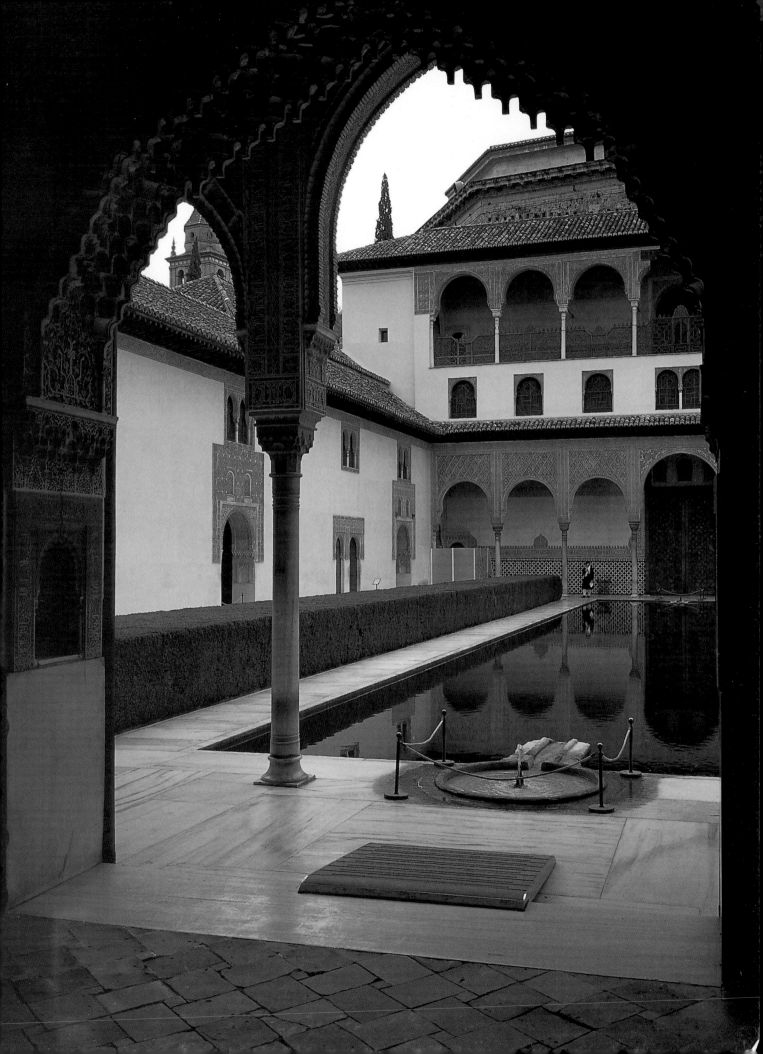

Telephoto Lenses

Telephoto lenses are available in a wide range of fixed focal lengths, from the 100mm portrait lens to 'long Toms' of 600mm and more. They have the obvious effect of bringing distant objects into closer view, and they are also used to isolate parts of a scene or even small details.

Telephotos produce a magnified image, so depth of field, which decreases as magnification increases (see page 30), is limited. Far from being a drawback, this is useful for isolating your subject in sharp focus, producing, for example, a portrait against a blurred background. To maximize depth of field, you need to use a small aperture (f/11 or smaller).

Telephoto lenses also appear to condense perspective, providing interesting pictures of subjects such as a crowd, a row of columns or perhaps vehicles in a street. They provide a tool for creating landscape pictures with a completely different feel from those taken with wide-angle lenses.

Modern apochromatic lenses banish colour-fringing and allow biting sharpness: the difference between these and earlier lenses is clearly visible. Another design advance is internal focusing, in which moveable internal elements allow you to focus without changing the tube length: this has made modern telephoto designs more compact.

TELE ZOOMS

The 70–210mm zoom offers all that many outdoor photographers need at the telephoto end. The best of these zoom designs can also be used with x 1.4 or x 2 teleconverters. Fitted between camera body and lens, these spread the light and magnify the image, giving a range of effective focal lengths of approximately 100–300mm and 140–420mm respectively. Maximum apertures are small because

the converter reduces the effective lens opening but, with a sturdy tripod, the results can be excellent.

SUPPORT

Whatever anyone says, if you want sharp pictures you cannot hand-hold the longer focal length lenses. It makes sense to use a tripod wherever possible and a monopod or beanbag otherwise. With any lens, a rule of thumb to avoid camera shake when

◀ **POPPY FIELD NEAR OTRANTO, APULIA, ITALY**
A telephoto lens appears to condense perspective by squashing together successive objects in the frame. In a field of poppies it can make the flowers appear more densely packed.
NIKON F4, SIGMA 180MM F/3.5 TELE MACRO WITH CIRCULAR POLARIZER, 1/00 SEC. AT F/8, FUJICHROME VELVIA

▼ **CLIFFFS NEAR DROUSIA, WESTERN CYPRUS**
Distant chalk cliffs were picked out by the sun while we sat under clouds. The appeal for me lay in the geometric shapes made by the cliffs and horizon, and a telephoto zoom lens allowed the frame to be changed easily.
NIKON F4, SIGMA 70–300MM F/3.5 APO ZOOM WITH CIRCULAR POLARIZER, 1/125 SEC. AT F/8, FUJICHROME VELVIA

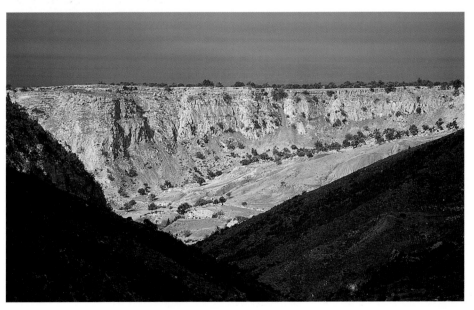

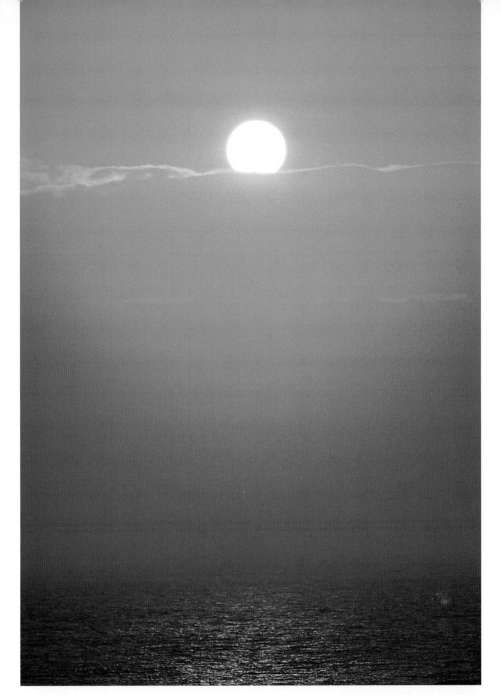

◀ **SETTING SUN, GARGANO, ITALY**
The sun and moon can appear lost in a wide-angle shot, but a telephoto lens increases the size of the disc or picks out a section of sky to emphasize the colours. For this picture an exposure reading was taken to the side of the sun. A few minutes later the sun disappeared completely behind clouds.
NIKON F4, 300MM F/3.5 APO, 1/125 SEC. AT F/8, FUJICHROME SIGMA VELVIA

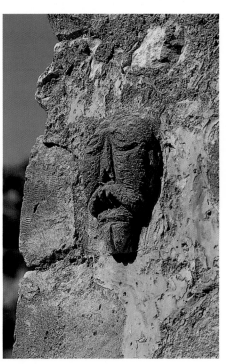

▲ **RUINED MILL, MALLIA, CYPRUS**
The traditional use of a telephoto is to act as a small telescope: it is ideal for isolating architectural details on buildings, such as this stone head carved on a ruined Venetian watermill.
NIKON F4, SIGMA 180MM F/3.5 APO-TELE MACRO WITH x 2 MATCHED MULTIPLIER TO GIVE A 360MM LENS, 1/30 SEC. AT F/11, FUJICHROME VELVIA

hand-holding is to use a shutter speed that is 1/focal length in mm. For a 500mm lens, for example, this would be 1/500 sec.

If you are using a lens of 300mm focal length or more, you must support the lens barrel itself. Some lenses have an integral tripod mount ring to support the lens and camera combination close to its centre of gravity, and this avoids the inevitable strain that is placed on the lens mount when the camera base is screwed to a tripod head. If there is no tripod mount it is possible to buy an accessory that supports the lens, such as the Manfrotto 293, or to have one custom made.

Low-dispersion glass and 'apo' lenses

Uncorrected lenses can act like prisms, splitting white light and dispersing its constituent colours, to create fringes of colour at the edges of objects in a picture. This is because the speed of light in glass depends on its colour – the red, green and blue light rays are bent to different extents and brought to a different focus. Apochromatic ('apo') lenses use special low-dispersion glasses in sophisticated combinations to focus all the colours at precisely the same plane.

Macro Lenses

The so-called 'macro' lenses produced by camera manufacturers and some independent firms also make excellent general-purpose lenses, though you pay for their high level of optical correction. Most of the macro lenses now made for 35mm format focus to 1:1 (life-size) as standard and many also incorporate a floating element system that maintains lens corrections throughout their focusing range. Autofocus (AF) can be a real nuisance in the close-up range, since the slightest movement of either camera or subject causes the lens to 'hunt' backwards and forwards. It is usually better to focus manually.

The choice of macro lenses lies between the 'standard' focal length of 50–60mm, the 'portrait' lens of 90–105mm and the increasingly popular 'tele macro' lenses of 180–200mm focal length. You will rarely need all three, so it is important to think about the kinds of subjects you will want to photograph.

FOCAL LENGTH 50–60MM
The front element is recessed with lenses within this range, and the lens front is just a few centimeters from the subject at 1:1. This can prove a little too close for comfort with active subjects like insects, but works very well with flowers and plants of all sorts and with inanimate objects such as rocks, seeds and carvings.

These lenses work well with macroflash units because at 1:1 magnification the flash tubes are close to the subject. This allows light to come in at an angle of about 35 degrees to the lens axis, creating relief (see page 25).

FOCAL LENGTH 80–105MM
Many people use a lens in this range for photographing subjects like insects or small frogs. It allows greater distance between lens and subjects, which helps to avoid scaring them off. Whereas manual focus macro lenses retain their marked focal length at all magnifications, that is not true with AF lenses. Modern AF macro lenses focus by moving internal elements, and the focal length decreases as you move closer to the subject. Some macro lenses in this range will get much closer than their marked focal length leads you to believe.

FOCAL LENGTH 180–200MM
A telephoto macro lens will render backgrounds as a soft blur and the effect

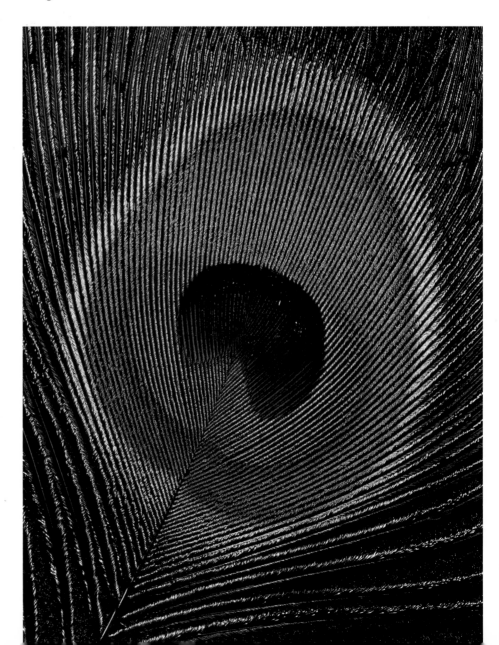

▼ **PEACOCK FEATHER**
To cover the film area in a roll-film format, image magnification must be greater than with 35mm. This means a reduced depth of field at the same aperture. With flat subjects such as this peacock feather that is not a problem and the superb detail of a roll-film frame is then used to advantage. The camera was held in a copy stand and the feather placed on the baseboard below it.
Mamiya 645 Super, 80mm f/4 macro, 1/8 sec. at f/16, Fujichrome Velvia

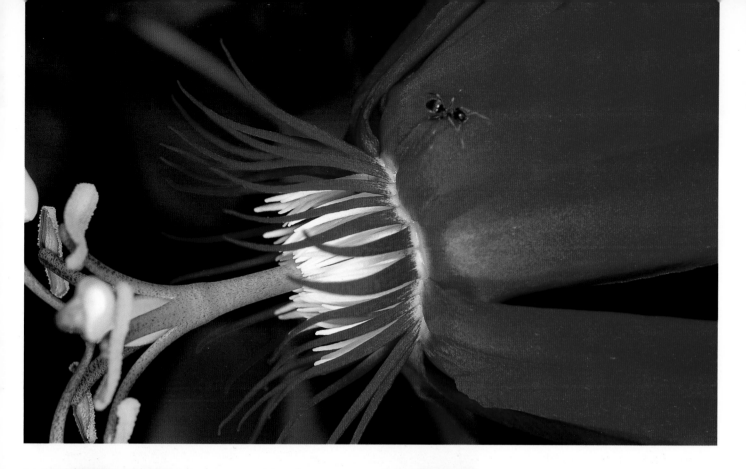

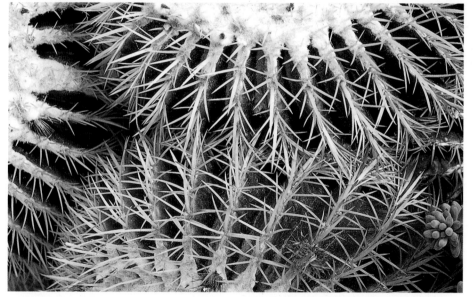

▲ PASSION FLOWER (*PASSIFLORA VITIFOLIA*)

For portability and a wide range of lenses and ancillary equipment, it is hard to beat 35mm for most macro work. I find the convenience of carrying my own lighting, in the shape of a TTL macroflash unit, makes it easy to obtain a large number of pictures at a range of magnifications on a photo assignment involving flowers and assorted insects.

NIKON F4, 60MM F/2.8 AF MACRO, SB 21B MACROFLASH, 1/60 SEC. AT F/16, FUJICHROME VELVIA

◀ CACTUS (*ECHINOCACTUS GRUISONI*)

Monochrome film seems to have been neglected in macro work but is ideal where shape and texture need to be emphasized. Here, three round heads of 'mother-in-law's seat' provided a subject for experiments; different arrangements of curves were produced in the viewfinder by changing camera position.

NIKON F4, 60MM F/2.8 AF MACRO, SB 21B MACROFLASH, 1/60 SEC. AT F/16, AGFA SCALA

is to make the subject seem to snap in and out of focus. It is ideal for lively subjects such as butterflies, which would be disturbed if you came too close. Most macroflash outfits do not have sufficient power to cope with the greater lens-to-subject distance and you have to assemble your own (see page 24).

These lenses are heavy and a tripod collar is essential. They usually have internal focusing, which means that you can use the focusing ring to sharpen an image in the viewfinder. (The focus ring of shorter focal length macro lenses simply acts as a magnification changer and changes the lens tube length. It is easier to focus by moving forwards with the camera, as described on pages 140–1.)

Ways and means of obtaining greater magnification, with their potential for field use, are discussed on pages 142–3).

Filters

Filters seem to divide easily into two categories – those that you use often and those you try once. In the first category come polarizers, warm-up filters, graduated neutral density filters, and also colour correction filters that enable you to use tungsten-balanced film in daylight and vice versa. For monochrome users there are a few tried and tested colour filters, such as red and green (see page 96). In the second category belong those described as 'effects' filters: starbursts, colour graduates, multiple image filters and so on.

Those in the first category really can improve your images in a useful way; many of the others are gimmicky and their attraction quickly palls – few serious photographers use them because the effects are so obvious.

POLARIZERS

Linear polarizers act as a simple gateway, for allowing polarized light through the lens. Unfortunately, they can affect the camera's AF system. For this reason, manufacturers recommend so-called circular polarizers for use with AF cameras. These incorporate an extra layer – a 1/4 wave filter – which changes the 'phase' of the light and allows the AF system to function properly. Since polarizers are expensive, if you use both AF and manual focus bodies it make sense to standardize on circular polarizers.

WHEN TO USE A POLARIZER

The plastics in polarizing filters are composed of molecules arranged in long parallel chains, which act like a grid, allowing through only light vibrating in one direction (see Appendix). By rotating the filter you can control the amount of polarized light allowed through.

Enhancing blue skies: The light-scattering created by molecules in the upper atmosphere, which creates a blue sky, partly plane-polarizes the light. As a polarizer is turned, it has the effect of deepening the blue, showing up wispy clouds you did not even realize were there. The effect is most pronounced when you stand at 90 degrees to the sun. A polarizing filter should be used with care, however: when the sun is at a low angle it can produce skies that appear almost black on film.

Eliminating reflections: When light is reflected from all non-metallic surfaces (water or glass, for example), it is partly polarized. As you rotate a polarizer while looking into water, reflections are cut and you are able to look below the surface – especially if the light reaching you comes at about 54 to the surface (the Brewster

▶ **NINFA GARDENS, LAZIO, ITALY**
A polarizer has an almost magical effect on the surface of water, cutting reflections to make it totally transparent. Eliminating reflection altogether makes the water surface very dark, so rotate the polarizer until the result in the viewfinder is what you want.
Mamiya 645 Super, 45mm f/2.8 with linear polarizer, 1/30 sec. at f/11, Fujichrome Velvia

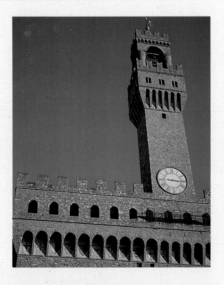

PALAZZO VECCHIO, FLORENCE, ITALY
A polarizing filter intensifies a blue sky, and many people use a warming filter such as an 81B in conjunction with it (or a combined filter such as the 'Moose' range from Hoya). The polarizer reduces the contrast between building and sky to a level film can handle more easily. In the picture on the left, an 81C warm-up filter has been used togther with the polarizer.
Mamiya 645 Super, 135mm f/3.5, linear polarizer, 1/30 sec. at f/16, Fujichrome Provia 100F

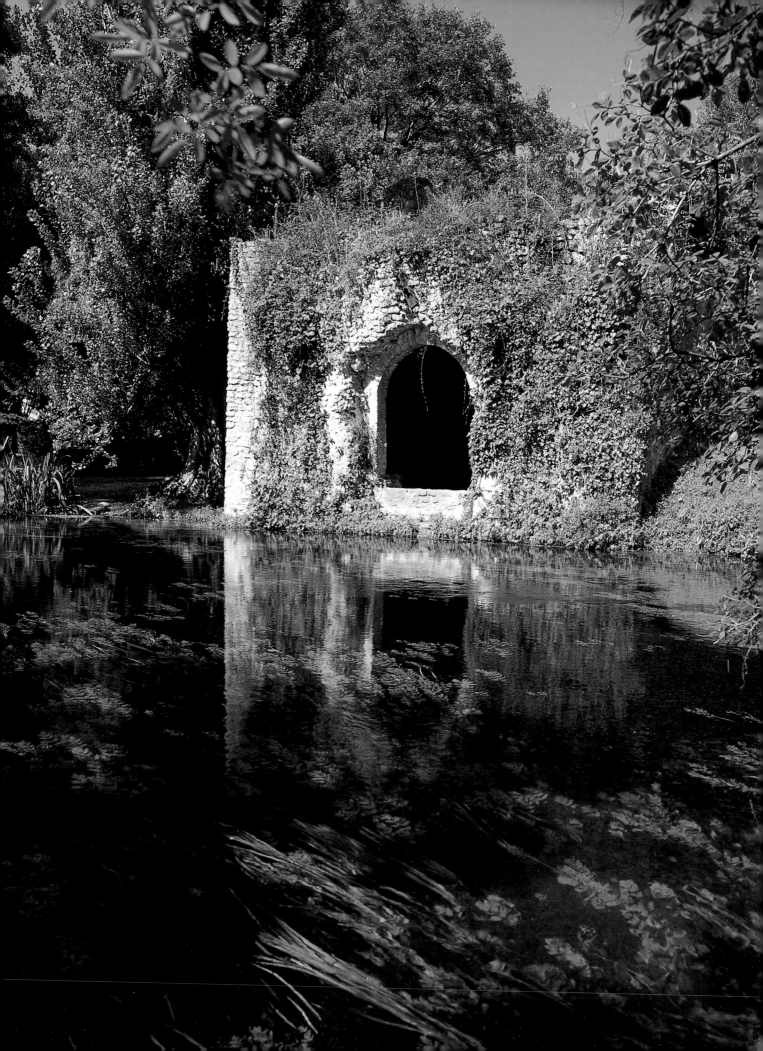

angle). You can alter the effect to produce partial transparency when photographing rivers and streams.

If you are trying to achieve a deeper blue for the sky while also cutting down reflections in a lake, you will have to compromise because it is unlikely that the light from both will be polarized in the same direction.

Intensifying colours in nature: Surfaces of leaves, grass and flowers can all reflect light. Careful use of a polarizer cuts down some of the randomly reflected light and make colours appear more intense. This is especially good for large areas of vegetation in a landscape with a variety of greens: in bright light, the surface reflection from leaves makes them appear grey and a polarizer makes the colours seem far warmer.

GRADUATED NEUTRAL DENSITY FILTERS

On a bright but cloudy day, the contrast between the land and the white sky can sometimes be too great for a film to handle (see page 36). Graduated neutral density filters vary from clear to a predetermined 'grey' that cuts light intensity. They are used in a filter holder that allows you to raise and lower them so that the graduated region coincides with the horizon and the relative brightness of the sky can be subtly reduced.

COLOUR COMPENSATION FILTERS

Sunlight changes 'colour' according to the time of day, with an increased proportion of red and yellow light giving it a warmer feel in the morning and late afternoon (see Appendix). For the few hours either side of midday the sun is higher and the blue content gives a cooler light.

On grey days and when the sky is bright but white, the 81 series of orange-tinted filters is useful to warm up the image. The filters are coded as 81, 81A–81F, in order of increasing strength. They can also be used to accentuate the colour of already 'warm' light, such as a sunset.

A correspondingly cool cast – useful for accentuating the cold light of dawn – can be created using the pale blue 82 series: 82, 82A, 82B and 82C, again coded in order of increasing strength.

UV AND SKYLIGHT FILTERS

Clear ultraviolet (UV) filters can reduce the bluish cast on film exposed in high mountain regions where the light has an unusually high UV content. A skylight

▼ **MATERA, ITALY**
On a cloudy day the contrast between the white sky and the dark tones on the ground can create a problem: if you expose for the sky the ground is too dark, but expose for the ground and the sky is burned out. A graduated neutral density filter can be used to reduce the contrast.
MAMIYA 645 SUPER, 80MM F/2.8 WITH GRADUATED (G1) NEUTRAL DENSITY FILTER, 1/30 SEC. AT F/11, FUJICHROME VELVIA

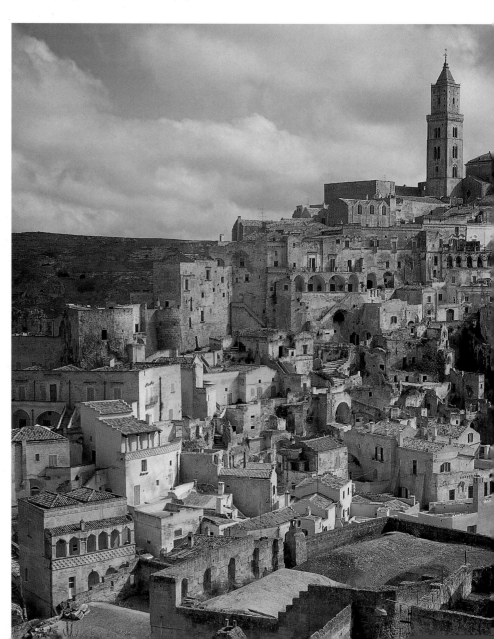

filter is slightly warm and can be used as a permanent fixture on the lens to protect its surface.

SPECIAL EFFECTS FILTERS

A wide range of special effects filters is available. Some are little more than gimmicks, but these are the ones you might find you want to use more than once.

Softening filters: Filters that have a clear central spot allow you to focus on a subject and blur the background (a great favourite with wedding photographers). Traditionally, this effect was created in a studio using a glass plate smeared with petroleum jelly, but plastic variants are less messy.

Diffraction filters: The diffraction of light can turn bright highlights into tiny 'rainbows' or spectra. To achieve this effect, diffraction filters have very fine lines or circles moulded into them, which cause the light to split into its constituent colours.

Multiple image filters: Some filters have their surfaces moulded to form several prism shapes, each of which produces a separate image.

Colour graduated filters: There was a time when every other photographer used a 'tobacco' filter to produce the kind of sunset seen in a dust storm in the Sahara – I confess to a personal prejudice against these, and all other colour graduates except blue graduates – a useful aid when photographing bluebells and other large expanses of blue flowers. The only exception to this rule would be the use of a blue filter when used with a large expanse of flowers such as bluebells.

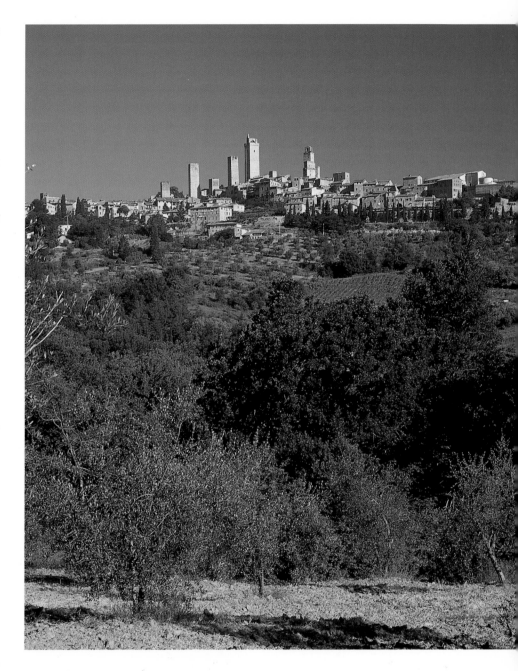

Resin vs. glass filters

There is no doubt that glass filters are less prone to scratching than resin-coated filters, but they are more expensive and have to fit the diameter of the lens you are using – so if you use lenses of different diameters, you may need to buy the same types of filter in several sizes. Resin filters slot into a holder that can be attached to any lens using an adaptor ring.

▲ **SAN GIMIGNANO, TUSCANY, ITALY**
In the height of summer, Tuscan skies can become a relentlessly bright, hazy white – a nightmare for photography. Here the late afternoon produced a bluer sky than usual – helped by a polarizer – and extra warmth was created using an 81C warm-up filter.
MAMIYA 645 SUPER, 45MM F/2.8 WITH LINEAR POLARIZER AND 81C WARM-UP FILTER, 1/30 SEC. AT F/16, FUJICHROME VELVIA

Flash Systems

Some photographers feel unhappy about using any form of artificial light when working outdoors, mainly because they feel it produces shadows that are unnaturally harsh. When flash is used properly that does not happen and there are many situations where a little extra light is invaluable. On dull days, for example, a flash exposure just a stop or so less than the ambient light – used as a 'fill-in' (see page 56) – can add a little punch to the colours in a scene and give the photograph the impact it might otherwise have lacked.

METERING FLASH

These days, it seems that there are few SLR cameras that come without some form of through-the-lens (TTL) flash metering system. This is a useful tool, but to use it successfully requires an understanding of how an exposure meter of any sort works, so that you can cope with the camera's tendency to underexpose bright subjects and overexpose dark ones (see page 36).

Many professionals rely on a hand-held flash meter in the same way that they use a hand-held exposure meter. In fact, the same meter can often be used for both daylight and flash. A Polaroid back, available for all roll-film cameras with interchangeable backs, gives a useful guide to how light is balanced in set-ups using a number of flash heads.

ON-CAMERA FLASH

The small pop-up flash guns which are integral to some camera designs are surprisingly useful. For general use the device is good, though the position on top of the camera's pentaprism often results in 'red eye' when it is used for portraits. A built-in flash can cover only a relatively small distance: a warning light usually tells you if you are out of range. If you try to

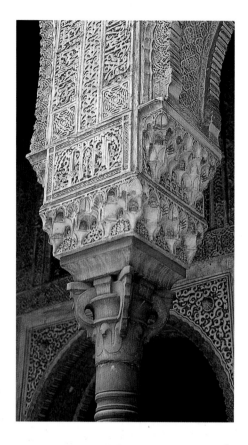

◀ **ARCH DETAIL, ALHAMBRA, SPAIN**
In general, authorities frown on the use of tripods – they get in the way and can scratch floors – and some will charge a heavy fee. To be as unobtrusive as possible I often use flash in low light – such as here to show the detail under an arch. However, in places of worship and many museums flash is forbidden: the argument is that it causes light damage, though more often the reality is that they want to sell you postcards and guide books, which is fair enough.
NIKON F100, 28–80MM F/2.8 AF, SB 25 FLASH GUN, 1/60 SEC. AT F/11, FUJICHROME VELVIA

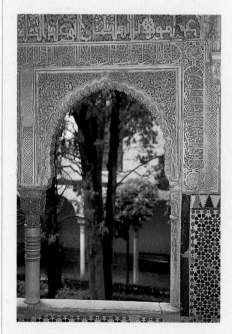
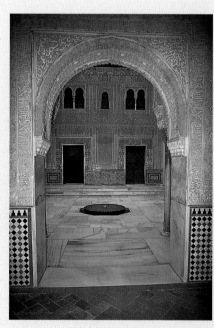

BALANCING FLASH AND DAYLIGHT
The shaded interior of the Alhambra Palace in Spain produces strong contrasts with the view outside, which can be handled by balancing flash and natural light (left). In the picture on the right, both the inside of the arch and the scene beyond were lit by natural light.

illuminate the vaulting in a cathedral, for example, you will be disappointed.

SEPARATE FLASH GUNS

Powerful guns can be fixed to a camera hot shoe and used with the TTL metering system. To get a higher degree of control, you will need to use your flash off-camera so that you can vary the direction of the light. A connecting cable conveys data from camera to flash and vice versa.

Working in medium and large formats often necessitates using powerful flash guns – the traditional 'hammerheads'. Several manufacturers have incorporated TTL flash technology. In fact, if you run two outfits – 35mm and roll film – you can use the same flash units for both, with different adaptors.

MACROFLASH

For close-up work, several camera systems now include a macroflash system. These are effective but expensive, and in reality you can get results that are just as good, if not better, using a pair of separate flash guns run from the camera's TTL system and mounted on a commercially made or home-built flash bracket.

REFLECTORS

Last but not least in the outdoor photographer's lighting kit are the indispensable, easily portable Lastolite reflectors, useful with either flash or daylight for throwing light into areas of shadow, which can reduce the contrast range the film has to handle. They have a white surface on one side and silver or gold – for warm tones – on the other.

▼ **GROUP OF FRIENDS, FRONTINO, ITALY**

Most on-camera flash guns and small flash units just cannot light the background successfully. You could use larger hammerhead guns, or a set of photofloods – but that would be severely disruptive for a group of friends chatting over drinks. Sometimes a 'snapshot' is all that is needed. Nikon F100, 28–80mm f/2.8 AF, SB 25 flash gun, 1/60 sec. at f/8, Fujichrome Velvia

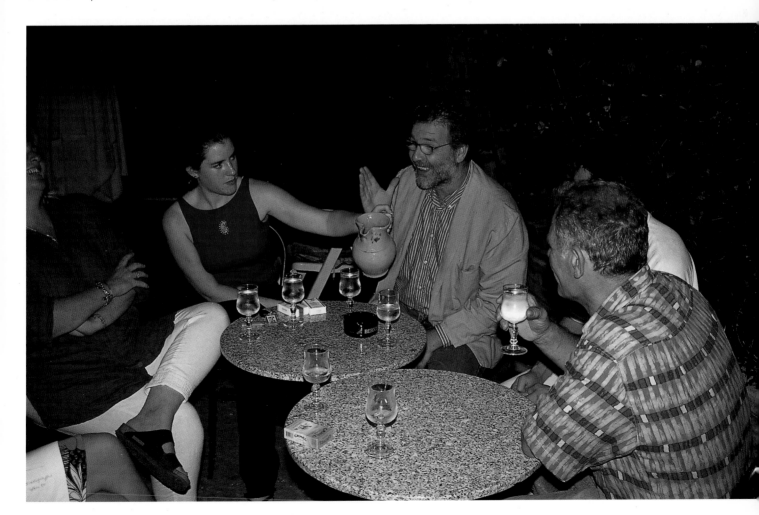

Supports and Storage

When you are carrying all your equipment with you into the field, weight becomes an important consideration. However, you can't afford to skimp on good protection for your expensive photographic gear, or on adequate support for the camera.

SUPPORTS

Most loss of sharpness in pictures is due to movement of the camera rather than the subject. In other words, 99 per cent of the time it is the fault of the photographer. Whenever light levels are too low to permit a fast enough shutter speed to eliminate camera movement (see page 16), some kind of support is needed.

You can brace yourself effectively against a wall or a tree or, when lying on the ground, use your arms and elbows to create an 'organic' tripod. Better still, rest a lens or camera body on a rock, the top of a camera case (soft or hard), or against a wall or column. A 'bean bag' is a simple and versatile accessory – a cloth bag partly filled with pulses that moulds itself to the shape of a lens barrel rested on it.

A monopod is useful in rocky terrain (where you can also use it as a walking aid). Your two legs and the monopod create the tripod effect, yet it is far less obtrusive than a tripod. However, the most stable form of support is a tripod, and for all longer exposures it is essential. Buy the most solid tripod and head you can manage and afford – but remember that you will have to carry it. Sadly, the lighter models (unless they are carbon fibre) are a waste of money for they vibrate and flex. Gitzo, Manfrotto and Benbo all make tripods to last – though the latter takes some getting used to since its legs and column are arranged around a central 'bent bolt'.

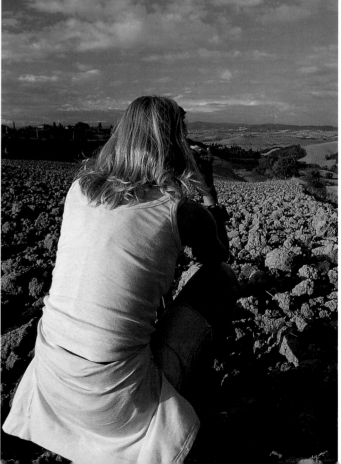

▼ **USING WHAT COMES NATURALLY**
Arms and legs make a natural support. While photographer Lois Ferguson captured the late afternoon light on a Tuscan landscape, I captured the scene with an eye on the next book.
NIKON F4, 24MM F/2.8 AF WITH CIRCULAR POLARIZER, 1/30 SEC. AT F/8, FUJICHROME VELVIA

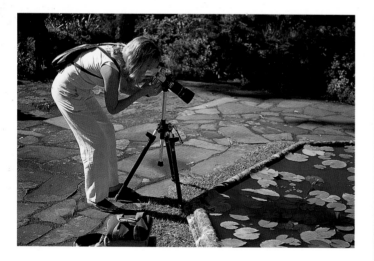

▲ **USING A TRIPOD**
With longer lenses, a tripod or at least a monopod is essential. People boast about their ability to hold lenses steady at slow shutter speeds, but I know of no serious photographer who can. (This is either a sign of a dissolute life or of high standards.) Tripods, bean bags, walls and camera cases can all be pressed into use to help reduce camera shake.
NIKON F100, 28–80MM F/2.8 AF WITH CIRCULAR POLARIZER, 1/125 SEC. AT F/8, FUJICHROME VELVIA

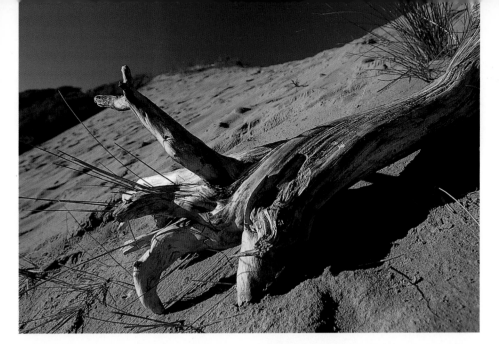

◄ **GETTING DOWN TO THE SUBJECT**
This driftwood on a sand dune could be photographed only by lying down with the camera balanced on a rucksack, which formed a giant 'bean bag'. This approach is often more convenient than setting up a tripod and getting into impossible positions.
NIKON F4, 24MM F/2.8 AF WITH CIRCULAR POLARIZER, 1/30 SEC. AT F/16, FUJICHROME VELVIA

CAMERA BAGS AND CASES

Protecting your investment in photographic gear is extremely important and there are cases and bags to suit all tastes, budgets and purposes.

Large metallic camera cases that have to be placed on the ground for access are vulnerable in crowded places – one quick push and the thieves vanish as the crowd melts around them. You might want to transport your equipment to your destination as safely as possible but then decant what you need for the day into a shoulder bag that does not scream, 'Affluent photographer, please rob.'

If you buy a camera rucksack, be conscious of comfort and not fashion. Try to get one that holds a sensible sized outfit and that has a well-constructed frame that lifts the bag clear of the small of your back to avoid making you perspire – if the foam padding gets wet in tropical countries it can harbour unpleasant moulds of all sorts.

Following the horrors in New York on 11 September 2001, airlines are far more safety conscious; bags you might have taken as hand luggage are now consigned to the hold. My solution is to pack equipment in hard resin or plastic cases which fit inside innocuous-looking bags. My clothes go in the camera rucksack, which has its partitions temporarily removed, and I switch the camera gear over to the rucksack before working in the field.

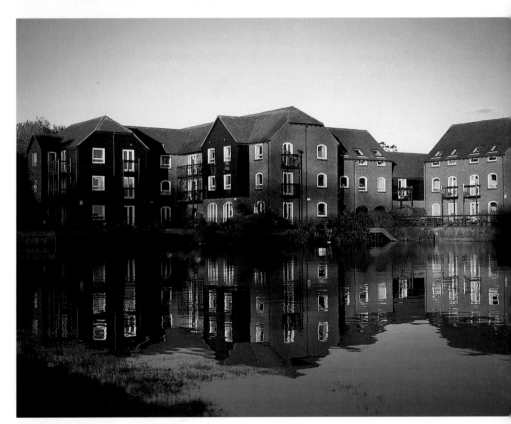

▲ **REFLECTIONS, SANDFORD-ON-THAMES, OXFORD, ENGLAND**
When light levels are low there is no choice but to use a tripod for maximum sharpness. For many years, my choice has been the Benbo, but just buy the firmest one you can consistent with your ability (and inclination) to carry it around.
MAMIYA 645 SUPER, 45MM F/2.8 WITH LINEAR POLARIZER, 1/30 SEC. AT F/16, FUJICHROME PROVIA 100F

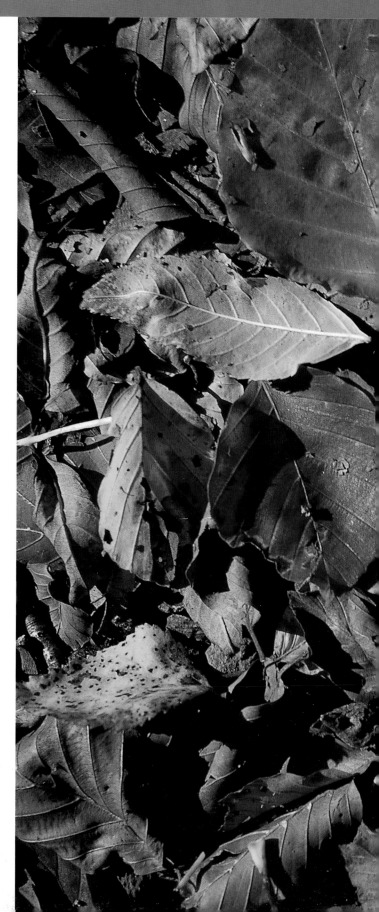

CHAPTER 2
LIGHT & FILM

Light is the medium with which a photographer works – the word 'photography' comes from two Greek words, *photos* and *graphia*, and means painting or drawing with light.

It is essential to understand how light affects film – described by the term 'exposure' – in order to be able to control it to get the result you choose. Getting the exposure right is the most basic skill in photography and one you go on learning for a long time. It is even more important than getting a sharp image. You, the photographer, have to decide what you want in terms of sharpness and colour rendition from a film, and which film suits the conditions and subjects you want to capture in your photographs.

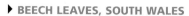

▶ **BEECH LEAVES, SOUTH WALES**
The beech leaves in this picture are the kind of subject that demand maximum sharpness from your lens and film. But without the right light – here coming from the side to provide 'relief' – pictures can become flat and lifeless. Photography is, after all, literally 'writing with light'.
Mamiya 645 Super, 80mm f/4macro with 81B warm-up filter, 1/15 sec. at f/16, Fujichrome Provia 100F

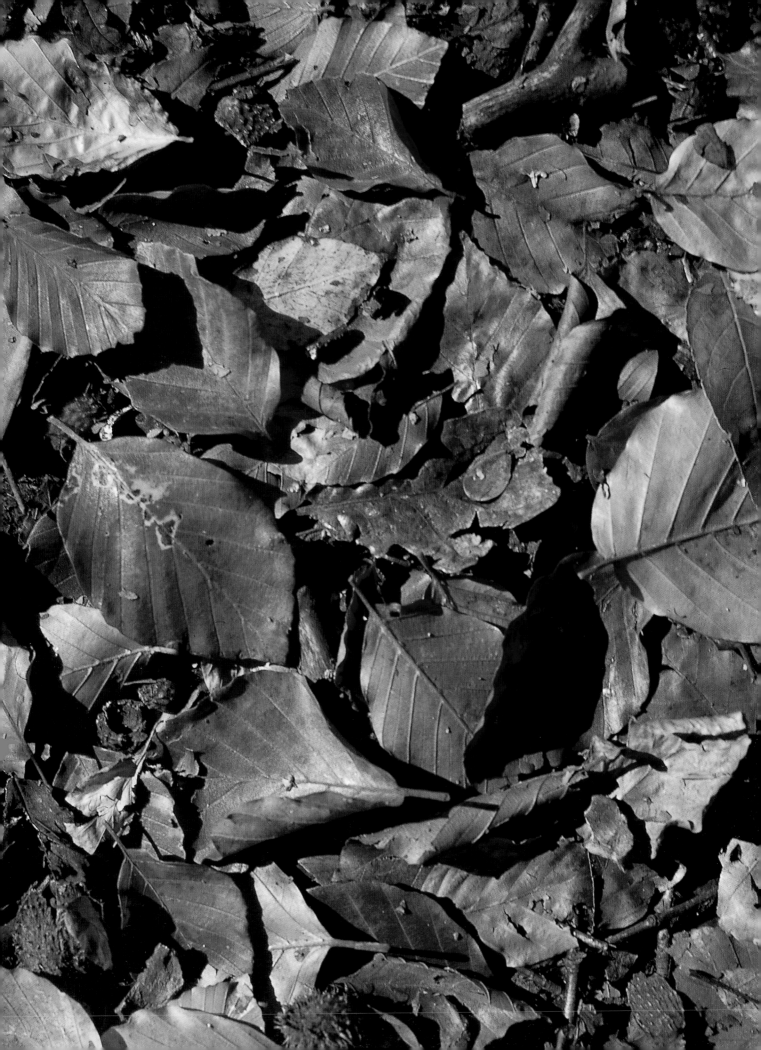

Apertures

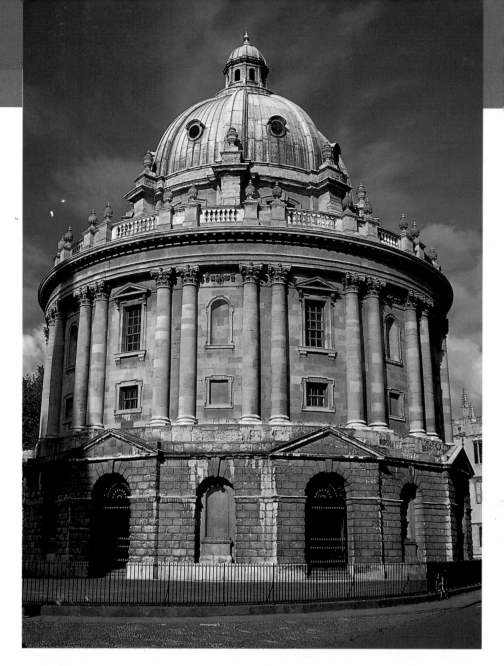

Stripped to basics, a camera is no more than a light-tight box with a lens at one end and a piece of light-sensitive material at the other. This material can be a film or, in the case of a digital camera, an array of receptors. Light is controlled by the opening and closing of the shutter and also by the iris diaphragm, which is adjusted to determine the size of the aperture through which light passes.

This description might seem simplistic, but a 'back-to-basics' approach can often help when you are not getting the results you intended. Correcting the fault is rarely complicated. Learning to take command, instead of just believing what the gadgets on the camera tell you, can make a big difference to your success rate. Your camera becomes what it should be – a tool.

A film is designed to be correctly exposed when a certain amount of light energy falls on it. Its sensitivity to light is given by its ISO (International Standards Organization) rating. Various combinations of aperture and shutter speed will expose the film correctly, but both have other functions, and you have to decide which should take priority: a fast shutter speed (needing a wider aperture for correct exposure) will freeze movement, while a small aperture (at a slower speed) will maximize depth of field.

'stop down' and you halve the aperture area; decrease and you 'open up', letting through twice the amount of light. Most lenses have intermediate 1/2 stop settings (1/3 stop in large-format cameras).

DIAPHRAGM AND F-STOPS

The diaphragm is controlled by a ring, which opens and closes the blades of the iris. On the aperture ring, you find all or part of a familiar series of numbers – the f-numbers: 1, 1.4, 2, 2.8, 4, 5.6, 8, 11, 16, 22, 32, 45, 64. The smallest aperture corresponds with the highest number. Moving from one number to the next changes the area of the aperture by a factor of two: increase by one place to

DEPTH OF FIELD

The extent of a scene, behind and in front of the plane of sharpest focus, that appears in focus – the depth of field – is controlled by the diaphragm. In general, the smaller the aperture (the higher the f-number), the greater the depth of field. About two-thirds of the available depth of field is beyond the plane of sharpest focus and a third is in front. Wide-angle lenses seem to give greater depth of field than

▲ **RADCLIFFE CAMERA, OXFORD, ENGLAND**
A small aperture was essential to ensure that every part of this picture is sharp.
Mamiya 7 II, 43mm f/4.5, 1/30 sec. at f/16, Fujichrome Provia 100F

telephotos, but in fact, depth of field depends on magnification (see page 14). All lenses at the same magnification give the same depth of field. Telephoto lenses appear to give a shallower depth of field because we use them to produce bigger and closer images, so the magnification is greater, and because a telephoto lens throws objects out of focus dramatically on either side of the focus position.

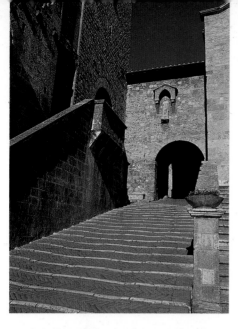

◀ **SAN GIMIGNANO, TUSCANY, ITALY**
Subjects such as this ramp or a flight of steps demand front-to-back sharpness. An exposure meter might give a reading of 1/125 sec. at f/16, equivalent to 1/250 sec. at f/11 or 1/1000 sec. at f/5.6. The ideal combination gives the depth of field you want and a shutter speed that allows you to hand-hold with confidence.

Mamiya 645 Super, 45mm f/2.8, linear polarizer, 1/60 sec. at f/11, Fujichrome Provia 100F

▼ **OLIVE GROVE, SALENTO, ITALY**
Spring brings a blaze of colour to the Mediterranean. A 6 x 7cm rangefinder camera was used to squeeze every possible bit of detail from the scene. The aperture was set to f/32 – since that meant using a very slow shutter speed the camera was set on a tripod and equipped with a cable release.

Mamiya 7 II, 43mm f/4.5, 1/15 sec. at f/32, Fujichrome Velvia

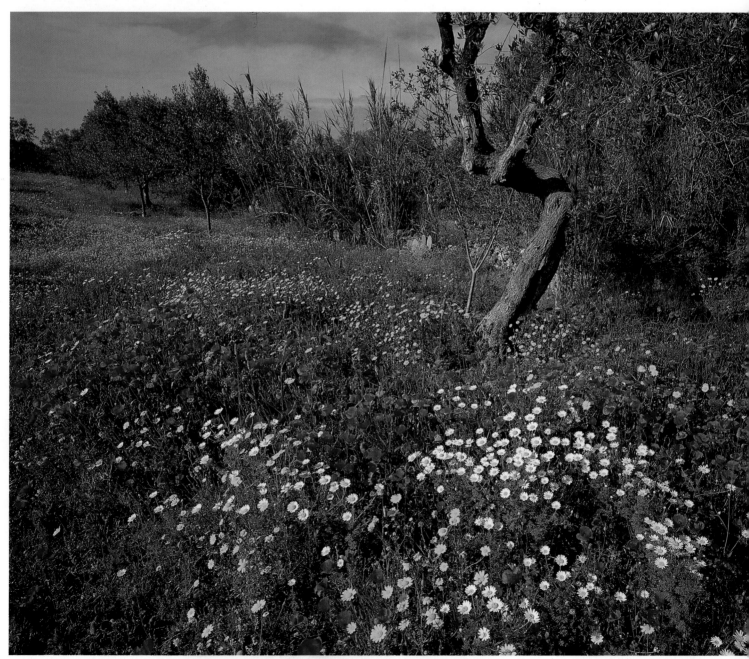

Camera shutters can be mechanical, electronic or a mixture of the two. They produce a range of speeds, measured in fractions of a second: 1, 1/2, 1/4, 1/8, 1/16, 1/30, 1/60, 1/125, 1/250, 1/500, 1/1000 and so on. Just as with the f-stops, moving from one speed to the next either doubles or halves exposure. Electronic shutters can also produce a stepless range of intermediate speeds, chosen by the camera's internal exposure system when a particular aperture is set.

TYPES OF SHUTTER

The shutter can operate in the lens or at the film plane. SLR cameras depend on you being able to look through the lens to compose the picture, and you could not do this with a lens (or leaf) shutter without exposing the film. Most 35mm systems have opted for film plane (or focal plane) shutters – a pair of curtains sitting just in front of the film.

The front curtain moves across the film plane to open the shutter, followed by the rear curtain travelling in the same direction to close it again. The result is that at higher shutter speeds the film is exposed in a moving strip as the space between the curtains moves across it.

The system cannot be used at all speeds with flash. Most cameras have a maximum synchronization speed of 1/250 sec.: above this, the result is a band of light on the film wherever the space between the shutter curtains happened to be when the flash went off. Some cameras have 'rear curtain' synchronization, enabling flash to be matched with higher shutter speeds.

The beauty of having the shutter in the lens is that it is easy to achieve flash synchronization at all speeds, because the shutter is fully open when the flash goes off. Some medium-format cameras provide between-the-lens shutters on a limited range of lenses and these are coupled to a film plane shutter, which opens just before the main shutter is fired.

SHUTTER SPEED TO CONTROL MOVEMENT

A fast shutter speed is often used in outdoor photography to freeze movement. Sometimes however, if the shutter speed is too fast and everything in a picture of a moving subject appears crisp, then the photograph itself looks lifeless. In sports photography some movement is essential. Sports photographers often use long telephoto lenses, for which a fast shutter speed is needed to overcome camera shake if they are hand-held. Using a tripod, a slower shutter speed can be employed and the camera and lens swung to follow the subject – keeping it in exactly the same place in the viewfinder. This is called panning and the sense of movement is conveyed by the blurred background.

With birds in flight (see page 134) the ideal is to have the body and most of the wings in focus, with the wing tips just blurred to suggest movement. With moving water in streams and waterfalls you have to decide how much movement you want. A fast shutter speed that freezes drops in mid-air might work well for a close-up of water. A slow speed creates a milky blur. The ideal may lie between the two, but you will not know until you see the pictures later, so the answer is to try a range of settings.

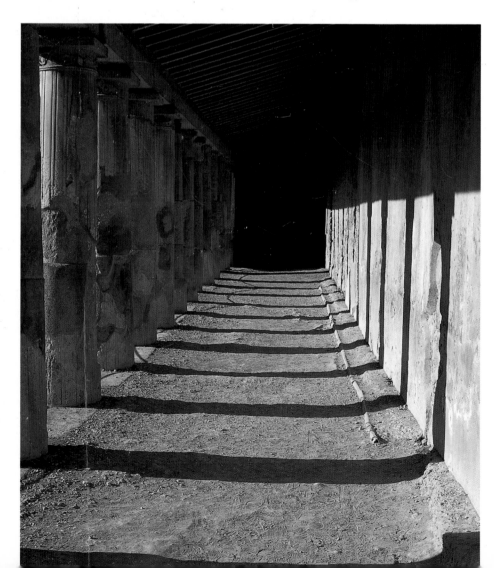

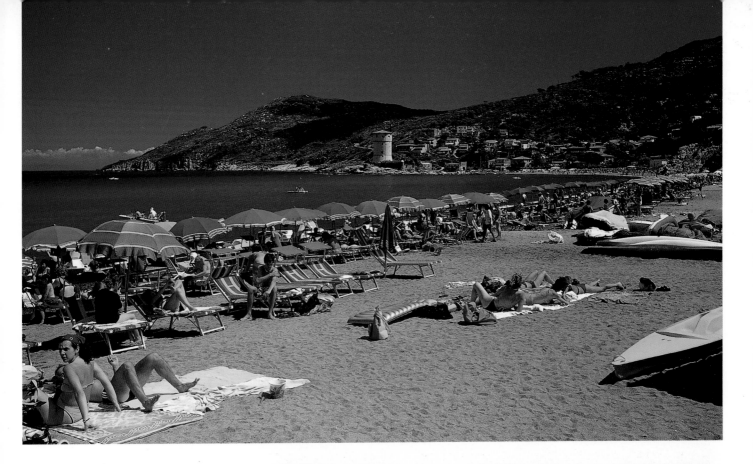

▲ GIGLIO BEACH, GIGLIO, ITALY

Although this scene is bright it is all well lit, with no extremes of contrast. Any centre-weighted or matrix camera meter will cope well and produce an accurate reading. At the coast I always use a UV filter in addition to any others to cut down UV light and also to protect the lens element from sand.

MAMIYA 645 SUPER, 45MM F/2.8 WITH LINEAR POLARIZER AND UV FILTER, 1/60 SEC. AT F/11, FUJICHROME PROVIA 100F

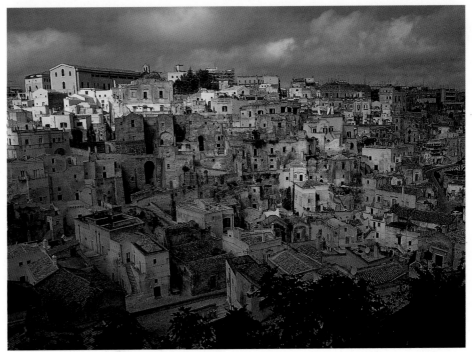

◀ SHADOWS OF COLUMNS, STABIAN BATHS, POMPEII, ITALY

This scene contains distinct areas of light and dark. If my first priority had been to retain shadow, all the texture in the light parts would have been burned out. Modern cameras manage to provide a very good compromise by using their matrix systems, but an alternative is to take spot meter readings of light and dark areas and work between the two.

MAMIYA 645 SUPER, 80MM F/2.8 WITH LINEAR POLARIZER, 1/30 SEC. AT F/16, FUJICHROME PROVIA 100F

▲ STORM LIGHT OVER MATERA, ITALY

Shafts of light breaking through the cloud picked out some buildings, and exposing for these would have given an inaccurate overall reading. I used a spot meter to assess grey tones – and there were plenty of these – which ensured that highlights were bright.

MAMIYA 645 SUPER, 80MM F/2.8, 1/30 SEC. AT F/8, FUJICHROME PROVIA 100F

Exposure Meters

An exposure meter is a photometer – a device used to measure the intensity of light. Its scale is calibrated to suit the needs of photographers. Once you understand exactly what an exposure meter measures you can achieve a much higher rate of success with correct exposure – especially when you are photographing 'difficult' subjects.

First, the film speed (ISO rating) is set. The exposure meter will produce a reading with alternatives. Using ISO 100 film, for example, suppose a scene is correctly exposed at an aperture of f/8 with a shutter speed of 1/125 sec. Other combinations of aperture and shutter speed would produce the same 'correct' exposure: f/5.6 at 1/250 or f/11 at 1/64. In each case, the shutter speed is halved or doubled and the diaphragm correspondingly opened or closed by a single stop.

There are two kinds of exposure meter. An incident light meter is placed in the subject position, where the light falls directly on to a diffusing surface. This is extremely accurate since you are measuring the same light that is falling on the subject. Reflected light meters measure the light reflected back to the camera position. They are calibrated to deal with average reflectivity or mid-tones, such as the 18 per cent reflection of a grey card (see page 36) but bright or very dull subjects can deceive the meter.

HAND-HELD METERS

Many professionals working in a studio use a hand-held meter, so that they can move around a set and measure the light falling on different parts of the subject. All hand-held meters can also work with reflected light.

Outdoors, a hand-held spot meter is a boon for many users of medium-format cameras. This kind of meter selects a very narrow cone of light – typically 1 degree – which means that you are able to take a reading from a mid-tone in any area of the subject.

CAMERA METERS

Integral exposure meters have improved by leaps and bounds, and now offer a sophistication undreamed of a decade ago. Since they are reflected light meters, the basic calibration gives correct exposure with mid-toned subjects. In the past, scenes involving high contrasts or extremes fooled them completely, but now there are several metering patterns to help overcome these problems.

Spot meters select a narrow area. The reading from a mid-tone, or an area of shadow or highlight, can then be locked using the auto-exposure (AE) lock and you can change the composition but retain the exposure setting.

Centre-weighted meters bias most of their reading of a scene towards the centre of the frame.

Matrix meters define a pattern of segments, usually five or more. The camera compares the brightness from the various segments, then compares them with the thousands of combinations that are programmed into its memory.

In addition, some cameras use data from the autofocus system to take into account the distance from the subject, so that the exposure meter can make allowances for reflectance.

We are spoiled by modern electronic wizardry, and yet many people still find they are producing a large number of unsatisfactory shots. This is great for film manufacturers, but not for photographers. The remedy lies in thinking about and mastering exposure.

▶ DUOMO AND CAMPANILE, SIENA, ITALY

From the nave opposite, the duomo and campanile of the cathedral could be framed by a window arch. My TTL meter head has two modes, 'spot' and 'average'; the latter, used here, is centre-weighted. I often check exposures with a hand-held meter but find the camera's own meter very reliable.

MAMIYA 645 SUPER, 45MM F/2.8 WITH LINEAR POLARIZER, 1/30 SEC. AT F/11, FUJICHROME PROVIA 100F

▼ WATERFRONT, GRAND CANAL, VENICE, ITALY

The contrast between gondolas and sky was almost too much for the film. This is the time to use a spot meter on areas of neutral tone.

NIKON F4, 24MM F/2.8 AF WITH CIRCULAR POLARIZER, 1/60 SEC. AT F/8, FUJICHROME VELVIA

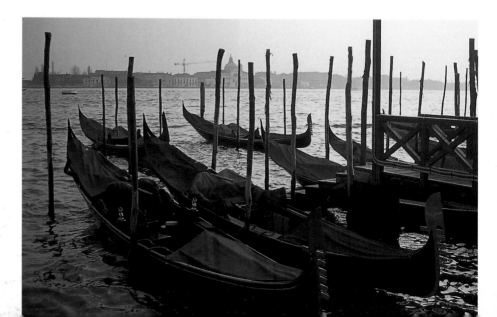

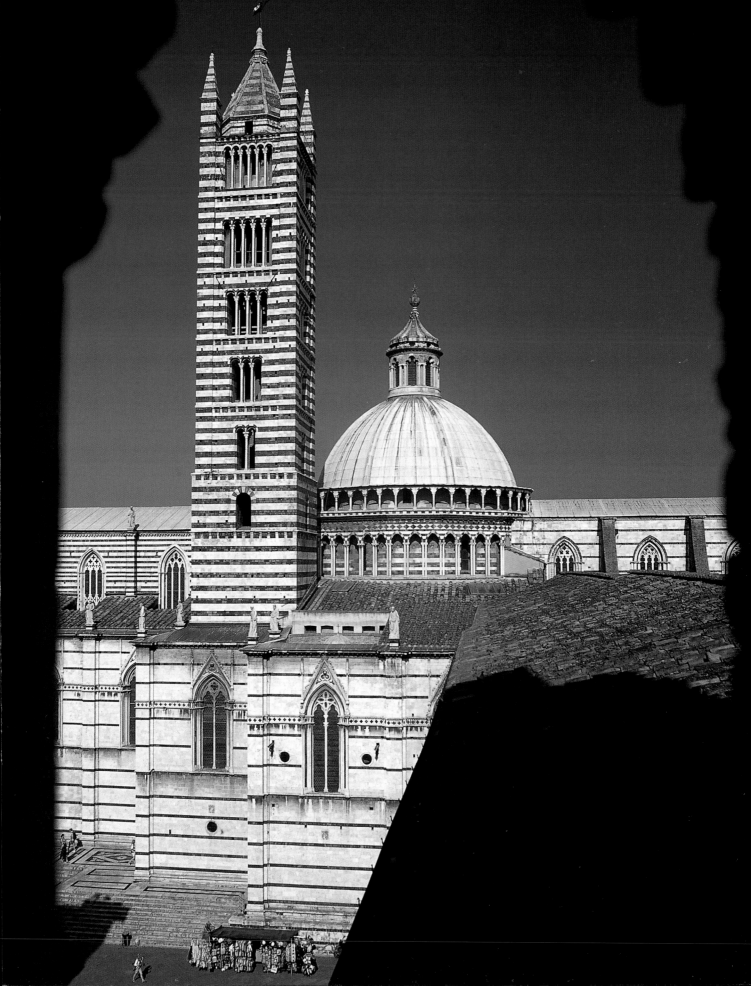

Exposure: Tricky Situations

uilt-in camera meters fall down when scenes include a wide range of contrasts, or contain either highly reflective or unusually dark subjects.

An exposure meter is designed to give exposures for mid-tones: when you meter from these the exposure will be 'correct'. The 'grey card', with its 18 per cent reflectivity of light, is an example of a mid-tone, and you can take a reading from a grey card, holding it so that it is illuminated in the same way as the subject. Red roses, green grass, most tree bark and the blue of the sky away from the sun are all mid-tones. But when you confront the meter with a bright yellow flower, for example, it will try to expose this as grey, producing a very dark, dull yellow on film.

TESTS WITH TRICKY SUBJECTS

With subjects that reflect a lot of light (such as white or yellow flowers) you have to overexpose so as to counteract the meter's tendency to register them as mid-tones. The best way is to use the camera's exposure compensation dial. This allows you to change exposure in 1/3 stops (remembering to return it to normal after use).

Choose a metering mode in which the subject dominates the viewfinder and the meter is not trying to consider the background – use spot metering if you have it. If your subject is a bright yellow flower – which if read as a mid-tone will be rendered as dull yellow – you have to decide that you want bright yellow, and how far away from dull yellow this is. To

▼ **SEED-HEAD, AKAMAS, CYPRUS**
Deliberately shooting into the sun can create silhouettes. In this case, to retain colour in the surrounding sky, an exposure was taken with the camera's spot meter just to the side of the sun – not from the sun's disc itself. Zoom lenses and other designs with lots of elements sometimes produce a series of bright dots when shooting near the sun as a result of internal reflections. NIKON F4, 28MM F/2.8 WITH CIRCULAR POLARIZER, 1/125 SEC. AT F/11, FUJICHROME VELVIA

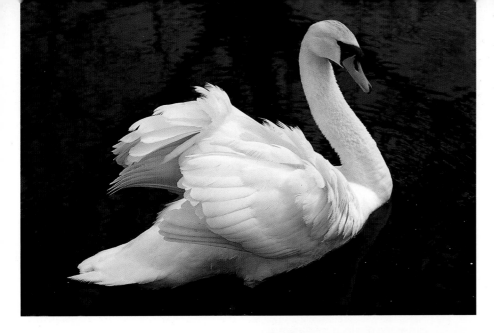

◀ **SWAN**

White birds, snow scenes and black cats in coal cellars are the traditional examples of subjects that 'fool' exposure meters. By experimenting early on with each new camera I know that with this one I can use the spot meter mode, expose for the white and then compensate by 1 1/3 stops overexposure. This retains detail in white as a series of light greys.

NIKON F4, 80–210MM F/2.8 AF, 1/125 SEC. AT F/8, FUJICHROME VELVIA

guarantee the result you want, you can bracket exposures, taking a range of shots at half-stop intervals from under- to overexposure.

An average subject with light and dark tones covers a tonal range of about seven stops, from pure white to black. Colour transparency films can just about embrace a six-stop range in tones, black and white films about eight stops. Dealing with a scene with strong contrasts is a question of compromise and deciding where you need to retain detail. The great landscape photographer Ansel Adams invented his 'zone system' to make best use of the tones in a scene (see Appendix).

THE SUNNY F/16 RULE

Films are designed to give correct exposure with the sun high in the sky when the lens aperture is set to f/16 and the shutter speed is 1/ISO rating. For example, ISO 125 film is correctly exposed when the shutter is set at 1/125 and the lens at f/16 on a bright day (outside the tropics). Because many films are rated at ISO 100 or ISO 50 there has to be a little licence in interpretation of the rule: for instance, exposing at 1/125 sec. rather than 1/100 sec. produces an underexposure of about 1/3 stop. The rule can be useful to give you an idea of what the exposure might be, especially if you suspect a fault in the meter or the batteries fail.

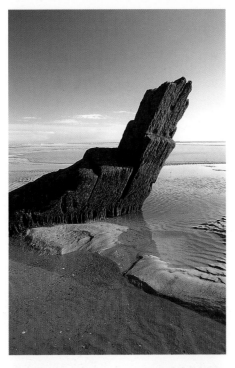

◀ **SHIPWRECK TIMBERS, SKER BEACH, SOUTH WALES**

I did not want the timbers to appear silhouetted against the sky, so took my exposure reading from the green weed covering them. Just enough colour is left in the sky for it not to appear burned out.

NIKON F4, 24MM F/2.8 AF WITH CIRCULAR POLARIZER, 1/60 SEC. AT F/8, FUJICHROME VELVIA

◀ **STREET DETAILS, GIGLIO ISLAND, ITALY**

Narrow streets are often lit for only a short time each day by direct sun, giving stark patterns of light and deep shadow. The camera's internal meter produced the compromise result shown here. The light areas are lesser in extent than the shadow and the meter reading gave the best balance between shadow and highlight. Several bracketed exposures were made but did not better the camera's own interpretation.

MAMIYA 645 SUPER, 45MM F/2.8 WITH LINEAR POLARIZER, 1/60 SEC. AT F/11, FUJICHROME PROVIA 100F

Film sensitivity to light is measured on the ISO scale – slow films are less sensitive to light but record detail better than fast films. The slower films, ISO 25, 50, 64 and even 100, have the finest grain and the keenest sharpness. They also show the greatest tolerance to a wide range of light intensities – or contrast – in the same scene.

Choice of film is highly subjective and really depends on your personal preference. If you are using colour, it will depend on how you like your colours to appear, since each film renders them slightly differently. Your choice might be made for you if you intend supplying book or magazine editors and picture agencies. They will prefer transparency film with as much sharpness and detail as possible. This means using slow to medium films such as Fujichrome Velvia and Provia and the equivalents from other manufacturers.

TRANSPARENCY FILM

There is a fashion for films with a warm balance and saturated colours pioneered by the Fujichromes (and by some Ektachromes). For a more realistic rendering of skin tones, many people favour Fujichrome Astia.

Kodachrome 25 and 64 give a slightly cooler rendition of colour, but they have a different structure, with thicker film emulsion and different dyes, and do not scan nearly so well as films designed for E6 processing.

Many fast films are available for low light photography in the range ISO 400–1600. The faster, or more sensitive to light, a film is, the more noticeable the grain, and many photographers have made a virtue of obvious grain, particularly for black and white prints. Fast films have a much higher contrast: there is no gentle gradation between tones and they are

much less forgiving of incorrect exposure. When overexposed they 'burn out' quickly and lose all highlight detail.

COLOUR NEGATIVE FILM

If you prefer to work with colour negative film, a great deal depends on the printing process, where you can control the final colour balance. Colour negative film stock has its advantages: it

▼ LAVA CLIFFS AT CAPELHINOS, FAIAL, AZORES

Book and magazine publishers have gradually shifted to using saturated colours, which is something to bear in mind if you intend to try selling your pictures. The browns of the lava cliffs in the Azores set against the sea were intensified by using a polarizer, and the film chosen was ideal for saturated colours.

NIKON F4, 24MM F/2.8 AF WITH CIRCULAR POLARIZER, 1/60 SEC. AT F/8, FUJICHROME VELVIA

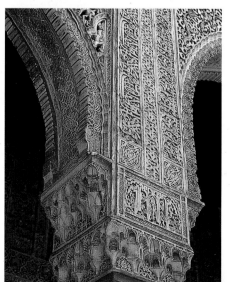

◄ ORNATE ARCH, ALHAMBRA PALACE, GRANADA, SPAIN

This intrictate carved stone work demanded a film that could capture both fine detail and the subtle range of tones. Agfa Scala was chosen since this produces results with very fine grain and a superb rendition of tones. It is also more tolerant of slight over- and underexposure than colour transparency film.

NIKON F4, 24MM F/2.8 AF WITH CIRCULAR POLARIZER, 1/60 SEC. AT F/8, AGFA SCALA

scans easily from the negative, often needs little or no correction and ends up much cheaper than transparency film. And you always have a set of prints to show people.

FILMS FOR TUNGSTEN LIGHT

Daylight films work well when there is a mixture of daylight and artificial light, such as at twilight, giving a 'warmth' to the artificial light. When there is no daylight, however, such as when a building is lit entirely by floodlights, daylight film gives far too orange-yellow a result. You can either use a film balanced for tungsten light, or use a blue 80 series filter: the values are 80A,

80B, 80C and 80D. Typically an 80A is used to balance ordinary room lighting for daylight film and an 80B for tungsten photoflood, which is less warm.

MONOCHROME FILM

Everyone working in black and white has their favourite emulsions. I have always preferred the finest grain possible in monochrome negative film (Ilford PanF or Kodak XP1) but I now use Agfa Scala, a black and white reversal film that can easily be pushed by a couple of stops. It shows a wonderful range of tones with very fine grain. It is available in both 35mm and roll film, it is expensive, and comes process paid.

▼ **COASTAL SPRING FLOWERS, GARGANO, ITALY**
The ideal colour film should be able to reproduce tones accurately throughout the visible spectrum. Here, Fujichrome Velvia has coped well with red and blue from the ends of the spectrum, and with the yellow. Some people prefer other films for the rendition of greens – the choice is subjective and you get used to the colours produced by a particular film.
Nikon F4, 28mm f/2.8 AF with circular polarizer, 1/60 sec. at f/11, Fujichrome Velvia

Film Care

Film is a high precision material made to exacting tolerances. Exposed and unexposed film has to be protected from exposure to light and excessive heat.

Film ages after manufacture, and so-called professional films are supposed to be sold to you at their optimum. But they do not decay suddenly as soon as they pass their 'use by' date. If your living depends on photography – or if you simply want to be sure – buy your film from a reputable dealer with a high turnover and regular fresh stock. Never buy from the corner kiosk in a hot country, because you don't know how long the film has been stewing in the heat.

Keep film cool before exposure – do not take it out of its canisters until absolutely necessary. Take with you each day as much as you think you will need (then add a reel or two). After exposure, pack the film away in a sealed plastic box – adding silica gel sachets to absorb moisture if you are in the tropics (see page 58). If you are going to be abroad for a while, find out where the local pros get their work processed rather than storing large amounts of exposed film.

After processing keep transparencies in archival filing sheets in cabinets – that way your pictures might even outlast you. These days many people scan their best pictures as soon as they return from the lab – these files can be copied indefinitely to prevent deterioration.

X-RAYS

From time to time, photography magazines run yet another story about X-ray damage caused to film at airports. Film damage is always hard to discern – it usually results in an overall fogging that reduces contrast. Naturally the manufacturers of all X-ray equipment claim it is 'film safe'. If you doubt this, you can, in theory, ask for hand searches of your film at an airport, but with increased security your request might not be met sympathetically.

Although there is evidence to show that very fast films suffer from repeated passes through airport X-ray machines, slow to medium films do not. You may encounter a problem if you make a lot of

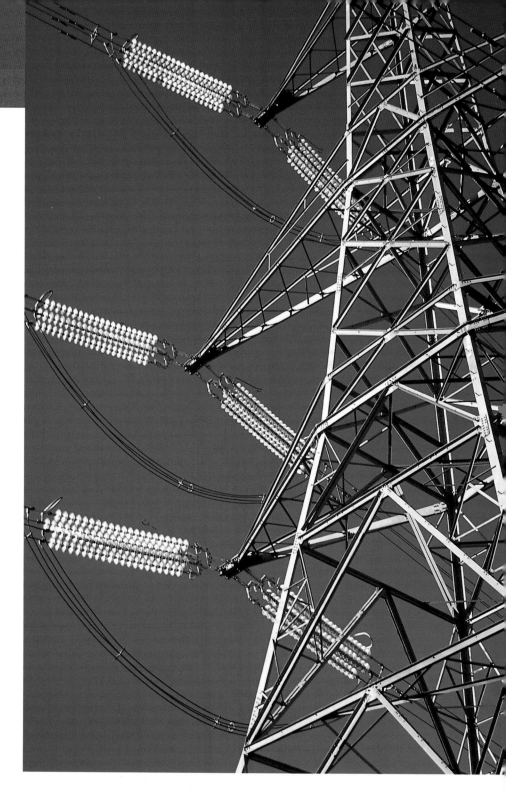

▲ **ELECTRICITY PYLON**
There is much discussion about the effects of electromagnetic radiation but, for example, the bundles of energy in the radiation from electric cables carried by pylons are simply not great enough to fog film. However, X-rays are far more energetic than light waves and can fog film by activating the same chemical reactions with the silver in the film.
NIKON F4, 28– 80MM F/2.8 AF WITH CIRCULAR POLARIZER, 1/30 SEC. AT F/8, FUJICHROME VELVIA

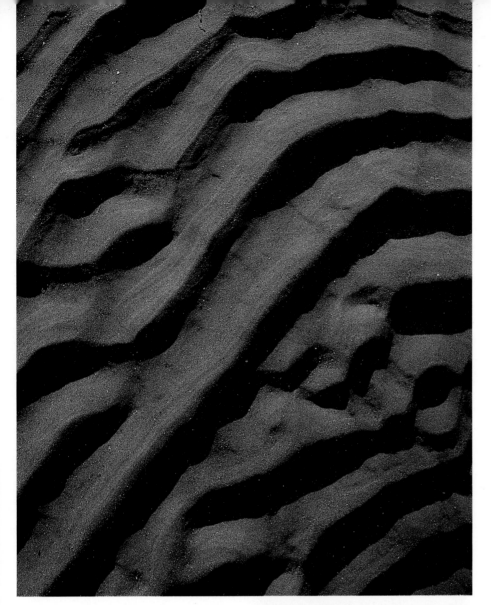

◀ **SAND RIDGES, WESTERN CYPRUS**
Dust is an enemy of all photographers but when that dust is abrasive it can permanently damage equipment. Wet sand in ridges is not actually the problem – it is the wind blowing the sand on beaches and in deserts that is harmful.
NIKON F4, 24MM F/2.8 AF WITH CIRCULAR POLARIZER, 1/30 SEC. AT F/11, FUJICHROME VELVIA

▼ **ISLAND OF FAIAL, AZORES**
I have only once suspected some X-ray fogging, and that was on ISO 400 film after a two-week stay in the Azores, during which I used eight internal flights and the film went through the X-ray machine each time. But the evidence was inconclusive . . .
NIKON F4, 24MM F/2.8 AF WITH CIRCULAR POLARIZER, 1/30 SEC. AT F/11, FUJICHROME VELVIA

internal flights via small airports. Their machines might well have been bought from larger airports and will not boast the latest technology.

If you try to protect your film by storing it in lead bags, and the operators see something opaque, they just turn up the voltage until they can see the contents of the bag. To minimize damage, pack all your film in hand luggage – hold baggage can be subject-ed to high X-ray doses on a random-search basis. I always send my film through the X-ray as hand baggage – so far nothing has gone wrong.

THE LANDSCAPE

We all react to scenes of natural beauty in an intuitive way, not stopping to think of the elements that are building the impression in our mind. The skill of a good landscape photographer is to isolate the important elements and create such a strong visual impression that even sounds and smells are evoked by the image.

Ansel Adams, doyen of landscape photographers, defined a good composition as one that could make a 'personal statement' about the photographer's feelings for the subject. It is a tall order, but there are useful approaches to try. A low viewpoint with a wide angle may include ploughed fields, the sea rippling over the beach, or objects in the foreground that lead the eye into the frame. Or a telephoto lens can isolate a partic-ular element and condense perspective. Where you put the horizon will make a big difference, especially towards evening, when foreground shapes will be silhouetted against the sky.

▶ **PIANO GRANDE, UMBRIA, ITALY**
Over a decade I have taken hundreds of photographs of the remarkable Piano Grande. I spotted some distant strips of scarlet and blue – poppies and cornflowers – walked until they were in the foreground and spent four hours working in the changing light, not wanting to leave.
MAMIYA 645 SUPER, 45MM F/2.8 WITH LINEAR POLARIZER, 1/15 SEC. AT F/16, FUJICHROME VELVIA

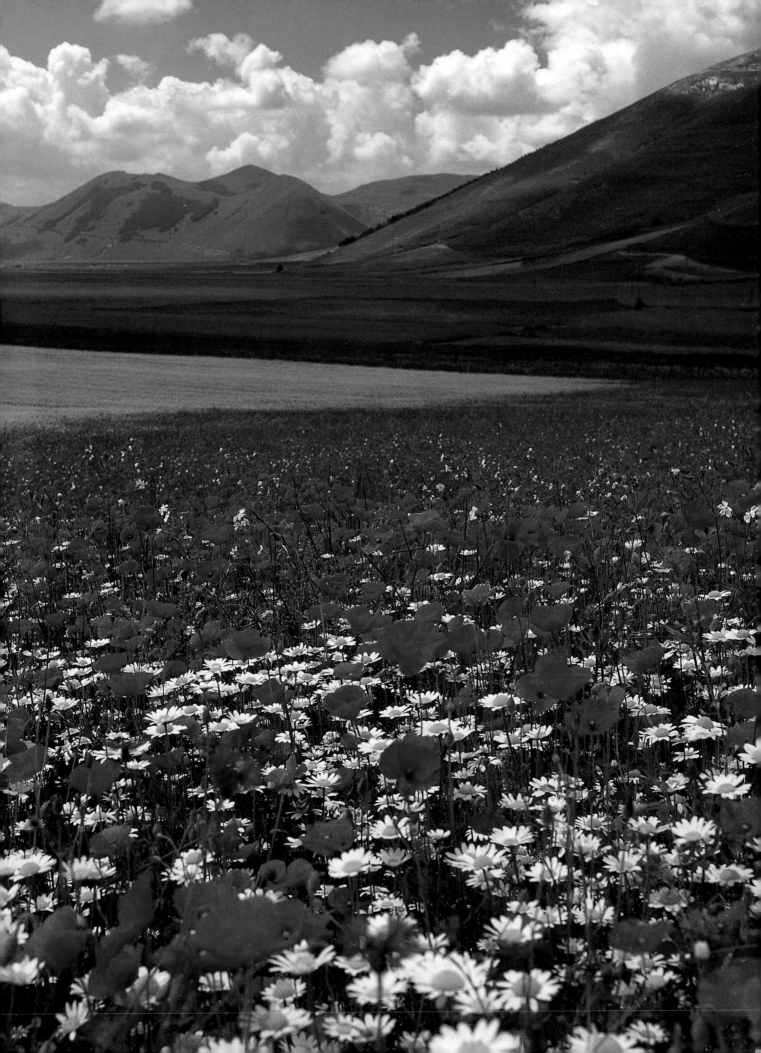

Light and Time of Day

The photographs that you take in the summer sunlight a few hours before and after midday will be very different in 'feel' from the ones you take on a late summer's afternoon or in the early morning. There are two factors that make the difference: the angle of the sun and the 'colour' of the light.

Daylight is much warmer at the beginning and end of the day. Equally, light from a hazy white sky has a very different quality from the light cast by a blue sky. We perceive colours by reflected light, and all the hues in the landscape are slightly changed by the proportion of reds and yellows or blues in the light.

If I am free to choose on an assignment, I always try to do as much of my photography as possible in mid- to late afternoon. This avoids the harsh overhead light of the middle of the day. If a landscape includes ancient walls and columns, which are often of limestone or sandstone, the evening light seems to make them glow. Human skin tones are warmer, too, and more flattering to the subjects. The early morning light also has some warmth, and at this time flowers and leaves in the landscape are at their freshest, sparkling with dew.

STRUCTURE AND TEXTURE

The height of the sun above the horizon dictates the length and nature of the shadows that give 'moulding' to a subject, defining its structure. The low angle of the light also means that every small bump and irregularity on the surface of an object casts its own small shadow, thus creating 'relief' that shows up the surface texture. Features such as architectural details, fine carvings, or the tactile texture of rock or tree bark are all emphasized by side lighting, which the early morning or late afternoon sun supplies.

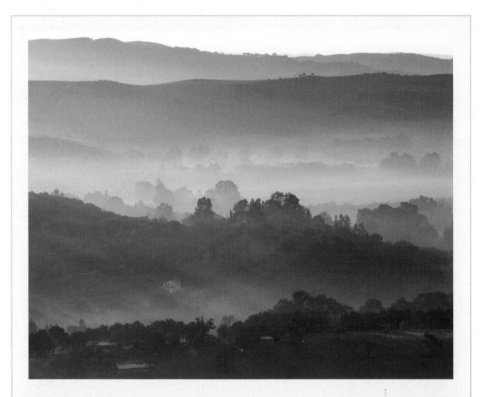

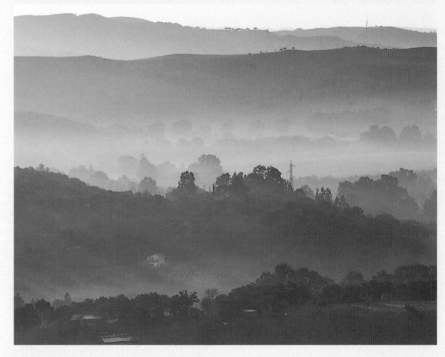

JIMENA DE LA FRONTERRA, SPAIN
Early morning effects are often fleeting, but if you can get into position just before sunrise you will be presented with a whole range of lighting in the same scene as the world around you wakes up. The original scene (above) contained a single electricity pylon, which was removed using the 'cloning tool' in Adobe Photoshop after the transparency had been scanned (top).

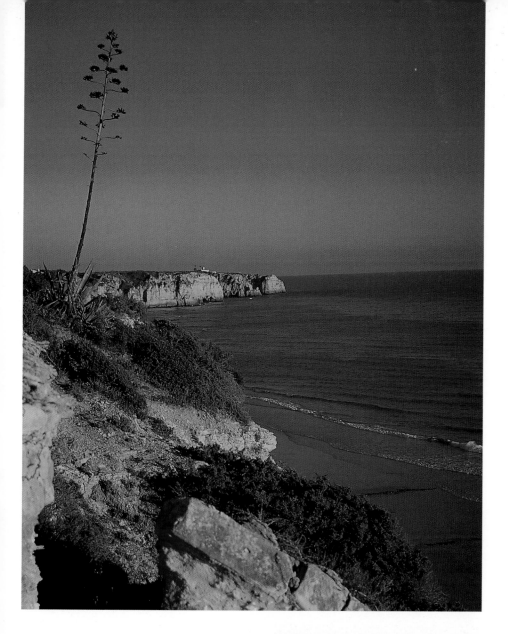

◄ COASTAL VIEW, ALGARVE, PORTUGAL

Light late in the afternoon contains a higher proportion of reds and yellows and produces a warmer feel in photographs. The long shadows increase the modelling in a landscape.

Nikon F60, 28–80mm f/2.8 AF with circular polarizer, 1/30 sec. at f/16, Kodachrome Gold 100, Photograph: Lois Ferguson

▶ PALM SHADOWS, MADEIRA

A low-angled sun in the early morning or late afternoon produces long shadows – outstandingly long just before sunset in winter. Here the shadows of palm trees overhead create patterns on the ground beneath.

Nikon F60, 28–80mm f/2.8 AF, 1/60 sec. at f/11, Fujichrome Velvia, Photograph: Lois Ferguson

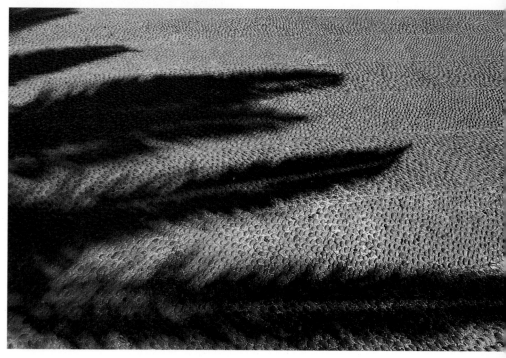

Sunrise and Sunset

There is something deeply satisfying about watching the deep red orb of the sun sink almost imperceptibly below the horizon. The scene changes quickly, as the undersides of clouds are illuminated and successive different mixes of purples, lilacs, greys and oranges are created. The spectacle cries out to be photographed, and yet many people who try to capture it are disappointed with the results. The secret of photographing vividly coloured sunsets lies in choosing the right part of the sky from which to take an exposure reading.

SUN ABOVE THE HORIZON

When the sun is still above the horizon, it is intensely bright. If you include it in the viewfinder, and are using matrix or centre-weighted metering, the meter will usually be fooled into underexposing the shot.

If you are using a wide-angle lens, you can get around this by changing to spot metering. With a telephoto, change your view to an area a few degrees to one side of the sun, take a reading, lock the exposure (or set the exposure manually), and re-compose your shot. The effect you get depends on the height of the sun above the horizon.

SUN ON THE HORIZON

When the sun is around 10 degrees above the horizon the reddening effect begins in earnest. Take a reading from the bright area, 5–10 degrees to one side of the sun.

▼ **DAWN OVER EASTERN SARDINIA**
The photographer happened to wake with the dawn and saw this spectacle from a hotel window. The silhouettes of trees, low in the frame, add both scale and interest to what is essentially a picture of the sky.
NIKON F60, 28–80MM F/2.8 AF, 1/15 SEC. AT F/11, FUJICHROME VELVIA, PHOTOGRAPH: LOIS FERGUSON

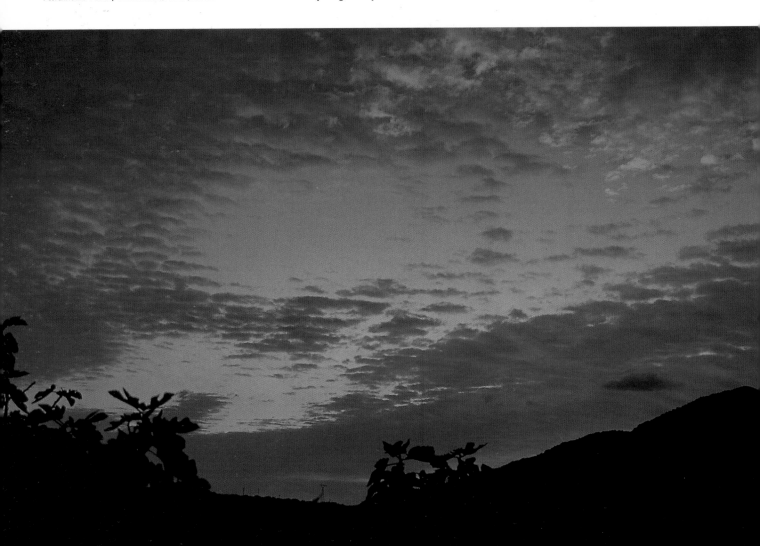

The results on film are dramatic, for although much of the scene is overexposed, slow films produce intense 'sunset' shades and silhouettes are created from rocks, trees and other useful 'compositional objects'. It might not be quite what you saw but it looks as if you meant it.

As the sun sinks lower, its light passes through a greater thickness of atmosphere and the colour tints become more varied as shafts of light pick out the edges and surfaces of adjacent clouds. The effect is accentuated by dust in the atmosphere that scatters the low-angled rays (known as the Tyndall effect). Factories and power station chimneys take on an ironic beauty when their form is silhouetted against the vivid sunset sky that their belching emissions have helped to create.

AFTER SUNSET

Some of the most eye-catching displays emerge in the changing light show that continues for half an hour or more after the sun disappears. The light level is now much lower than it seems, so to capture the fullest range of tones you should use a tripod and take a meter reading from a mid-toned rather than a dark area, near where the sun has set. Now is the time when you can mix daylight and artificial light to good effect (see page 48).

BRACKETING SHOTS

These suggestions are just a starting point for experimentation. By over- or underexposing up to a stop or so either side (see page 48) you get a range of results which accentuate different tones, since there is such a range of contrasts in the scene. This is one instance when bracketed exposures can yield a range of acceptable results rather than a single 'best' shot.

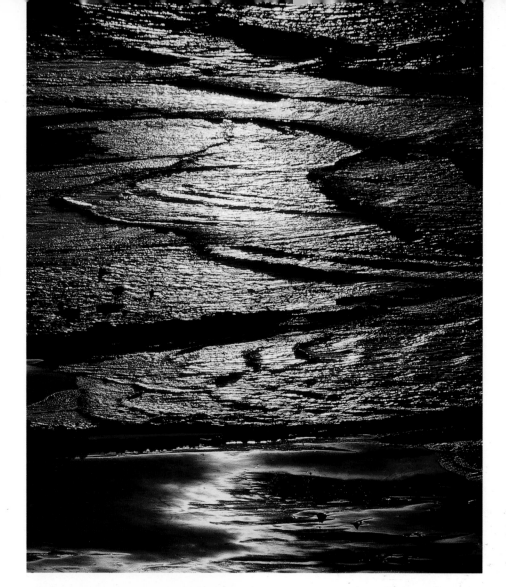

▲ **REFLECTIONS AT SUNSET, PORTUGAL**
At the water's edge a low sun creates long reflections on water and wet sand. The exposure was left to the camera's meter – this subdued some of the highlights but made shadows darker, increasing the dramatic effect.
Nikon F60, Sigma 300mm f/4 apo macro, 1/60 sec. at f/11, Fujichrome Velvia, Photograph: Lois Ferguson

◀ **ROCK SILHOUETTES, GIGLIO, ITALY**
Silhouettes arise as a matter of course when you shoot against the sun, and the shapes of rocks or frameworks of trees make good subjects, though large blocks of darkness should be avoided as they are just a waste of film. The rocks here sit at the end of a bay and because of their shape they are much photographed, though they tend not to appear on local postcards.
Nikon F60, Sigma 300mm f/4 apo macro, 1/30 sec. at f/11, Fujichrome Velvia, Photograph: Lois Ferguson

Low Light

For the first half hour or so after sunset, when there are still residual reds and purples in the sky, particularly towards the west, many of the most effective 'night-time' townscapes can be created. Street lights and lights inside buildings may have been switched on, but if you begin taking photographs too soon after sunset the artificial light will be swamped by the light still in the sky. A little later, the buildings will be in partial silhouette. Leaving the shutter open for up to 10 sec. will produce trails of red and white lights from passing traffic.

After sunset, when the reddish shades disappear from the skies, there is a lovely greenish to deep cobalt hue: this is 'afterlight', which occurs some 30–40 minutes after sunset in summer and after about 20 minutes in winter. Artificial and ambient light levels are about the same, making this a good time to photograph buildings that are artificially lit. Typically, with ISO 50 film you need a 10 sec. exposure at f/4–5.6.

Getting the right exposure is slightly hit and miss. With long exposures some films show reciprocity failure: the breaking down of that convenient relationship where opening or closing the lens diaphragm has the same effect on film as halving or doubling shutter speed (see Appendix). However, there is some flexibility in what looks good on film. If you bracket exposures you can choose the picture with the light balance you prefer. This involves taking a series of pictures with 1/2 stop differences in exposure either side of what the meter decides is 'correct'. Some cameras will do this automatically. You might shoot from 1 stop underexposure (–1 stop) to 1 stop over (+1 stop) in a series to get five pictures (–1, –1/2, 0, +1/2, +1 stop).

BEFORE DAWN

The earliest morning light has a much colder feel than twilight since it is reflected from the sky and any clouds in it, which acts as a giant diffuser. There is often a steely blue quality to the light, which produces unique pictures, especially over water, because it reflects a lot of light. If there are artificial lights present they create additional reflections when the water is calm. The effect can be enhanced by using a pale blue filter, such as an 82B or 82C.

Guide exposures for twilight and night subjects at f/16

As an approximate guide, for each full stop you open the lens, halve the total times given: this works best with shorter times, where reciprocity still works

TYPICAL EXPOSURES	ISO 50	ISO 100	ISO 400
Cityscape – just after sunset	1/2 sec.	1/4 sec.	1/15sec.
Cityscape – twilight	60 sec.	30 sec.	8 sec.
Cityscape – night	4 min.	2 min.	30 sec.
Buildings – floodlit	15–30 sec.	8–15 sec.	2–4 sec.
Landscape – twilight	60 sec.	30 sec.	8 sec.
Landscape – moonlight	1 hr.	30 min.	8 min.
Fairground rides	30 sec.	15 sec.	4 sec.
Traffic trails on motorway	60 sec.	30 sec.	8 sec.
Firework display (aerial)	60 sec.	30 sec.	8 sec.
Bonfire (flames)	4 sec.	2 sec.	1/2 sec.
Bonfire light on a face	30 sec.	15 sec.	4 sec.
Full moon	1/125 sec.	1/60 sec.	1/15 sec.
Crescent moon	1/60 sec.	1/30 sec.	1/8 sec.

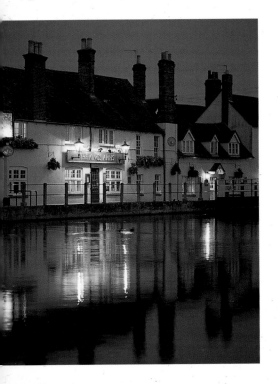

◀ RIVERSIDE PUB, SANDFORD-ON-THAMES, OXFORD, ENGLAND

A mixture of residual daylight and the artificial lights of a building can be handled by daylight film; artificial lights are more yellow but that adds to 'warmth'. Bracketing up to 1 1/3 stops either side of the meter reading gives several usable results that emphasize either the artificial or the ambient light.

Mamiya 645 Super, 80mm f/2.8, 1/2 sec. at f/8
Fujichrome Provia 100F

▶ DUNRAVEN BAY, SOUTH WALES

You may have been expecting a glorious sunset when the sun disappears behind clouds on the horizon. But a few rays from a low sun breaking through the clouds can lift the gloom, creating dramatic highlights on waves and wet sand. By turning a linear polarizer I could control the strength of the reflections until I liked what appeared in the viewfinder.

Mamiya 645 Super, 80mm f/2.8 with linear polarizer, 1/00 sec. at f/11, Fujichrome Velvia

Night Time

The moon's light is simply reflected sunlight. Using long exposures of an hour and more (with ISO 50 film and an aperture of f/16) in the light of a full moon will show up a landscape as if lit by daylight.

PHOTOGRAPHING THE MOON

To obtain a reasonably sized image of the moon – say 6mm (1/4in) on 35mm film – needs something like a 600mm lens. As a useful rule of thumb, a 100mm lens gives a 1mm (1/25in) diameter image on film and each extra 100mm focal length produces an increase of 1mm (1/25in) diameter in the image. The moon appears to move a distance equal to its own diameter every two minutes, so its image would be blurred in exposures longer than 1 sec. with a 400mm lens, for example. With a full moon, use an exposure of 1/250 sec. at f/8 with ISO 100 to freeze movement; with a crescent moon, expose for 1/125 sec.

Using a tripod, take the photograph on a clear night a day or so either side of the full moon, at any time when the moon is high in the sky so that there are no silhouettes in the frame. This image can be scanned and added to other pictures. If you work with Adobe Photoshop, a moon of any size you want can be pasted into another layer and then positioned and blended with a landscape.

Including the moon in a shot is sometimes best done by double exposure, adding it to a frame shot earlier to give landscape detail. Some cameras have a small clutch device that allows you to do this. With others, you have to remove and reload the film and then wind on with the lens cap in place to get to the frame to which the moon is to be added. (Do this with several frames suitably exposed to eliminate a simple counting mistake.)

If your eyepiece has a grid – if you use roll film you can mark the viewfinder screen with a marker pen – you can get the moon exactly where you want it in frame. I draw a rough sketch of the elements in the picture to make sure everything is where I want it.

STAR TRAILS

Star trails are parts of concentric circles created on film by long exposure as the earth rotates. The camera must be mounted on a sturdy tripod because the exposure is a long one. The camera viewfinder should be exactly centred on the celestial pole (conveniently marked by Polaris in the northern hemisphere). Set the shutter to B and lock a cable release open for 30 minutes or longer (aperture f/4 with ISO 100 film). This saves on batteries if you have an electronic shutter. Before you try this, make sure the full moon, car headlights or aircraft are not going to cross the lens axis while the shutter is open.

▼ **BELLAPAIS ABBEY, NORTHERN CYPRUS**

Many buildings are floodlit using mixed mercury/sodium discharge tubes. The light contains a lot of yellow (from the sodium) and greens and blues (from the mercury). The effect suits limestone and sandstone, but looks awful on daylight film. Tungsten-balanced films work better, but perfectionists might want to remove the greenish cast at the printing stage by adding magenta as a filter gel, or as a colour adjustment in Adobe Photoshop.

MAMIYA 7 II, 80MM F/2.8, 4 SEC. AT F/5.6, FUJICHROME 64T

◀ THE MOON

The colour of the moon changes, like that of the setting sun, according to its position in the sky. This low orange moon was photographed using a 300mm telephoto with a x 2 multiplier to produce the equivalent of a 600mm lens. The lens was held on a tripod and a shutter speed of 1/125 sec. was just enough to freeze movement and reveal some surface detail.

NIKON F4, SIGMA 300MM F/4 AF APO MACRO WITH x 2 CONVERTER, 1/125 SEC. AT F/8, FUJICHROME PROVIA

▼ AURORA BOREALIS, FINLAND

Wildlife photographer Steve Young heard that the coming night promised a good display of this remarkable but fleeting light show. 'As we looked overhead, five small shafts of light burst from the otherwise black-looking sky. These began to shimmer and change to greens and reds…' The lengthy exposure revealed colours that had not been obvious to viewers.

NIKON F4, 24MM F/2.8 AF, 40–65 SEC. (BRACKETED) AT F/4, FUJICHROME SENSIA 100 UPRATED TO ISO 200, PHOTOGRAPH STEVE YOUNG

Weather

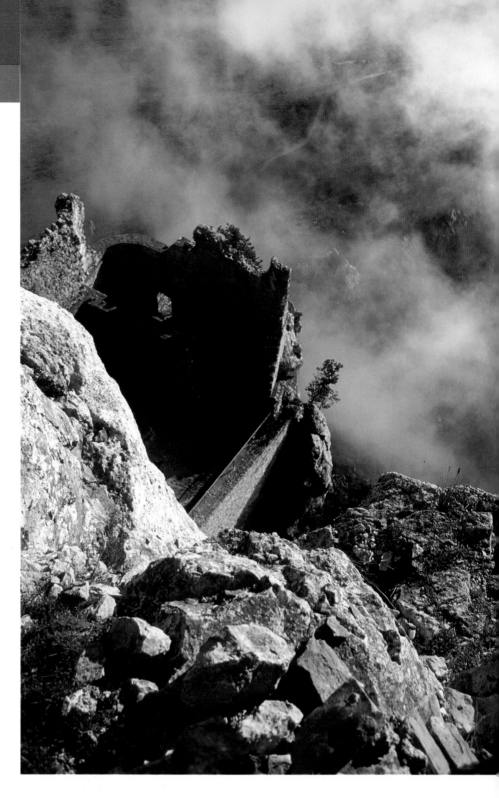

When photographing aspects of weather it is essential to include some of the landscape – even as a thin strip at the bottom of your picture – if you want to give some sense of scale and points of reference. Extreme wide-angle, even fish-eye, lenses can be used to create highly evocative pictures of weather conditions. Weather is notoriously unpredictable and forecasts often fanciful. I have found that those who live in an area – particularly farmers, fishermen and others whose livelihoods depend on the weather – often have a much better idea of the way a day will turn out than professional meteorologists.

It takes persistence to capture fleeting phenomena such as rainbows or lightning flashes, and great luck to be ready to capture the unusual, such as waterspouts and whirlwinds. The only thing to do is to have some sort of camera at hand at all times. Modern compact cameras with zoom lenses and automated exposure facilities fit the bill perfectly.

CONVEYING ATMOSPHERE

Dramatic skies (see page 54), particularly at dawn, at sunset and its immediate aftermath, or during storms can help to create a strong atmosphere in your landscape pictures, but it is not easy to produce interesting pictures on dull grey days. One approach is to evoke that gloomy atmosphere using trees, bushes and buildings as silhouettes partly revealed. Another possibility is to introduce a strong contrast in an otherwise monochrome scene – the red of an umbrella, for example.

The effects of weather can make better pictures than the weather itself. Snowdrifts and children on sleds evoke the time of year better than pictures taken during a blizzard when visibility is reduced. The

aftermath of floods may be distressing but can also produce arresting images when familiar objects, once high and dry, are surrounded by water.

Individual raindrops photographed at close quarters, with the blur of falling rain in the background, or birds huddled together with raindrops on their beaks, leave no doubt about the weather conditions being portrayed.

▲ **BUFFAVENTO CASTLE, CYPRUS**
The castle sits high on a range of jagged peaks and its name, aptly, means 'buffeted by winds'. On our visit, clouds swirled around it, alternately covering and then revealing the walls and giving a strong sense of the sheer isolation and impenetrability of the place. On clear days the views are staggering, but then the castle seems much less ominous.
MAMIYA 7 II, 80MM F/2.8, 1/125 SEC. AT F/8, FUJICHROME PROVIA 100F

LIGHTNING

Lightning may be unpredictable but it is not as difficult to photograph as many people think – provided, of course, you don't set up your equipment in an exposed position where you risk being struck by it.

When there is little residual light around, at twilight or at night, the camera shutter can be left open and the lightning flash will take its own photograph. The camera needs to be pointed at the area of sky where the flashes seem to be occurring and a wide-enough field of view used to include some of the landscape. The flashes will occur in the same general area because that is where the electric potential gradient between ground and earth has built up, but this area moves slowly with the clouds. Several flashes can be recorded which makes an even more dramatic result. The faint glow of a purple discharge in the air might also be observed and the flash will show all sorts of branches.

When there is a higher light level in the daytime then a very slow film and small aperture must be used to allow the shutter to be open for long enough to have some chance of recording a flash without the film becoming over-exposed.

▲ **STORM LIGHT, HORTO HARBOUR, FAIAL, AZORES**
Black clouds passing over after a storm provide a dramatic backdrop as the sun lights the foreground. Such conditions are not uncommon in spring and fall, and weather and skies change rapidly in the Azores. The camera's matrix metering produced a compromise between the dark sky and the detail in the foreground – exactly what was wanted.
NIKON F4, 24MM F/2.8 AF WITH CIRCULAR POLARIZER, 1/60 SEC. AT F/8, FUJICHROME VELVIA

▶ **CLOUD FORMATIONS. TUSCANY, ITALY**
The sun emerging from clouds after a storm can produce dramatic lighting effects. The problem lies in exposure – the bright sun here will fool the camera meter into under-exposure but the result makes the clouds darker and more dramatic.
SAMSUNG, COMPACT CAMERA, KODACOLOR 200,
PHOTOGRAPHER: LOIS FERGUSON

Skies

Land-based details will impart a sense of scale to a skyscape, but you may prefer a more abstract approach. There is a considerable appetite amongst photo buyers for good skyscapes. They make effective screen savers, abstract posters and wall hangings and are relaxing and easy to live with.

Wide-angle lenses and the wide end of a medium-range zoom are best for capturing the whole picture of a dramatic sky. Details of individual clouds or beams of sunlight can be isolated by a telephoto lens or tele zoom.

BLUE SKIES

Perfect blue skies, preferably with a few wispy clouds to relieve their uniformity, are *de rigueur* in travel pictures intended for brochure use. A polarizing filter can be used to emphasize the blue (see page 20).

The extent depends on your orientation, and the effect is strongest at 90 degrees to the sun. The deepening of blue is also more dramatic with a low-angled sun, and skies appear black with over-zealous use of this filter.

Cloud formations can very often be enhanced by the use of a polarizer, which reduces contrasts so that light clouds become better defined.

CLOUDSCAPES

Uniform skies quickly become monotonous – even blue skies, so welcome after grey spells, can become harsh and unrelenting in a long hot summer. On the other hand, the variety and changing light created by cloud formations is endlessly fascinating. Some of the most dramatic weather changes occur around oceanic islands. The Azores, for example, lie almost in mid-

▼ **BROCKEN SPECTRE, BUFFAVENTO CASTLE, NORTHERN CYPRUS**
A combination of sunlight at the right angle and layers of cloud produces a curious optical phenomenon named after the Brocken, a mountain in Germany where it was first observed. The photographer's shadow is surrounded by a halo of rainbow colours. Doubting that it would appear on film, I bracketed, getting a slight underexposure of the clouds so that the spectral colours would be intensified rather than washed out.
NIKON F100, 28–80MM F/2.8 AF WITH CIRCULAR POLARIZER, 1/30 SEC. AT F/8, FUJICHROME VELVIA

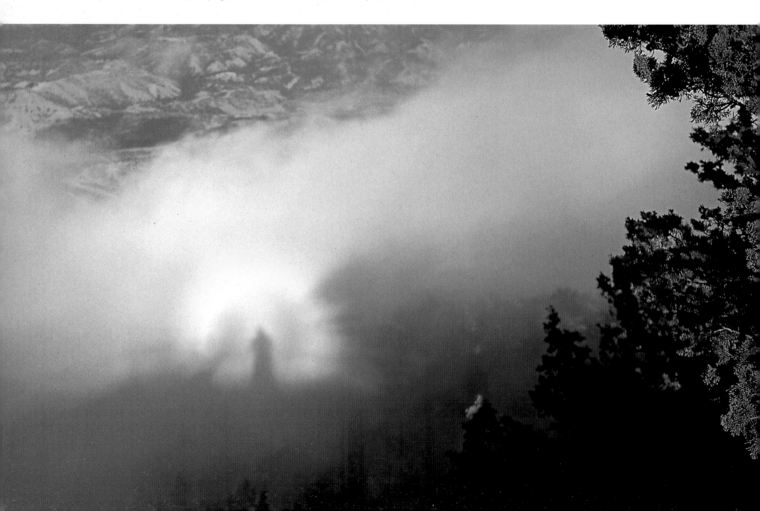

◀ **MOUNTAINS IN HAZE, NORTHERN CYPRUS**

A sudden break in the clouds illuminated a range of distant hills. The haze gave each 'layer' a slightly different hue, strengthening the sense of perspective.

NIKON F100, SIGMA 180MM F/3.5 AF APO MACRO, 1/30 SEC. AT F/8, FUJICHROME VELVIA

Atlantic and at the centre of a weather system, and their skies will change at an astonishing rate throughout the day. I have never seen so many rainbows, or such dramatic after-storm effects, anywhere else.

RAINBOWS

Rainbows are evanescent – they disappear as readily as they appear – but they are much easier to capture on film than the pot of gold reputed to be at their end. They are formed when the sun is behind you and rain clouds in front, and also occur in the fine spray near waterfalls.

For the primary bow, the sunlight is refracted twice and internally reflected once by water droplets; the refraction splits up the light into its constituent colours. A secondary bow results from a further reflection inside the drops and appears above the main bow as a more diffuse arc, with some mixing of colours.

Since rainbows usually occur against a dark sky, to appear bright on film the exposure needs to be taken from the grey area to the side of the rainbow.

Haze and perspective

An atmospheric haze enhances a sense of perspective, as distant hills become softened and the composition is reduced to a few planes. Haze scatters ultraviolet (UV) light, invisible to the eye but recorded as blue on colour film. A UV filter can reduce haze slightly, although it will never cut it out completely.

▲ **STORM CLOUDS AT SUNSET**

A section of sky can be isolated with nothing to convey a sense of scale – the cloudscape speaks for itself. Here the portion of interest was quite small. A telephoto lens was balanced on a windowsill, and exposure was via the camera's TTL matrix meter.

NIKON F100, SIGMA 300MM F/4 AF APO MACRO, 1/30 SEC. AT F/8, FUJICHROME VELVIA

◀ **RAINBOW OVER POLIS, CYPRUS**

Slight underexposure makes the colours in a rainbow appear as saturated as possible. Rainbows often appear after storms, but inevitably you always see the best ones – bright, semicircular, with a secondary bow – when you don't have a camera with you.

NIKON F801, 24MM F/2.8 AF WITH CIRCULAR POLARIZER, 1/30 SEC. AT F/8, FUJICHROME VELVIA

Woodland

A wood is a complex community that can include many different plant species, and it is constantly changing. Seasonal changes are naturally more marked in deciduous woodlands, where the trees lose their leaves, than in conifer woods.

A deciduous wood in spring, when leaves appear and flowers carpet the floor, exudes freshness. By summer, the wood will be shrouded in dappled green shade and humming with innumerable insects, then comes a new colour display as the leaves turn colour before falling. In winter, there are patterns in the carpets of fallen leaves, mosses and the skeletons of trees.

Many deciduous woods are carpeted with flowers each spring. A wide-angle lens (28mm or wider in 35mm), used close to the ground, can be used to set flowers in the foreground against a background blur of colour that accentuates the lavishness of the display. Shafts of sunlight that filter through the leaves may pick out individual blooms, catching them with backlighting that makes them glow for a moment, before the light changes and the effect is lost.

NATURAL LIGHT AND FLASH

The contrast range in a wood or forest means careful exposure is needed to retain background detail. Portable reflectors are a great help in lighting subjects in woods, and if individual flowers are going to be photographed, a diffusion tent gives a consistent soft lighting.

Alternatively, you can mix flash and natural light, using the camera's TTL flash meter to control the main light for a subject. Before connecting the flash, meter the background in natural light: suppose this is 1/8 sec. at f/8. Set the camera's manual controls to 1/8 at f/11, to give 1 stop underexposure.

The flash is metered by the camera, but the shutter stays open long enough to allow light in the background to expose the film. You can also experiment with different balances between the background and foreground light until you get something you like.

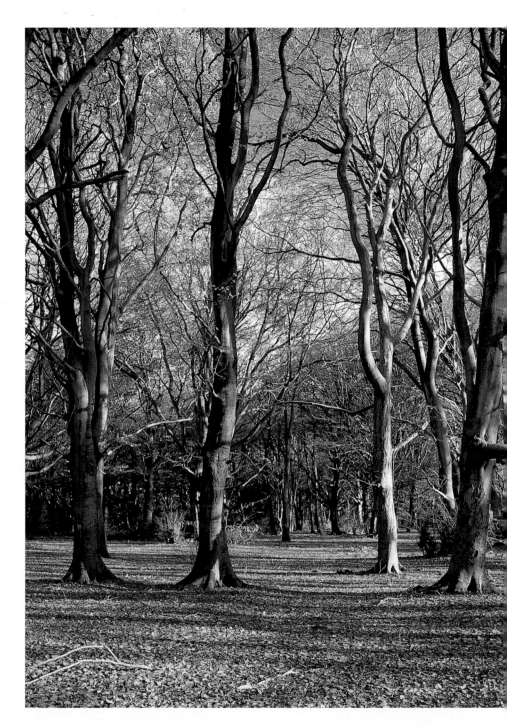

▲ **BEECHWOOD IN WINTER**

In autumn and early winter, beechwoods show their stately, smooth-barked trees against a carpet of warm brown leaves, but are a source of inspiration all year round.

MAMIYA 645 SUPER, 45MM F/2.8, LINEAR POLARIZER, 1/15 SEC. AT F/11, FUJICHROME PROVIA 100F

Cameras with matrix metering and sophisticated matching flash guns allow you to control the extent of the fill-in flash. You can, for example, set the flash gun to be the dominant light source or to give a burst just a stop or two below the ambient light level. This improves contrast and produces results with more 'punch'.

ROTTING WOOD AND LOG PILES

In well-managed woodland, piles of wood will provide homes for smaller mammals and a host of insects – especially beetles. Many fungi grow on logs and fallen trees as the wood decays, and photographic opportunities, particularly in the close-up realm, are endless. You should always carefully replace any overturned wood or stone in order to protect the creatures living beneath.

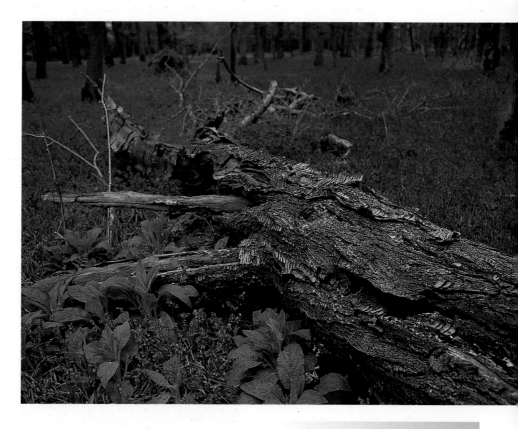

▼ BAMBOO STEMS

The appeal of this subject lay in the regular geometry of the densely packed stems. When dealing with shapes, I often use black and white film, or produce a monochrome image from a scanned transparency in Adobe Photoshop. Here the image is essentially monochrome.

Mamiya 645 Super, 80mm f/4 macro, 1/15 sec. at f/8, Fujichrome Provia 100F

▲ BLUEBELLS NEAR HENLEY-ON-THAMES, ENGLAND

After photographing seemingly endless expanses of bluebells, a fallen tree offered some 'foreground interest'. Objects like this have a way of leading the eye into a frame.

Nikon F60, 28–80mm f/2.8 AF, 1/15 sec. at f/16, Fujichrome Velvia, Photograph: Lois Ferguson

Blue flowers

Capturing the true colour of a glade of bluebells is not easy. When shady and sunlit expanses are compared, their colour looks completely different on film. Like many blue flowers, bluebells reflect both infrared and ultraviolet light, which is invisible to the naked eye but affects film. I have found that scattered infrared is minimized on dull days, and often choose these conditions to photograph 'difficult' blue flowers by natural light. The young leaves of the trees can create a strong green cast which affects the realism of the flowers on film. A warm-up filter on the camera or a touch of added magenta at the printing stage can counteract this. Kodachrome 25 probably gives the best rendition of these awkward blues. Blue graduated filters can work well provided the bluebell area is well defined.

Without doubt, rainforest is the richest terrestrial habitat on earth – and a large proportion of its species have yet to be classified. Countries such as Costa Rica have now recognized the rainforest's potential for eco-tourism and have developed wonderful systems of national parks and trails, making these ideal destinations for your photographic forays.

Your first impression of a rainforest can be of darkness and gloom, with vast tree trunks like pillars topped by dense crowns forming a natural Gothic cathedral. Much of the life is in the canopy, where plants and animals strive to reach the sunlight. Some forest parks have aerial walkways which allow the reasonably fit to take pictures at treetop height.

Clearings, cliffs and river banks offer chances to photograph whole trees or groups, but most of your best pictures will come from taking a closer look at your surroundings, and a good reliable flash system will prove a great asset. A recently fallen tree often provides a host of close-up opportunities, from the epiphytic plants growing on its trunk to the new growth of the species surrounding the clearing it has created, and the countless fungi that colonize the dead wood.

ANIMAL LIFE

Numerous small animals inhabit the forest floor, but many are nocturnal. Rainforest insects show an astonishing diversity of form, but it is often impossible to identify them except in the most general terms. Many species of monkey live noisily in the canopy and quickly gather on trees that have come into fruit. Because of the low light levels they are not easily photographed from ground level; they are often best approached and photographed from a boat. This is also a

good way of seeing large birds, such as herons and raptors, while riverside cliff faces with friable soil may provide nesting sites for colonies of species such as parrots and macaws.

PROBLEMS

The tropical climate is ideal for growth of all sorts – including fungi, which attack your film and can etch the coating on a

▼ ORCHID (*DENDROBIUM LAWESII*), PAPUA NEW GUINEA

There are innumerable tales to tell of the links between rainforest flowers and animals. Both the tubular structure of these *Dendrobium* flowers and their bright red colour are related to the fact that they are bird-pollinated.
NIKON F4, 105MM F/2.8 AF MACRO, SB 21B MACROFLASH, 1/60 SEC. AT F/16, FUJICHROME VELVIA

◀ **LION-HEADED KATYDID**

Many rainforest insects seem oblivious of your presence, giving you time to compose a picture. I prefocus my macro lens and just move in slowly until sharp focus is reached. Pressing the shutter fires a TTL macroflash set-up, essential in the low light conditions.

Nikon F4, 105mm f/2.8 AF macro, SB 21B macroflash, 1/60 sec. at f/16, Fujichrome Velvia

lens. Heat can also prove damaging, and dark camera cases and even black camera bodies should be avoided. For a fortnight's visit, simple precautions will suffice, but if you are working in tropical conditions for any length of time, then planning is needed.

Camera cases should be reflective and airtight. To ensure dryness use silica gel , but you will need more than the small sachets packed with lenses. It is better to make up your own bags from muslin and purchase silica gel from a lab supplier. Use the self-indicating variety that turns colour when saturated: it can be regenerated by heating above 100 degrees centigrade to drive off stored moisture. Make sure that exposed film is not subjected to heat and get it processed as soon as possible to avoid damage from fungal growth.

▶ **ORCHID (*GONGORA TRICOLOR*)**

Many plants are epiphytic – that is literally growing on trees with their roots entangled in the bark or mosses where they gain water and nutrients. Unless you are prepared to climb, many of these highly photogenic plants – orchids and bromeliads included – will only be found where a tree has fallen or been felled.

Nikon F4, 105mm f/2.8 AF macro, SB 21B macroflash, 1/60 sec. at f/16, Fujichrome Velvia

Open Plains and Expanses

For many of us, the first attempt at using a wide-angle lens meant just pointing it and then capturing the landscape as we thought we saw it. The result was inevitably flat, boring and not nearly as exciting a scene as the one we remembered.

With any expanse such as a meadow or, larger still, a prairie, you have to find ways to relieve the monotony of the scene. It is essential to identify the elements that attracted you to the vista and to exaggerate or isolate them, and there are several ways of doing this.

FOREGROUND SUBJECTS

By choosing a viewpoint close to the ground, you can lead the eye into the scene: across a rocky area, through crops or a flower-filled meadow. It helps to choose a vantage point slightly higher than the surroundings, or even at the base of a gentle hill, so that more of the foreground is revealed sloping away from you.

The tripod you use should allow you to get close to the ground, either by splaying its legs or by adjusting the centre column. Many roll-film cameras have a waist-level viewfinder, and right-angle viewfinders are available for 35mm cameras if you care about your clothes and want to avoid sprawling on the ground.

In crop fields, a wide-angle lens allows you to have foreground subjects large enough to be in modest close-up. These could be individual examples of the plants

▼ **STEELWORKS, PORT TALBOT, WALES**
A huge tract of former duneland was occupied by steel and petrochemical plants near where I grew up – I wanted to show it in the context of the sea coast and the sweeping bay.
MAMIYA 645 SUPER, 45MM F/2.8, 1/60 SEC. AT F/16
FUJICHROME PROVIA 100F

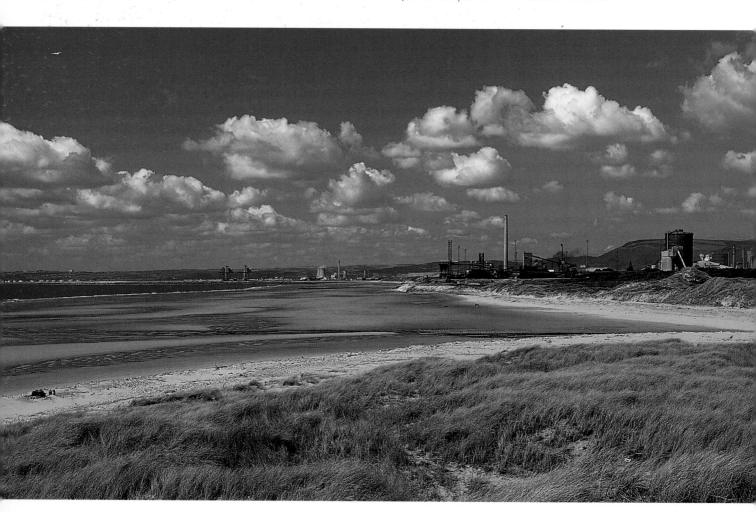

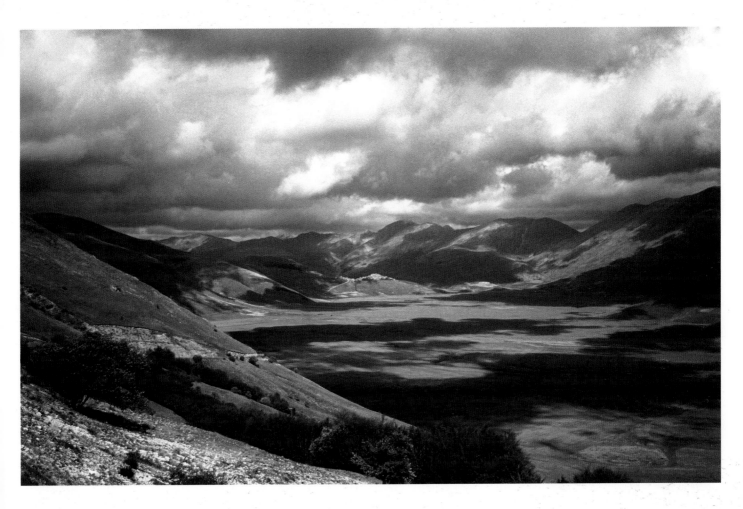

being grown, while the rest of the picture in the frame gives the overall impression of the crop and the surrounding landscape. Maximum depth of field is all-important (see page 30), and this means using small apertures and low shutter speeds. Alternatively, a telephoto lens will isolate just a few flowers or ears of corn in an otherwise blurred expanse, and this can give a different sense of 'space'.

FRAMING

A large vista becomes more interesting when the elements make a pattern, which might be created by areas of colour or by well-defined light and shade. The position of the horizon in the image is important, as it defines the relative importance you choose to give to sky and land. Placing it dead centre gives both equal weight, whereas dividing the picture in the

'traditional' way, to give one-third sky or land, makes different statements. If you always stick rigidly to so-called compositional rules your work will become devoid of variety. Many pictures have impact simply because they take the familiar and depict it in unusual ways.

SKYSCAPES

An interesting sky, with dawn or sunset colours, storm light or intriguing cloud formations, can lift the picture and turn an otherwise 'ordinary' vista into something special. When a sky has patches of blue between clouds, parts of the scene may be picked out in sunlight as the clouds move: at such times you have to take your chances and simply capture quickly whatever comes along. The changing light can create dramatic strips of colour within a landscape.

▲ **SHADOWS ON THE PIANO GRANDE, ITALY**

The Piano Grande plain sits high in the Italian Appennines surrounded by even higher mountains. The weather system is complex and dramatic light changes occur in a short time. Here late afternoon light following a storm creates dramatic shadows on the plain itself.
SAMSUNG COMPACT, WIDE-ANGLE END OF IN-BUILT ZOOM, KODACOLOUR GOLD 200, PHOTOGRAPHER: LOIS FERGUSON

Deserts

The unforgiving starkness of a desert landscape leaves many people deeply affected. The skies are vast and the night-time clarity reveals an unbelievable abundance of stars.

An area is technically a desert if it receives less than 25cm (10in) of rain, falling seasonally, in a year. Some deserts, such as South Africa's Namib Desert and the coastal deserts of Chile and Peru, receive their moisture not as rain but from mists which condense at night and in the early morning. Life forms have evolved ingenious strategies to make use of this moisture. They are active only at night or at the extreme ends of the day, making life much more comfortable for those seeking to photograph them.

Occasional rains can revive long-dormant seeds from flowering annuals, bringing a brief blaze of colour. Reliable winter displays are produced in the Namib and in Namaqualand, just to the south, to give South Africa some of the world's finest floral events.

Desert peoples have evolved nomadic lifestyles as survival strategies. They have great dignity and it is very rewarding to be able to photograph them, though this has to be done with tact.

LANDSCAPES OF ROCK AND SAND

Long shadows from a low sun create relief and bring form to the desert landscape. To get wonderful shots of sculpted sand dunes and rock forms, it is necessary to work in the evening close to sunset or in the early morning shortly after sunrise. Colours can be intensified with a polarizer that cuts out

▶ **NAMIB DESERT, SOUTH AFRICA**
Desert expeditions require lengthy planning and special care of equipment, but well-organized tourist services in Namibia offer short, safe, visits. Early in the morning or late in the day the dune colours are extraordinary.
OLYMPUS COMPACT CAMERA, F/8, KODAK GOLD 200,
PHOTOGRAPH: ANNA BUTCHER

▼ **NAMIB DESERT, SOUTH AFRICA**
In the desiccated conditions of a desert, the skeletons of dead trees last a long time as a reminder of the harshness of the environment. Landscapes of distant dunes and expanses of sand need something else of interest in the frame.
OLYMPUS COMPACT CAMERA, F/8, KODAK GOLD 200,
PHOTOGRAPH: ANNA BUTCHER

▼ **NEGEV DESERT, ISRAEL**
Many deserts are rocky and lack the vast dunes usually associated with deserts. The Negev desert has a barren and yet highly evocative landscape – here photographed early in the year away from the unbearble heat of summer.
SAMSUNG COMPACT, WIDE ANGLE END OF INBUILT ZOOM, KODACOLOUR GOLD 200, **PHOTOGRAPH:** LOIS FERGUSON

reflected light and accentuates the redness of sandstone rocks, such as those in the Arizona desert.

Large expanses of sky and highly reflective rocks and sand can play havoc with exposure meter readings, especially when wide-angle lenses are used. This can cause underexposure, and regular checking of incident light readings with a hand-held meter is essential.

EQUIPMENT

Photographic equipment is best kept in reflective camera cases with sealed rims. Cases should never be black, and you may even consider covering them with a damp white towel that cools by evaporation. Open them as little as possible. Excessive heat causes colour casts on all films, it buckles roll film, loosens lens cement and causes camera lubricants to run.

In the dry desert climate, dust and grit particles are carried in the air – they get everywhere and are highly abrasive. Lens surfaces should be wiped only after they have been given a good blast with a 'dust remover'.

Keep film in plastic canisters at all times and brush the film leader carefully to dislodge grit. If there is the slightest breeze, use a changing bag for loading the camera and even for changing the lens. This may be inconvenient but it helps prevent disasters. Some cameras claim to have O-ring seals, but taping over all joints is an extra precaution.

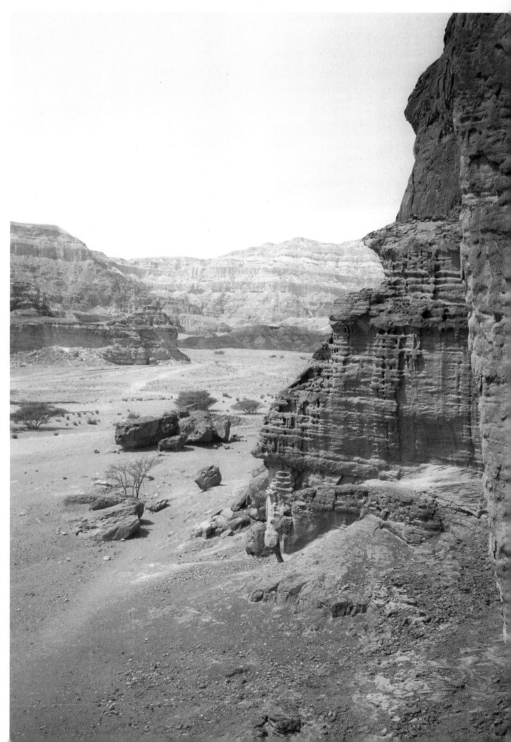

Mountains

Mountain scenery, spectacular in its own right, can also offer some of the most impressive backdrops imaginable to pictures of plants, birds, animals and villages.

Many mountain ranges that are winter ski resorts take on a new lease of life in summer, when hikers visit and cable cars are re-opened. My favourite mountains are Italy's Dolomites, with craggy peaks and wonderful colours at dawn and in the early evening. I have often ridden up to clear heights through low-lying clouds covering the valley below.

Mountain vistas seem to demand wide-angle views, yet a short telephoto or zoom can produce dramatic effects by appearing to condense perspective in a mountain range. Haze is inevitably present but is less of a problem in the early morning or late afternoon. It can be slightly reduced by using a haze filter plus a polarizer.

WEATHER

The highly changeable weather conditions inevitable in any high mountain system greatly affect the photographs you can take. Clouds may linger for several days, only to part and reveal snow-capped peaks the day you are due to leave. You simply have to be there long enough for bad weather to change.

The mood of a mountain changes with the weather and can rapidly become threatening. Days that start clear can cloud over by early afternoon as vapour rises towards the peaks from the moist valleys below. Every few days conditions build to a storm, and after this the clarity can be staggering.

You must take good maps with you, but you should also tell others where you are going and never work alone if you can help it. Talk to and use local guides: they seem to have a 'sixth sense' that is born of long experience when it comes to changes in the weather.

LIGHTENING THE LOAD

Unless you are on an expedition with porters you will be carrying your equipment up the mountain with you, probably in a rucksack of some sort, and weight is an important consideration. Until I know what I intend to photograph I carry a minimal outfit which allows me to photograph scenery, rocks, lakes, meadows and a wide range of natural life.

Apart from the camera body, my kit includes a 24mm or 28mm manual wide-angle lens with a good close-focus, which does double duty for landscapes and close-ups of alpine plants. A macro lens

▲ **TUCKETT PASS, DOLOMITES, ITALY**
To get to this pass at 2750m (9022ft) required trudging through a steep snowfield carrying heavy equipment. Close to the top I wondered at my sanity but those thoughts evaporated as I viewed the world on the other side. Since then I have carried a monopod rather than a tripod and a rangefinder roll-film camera, cutting pack weight considerably.
Mamiya 645 Super, 45mm f/2.8 with linear polarizer and UV filter, 1/30 sec. at f/11, Fujichrome Velvia

and a small flash gun serve for butterflies and other insects, and I also carry a medium telephoto lens. Accessories include a teleconverter, polarizer and warm-up filters.

Tripods are heavy but I take one on days when I know I am going to do a lot of medium format work or bird photography. Otherwise, a good, well-padded camera rucksack makes an excellent support, as do bean bags and rocks.

▶ DOLOMITE PEAKS, ITALY

The Dolomites, with their jagged peaks, are my favourite mountains. The reflectivity of the rock changes the colours of the mountains throughout the day, with pinks at dawn and orange in the evening as they catch the rays of the setting sun.
MAMIYA 645 SUPER, 150MM F/3.5 WITH LINEAR POLARIZER AND UV FILTER, 1/60 SEC. AT F/8, FUJICHROME VELVIA

◀ PIANO GRANDE, UMBRIA, ITALY

The rocks on either side of the route down Monte Vettore to the plain below have been named the Palazzo Borghesi. They formed an ideal frame to show the extent of the view, following a severe storm the day before that had cleared the dust from the atmosphere.
MAMIYA 645 SUPER, 45MM F/2.8 WITH LINEAR POLARIZER AND UV FILTER, 1/30 SEC. AT F/16, FUJICHROME VELVIA

Filters

Ultraviolet radiation tends to increase at high altitudes and can create an unpleasant bluish cast on your pictures unless you use a UV filter. To guarantee a warmer 'feel' to your pictures you can add an 85A or 85B filter.

Volcanoes

Those intrepid cameramen who bring back film footage from active volcanic craters have added greatly to our awareness of the sheer might of an eruption. But close encounters of this kind are best left to those with expert knowledge and reliable back-up. In any actively volcanic region, there are many associated aspects of volcanic behaviour that deserve the photographer's attention and are, on the whole, safer than crater photography.

Erupting volcanoes can be photographed most effectively (and safely) from a distant position from twilight onwards, when the glow from the crater and any lava flow becomes apparent. The exposures needed may, of necessity, be quite lengthy because of the low light levels (see page 48).

EXTINCT VOLCANOES

The familiar cone shape of long-dead volcanoes can be seen in the mountains of the Auvergne in France. The shape lends itself well to silhouettes, at sunset or at dawn. The same silhouette characterizes

more recent volcanoes and is created by violent eruptions that have piled up ash. Cones occur where the lava is acidic and contains a lot of silica that solidifies quickly, plugging the vents. Huge pressures build up again and create further eruptions, spewing out more ash and lava. Ancient lavas that

cooled under the sea have a characteristic rounded shape and are called pillow-lavas.

On Vesuvius and other volcanoes there are mineral deposits, often brightly coloured, such as yellow sulphur and red cinnabar, where crystals have formed as the molten rock solidified.

▲ **HOT SPRING, SAN MIGUEL, AZORES**
Thermal springs and bubbling mud are a gentle reminder of what is going on below.
Nikon F100, 28–80mm f/2.8 AF with circular polarizer, 1/30 sec. at f/8, Fujichrome Velvia

◄ **ENCRUSTED ROCKS, SAN MIGUEL, AZORES**
The mineral-rich water flushing from underground springs evaporates to leave crystalline deposits on the rocks, and several species of bacteria, which also find these inhospitable conditions to their liking, add to the display.
Nikon F100, 28–80mm f/2.8 AF with circular polarizer, 1/30 sec. at f/8, Fujichrome Velvia

HOT SPRINGS AND GEYSERS

Pools of hot to boiling water are common in any actively volcanic area. They may also have mud springs associated with them and these are sometimes considered beneficial because of their mineral content.

Wherever the water contains dissolved carbonates, encrustations of tufa form weird shapes as the water evaporates. Bacteria and algal life forms are capable of surviving in these inhospitable places and produce a range of photogenic colours – yellows, greens and browns – in and around the pools.

Geysers occur where subterranean water in contact with hot rocks turns to steam and forces out jets of water with explosive power. The most famous of these occur with clockwork regularity. Fumaroles are vents that emit steam (often with dissolved sulphur dioxide) long after an eruption.

PROTECTING EQUIPMENT

Camera equipment needs special care and attention in an active volcanic region. There is the obvious effect of heat, though most people do not stay long enough for this to cause damage. Far worse is the volcanic dust with its abrasive silica particles. Acrid sulphur dioxide gas, which is ever present, dissolves in steam to form highly corrosive sulphurous acid. It is this, as many photographers have found, that makes short work of metal parts on cameras and lenses. In this kind of atmosphere nothing short of a perspex case designed for subaqua work will give proper protection, and camera equipment needs to be carefully cleaned.

▼ **PICO ISLAND FROM HORTA HARBOUR, FAIAL, AZORES**
The steep-sided volcanic cone that dominates Pico rises from sea level to 2351m (7714ft). It can be seen on the horizon from the adjacent island of Faial but is often enshrouded in cloud. It took four days of rising before dawn to get this shot.
NIKON F100, 28–80MM F/2.8 AF WITH CIRCULAR POLARIZER, 1/30 SEC. AT F/11, FUJICHROME VELVIA

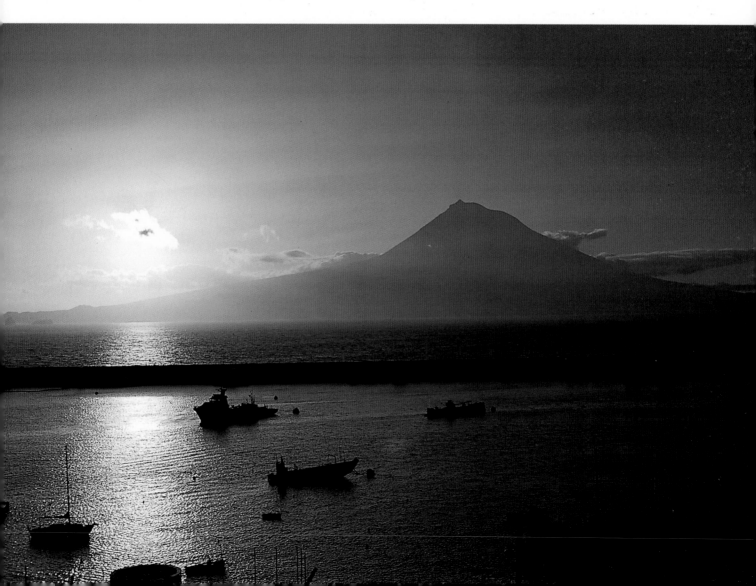

Because of the role it plays in creating the landscape, water often forms the central feature of an area of natural beauty. From a still, reflective pool to a rushing stream, it presents a series of challenges to the photographer.

VIEWPOINTS

A low viewpoint, with the camera almost at water level, creates dramatic wide-angled effects as the eye is led along the water surface into the picture. This is relatively easy with shallow stony streams but with deeper water you may need to wade in – and protect your equipment from moisture. Alternatively, you can use a canoe, punt or other low boat.

If you can arrange to fly over a large river system in a light aircraft or balloon, the river will look like a map beneath you. A shutter speed of 1/125 sec. or greater is needed in a light aircraft because there is a significant level of vibration that is easy to

overlook. For rivers that pass through gorges a high vantage point on land will give you a near aerial view – before making your visit check the orientation on a good map to work out whether your subject will be in sun or shade.

Landscape photographs involving rivers or lakes are often made very much more attractive by including some sort of foreground interest – this may be a few waving reed stems at the edges of a picture or the overhanging trunk and branches of a tree used to create a frame. The arches of a bridge, a jetty or the deck of a boat are just a few examples of ways of leading the eye into the picture.

River and canal-side architecture is often picturesque. Relics of the river's working history may include old jetties, abandoned water mills and ancient stone or iron bridges. Boats are impossible to resist – their shining brass fittings and bright paintwork are highly photogenic.

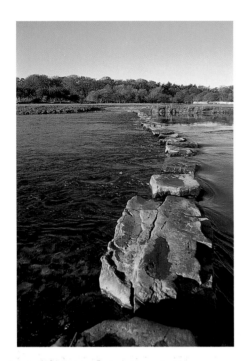

▲ STEPPING STONES, OGMORE-BY-SEA, SOUTH WALES

Rocks and stones in water are useful devices in a composition. I had crossed these stones hundreds of times but having to illustrate a magazine article forced me to look afresh from a low camera position.

MAMIYA 645 SUPER, 45MM F/2.8 WITH LINEAR POLARIZER, 1/30 SEC. AT F/16, FUJICHROME VELVIA

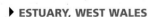

▶ ESTUARY, WEST WALES

Receding tides reveal mudbanks, streams and rippled sand. The low sun creates relief with shadows and a succession of highlights from the still-wet mud. For bird photographers, estuaries are some of the best places to photograph feeding birds and migrant water fowl.

MAMIYA 645 SUPER, 45MM F/2.8, 1/30 SEC. AT F/16, FUJICHROME PROVIA 100F

REFLECTIONS

On still water surfaces, reflections of distant mountains, or closer objects such as a row of trees or a boat hull, make good photographic subjects. As the slightest breeze can destroy the placid surface it is important to work quickly. With a polarizing filter fitted to an SLR you can intensify or decrease the strength of the reflection as you look through the viewfinder while rotating the filter on the camera.

MOVEMENT

A sense of movement brings any picture involving water to life. Ripples on the surface of a lake, or fluttering flags and sails on boats, evoke breezes. With fast-moving streams and rivers, as with waterfalls (see page 70) fast shutter speeds will freeze all movement – even droplets in mid-air. At the other extreme a long shutter speed creates a blur of water. I find that a slight degree of blur usually gives the result I want.

WATER WILDLIFE

Water lilies are delightful to photograph in their own right – they are large and make good foreground subjects in a wide-angle composition where depth of field is important and you have to move back a little to maximize it.

Many attractive birds – including heron, grebe and kingfisher – haunt lakes, rivers and streams. They all have established territories, and with patience you should be able to simply fade into the background – concealed in reeds, a hide, or a small boat – to photograph them.

▼ **MOLVENO AND ITS LAKE, DOLOMITES, ITALY**
The combination of lake and mountains is impossible to resist. The scene changes throughout the day as clouds move and cover the peaks. Rarely, when there is no hint of breeze, the mountains are perfectly mirrored in the lake. On this occasion, the clarity of the air was the result of an earlier storm.
MAMIYA 645 SUPER, 45MM F/2.8, 1/60 SEC. AT F/16
FUJICHROME PROVIA 100F

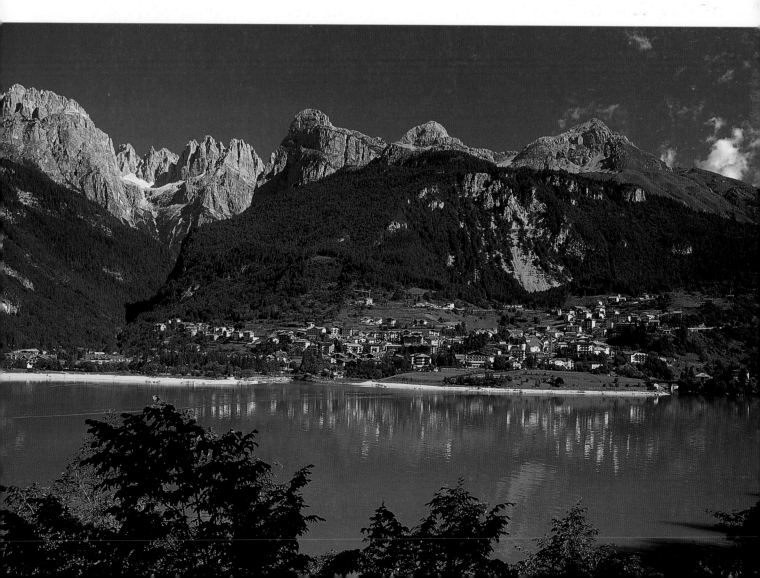

Waterfalls

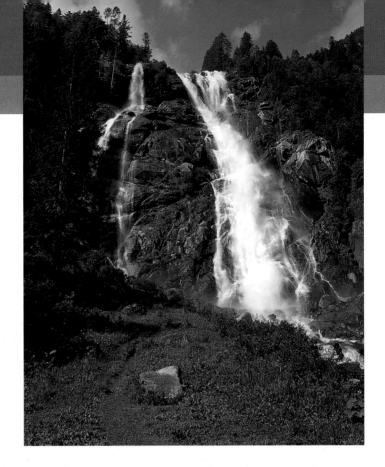

Take any combination of mountain and running water and somewhere along the course there will be a waterfall. Some falls are visually stupendous, dropping hundreds of meters. When faced with the majesty of the Angel, Niagara or Victoria Falls, capturing the drama in front of you is almost as easy as pointing and shooting.

To create something special, however, you need an awareness of both your position in relation to the fall and of the possibilities afforded by different times of day and weather conditions. To capture the sense of 'life' in a waterfall you need those myriad reflections from falling water, spray and wet rocks that occur on a sunny day.

VIEWPOINTS AND LENSES

At large falls there are usually fixed viewing stations protected by walls and strong fencing for your safety and it would be madness – and probably illegal – to depart from a path and try to get closer. You can create variety in your shots by using lenses of differing focal lengths, or the full range of a zoom, to see the possibilities.

A wide-angle shot will set the falls in the context of the landscape. You can also use the exaggerated perspective afforded by a wide-angle lens to impart an element of drama. An overhanging tree or rock face can be used at the edge of a picture to create a frame. Alternatively, if you can walk beneath the fall, take a low viewpoint and use the rocks and pebbles in the foreground to lead your eye into the picture.

The ability to condense perspective with telephoto lenses is very useful in situations where a waterfall has several separate downfalls: by taking an angled view from the side, you can include all the chutes of water in your picture and show them receding into the distance.

▲ NARDIS WATERFALL, DOLOMITES, ITALY

When photographing the spectacular Nardis waterfall, a set of pictures was taken over a range of shutter speeds from 1/8 to 1/500 sec. Here a shutter speed at the lower end creates the 'milkiness' that suggests movement.

MAMIYA 645 SUPER, 45 MM F/2.8 WIDE-ANGLE LENS WITH LINEAR POLARIZER, 1/15 SEC. AT F/16, FUJICHROME VELVIA

▶ WATERFALL AFTER DAWN NEAR DUNRAVEN, SOUTH WALES

The beach runs roughly west to east and I wanted to capture a winter's dawn as it brought the sun in behind the waterfall in a low arc. I positioned myself close to the fall, taking care to select a viewpoint that avoided flare – I used an extendable lens hood and checked the viewfinder carefully for vignetting. A linear polarizer was used to reduce the reflections from wet rocks together with a 81B warm-up filter – a combination I often use.

MAMIYA 645 SUPER, 45 MM F/2.8 WITH 81B WARM-UP FILTERS AND LINEAR POLARIZER, 1/30 SEC. AT F/11, FUJICHROME VELVIA

Shutter speed and aperture

Choice of shutter speed is important. Fast speeds of around 1/125 sec. and higher will tend to 'freeze' movement – though to capture individual droplets in spray sharply you will need a shutter speed of about 1/1000 sec. Slower speeds, around 1/15 sec. or longer, create a blurring in the rushing water which suggests movement. Long ago I learned never to shoot either one or the other. I take both and make my choice much later according to requirements when I see my pictures on the light box.

To get the falls in focus means using a small aperture such as f/16 and a tripod, since your shutter speed will be longer and there is more risk of camera shake. Having a pin-sharp foreground and allowing the falls in the background to go slightly soft can also be effective. If you want pin-sharp results from foreground to infinity, then focus at the hyperfocal distance (see Appendix). However, if your goal is to get the water in sharp relief against a blurred backdrop, then leave the lens aperture wide open or just slightly stopped down, and focus on the water.

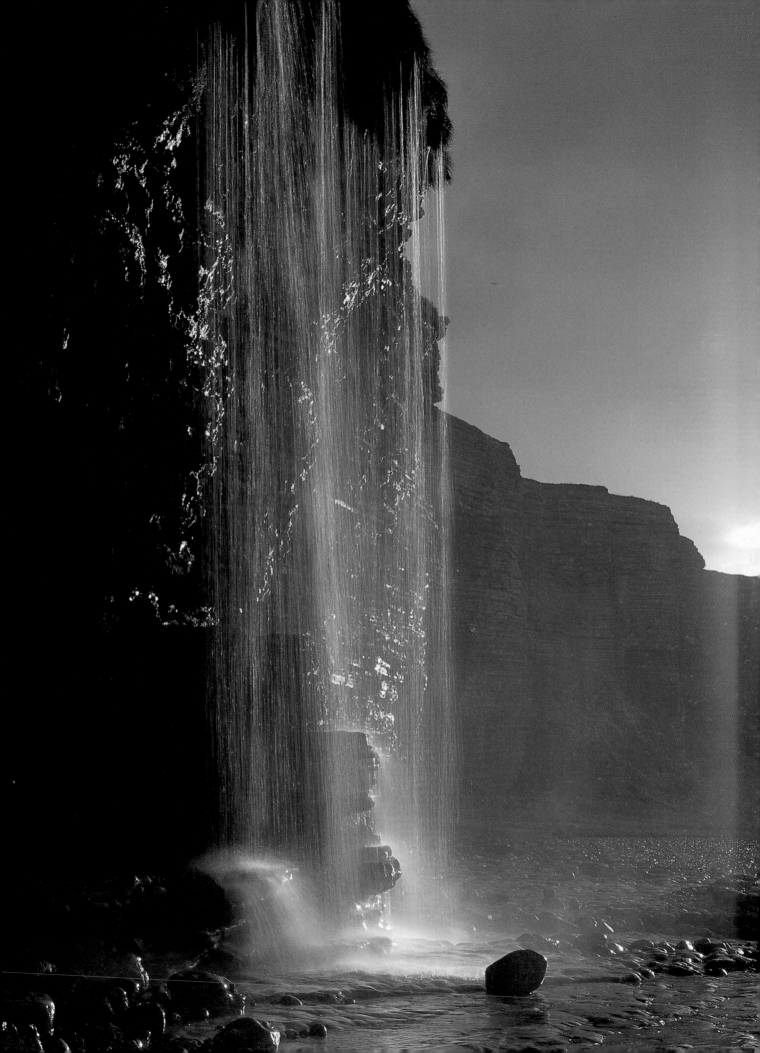

Ice and Snow

rozen conditions and snow transform the landscape, creating unique photographic opportunities, but also presenting technical challenges. Thus, on a clear day, the blue sky over a snowfield can be intensified with a polarizing filter. On dull days, a snow scene takes on a monochrome appearance but the inclusion of a single brightly coloured object can produce a dramatic contrast.

The bare limbs of deciduous trees outlined in hoar frost, rafts of pine needles covered in snow, plant stems trapped in ice, leaves with their veins and edges delineating by frost, or icicles on frozen waterfalls all make artistic, even abstract subjects for the camera. Frost crystals on a window form exquisite feathery fronds.

Flowers such as crocuses, winter aconites and snowdrops emerge as the snow melts. In fact, the heat generated as they emerge from their bulbs and corms melts the snow around them in a circle. These first signs of spring can provide a spiritual uplift as well as good photographs.

ANIMALS IN SNOW

Some mountain animals, such as hares and foxes, and birds such as ptarmigan, snow bunting and snow finch, moult to white in winter and are effectively camouflaged in snow. To photograph them means using a suitable hide – one that blends with the winter scene.

A popular fascination with polar bears has developed as a result of the superb natural history footage shown on television. Their annual migration through Anchorage, Alaska, has made the town a place of pilgrimage for visiting naturalists. With such large and potentially dangerous animals it is essential to travel with an organized party or tour, using experienced guides.

EXPOSURE

Large areas of snow in a landscape can fool any exposure meter into underexposure when it tries to expose the white as an average 'grey' and you will need to compensate. But to record detail in snow –

▲ **ALPINE SNOWBELL (*SOLDANELLA ALPINA*)**
This delicate relative of the primrose generates enough heat to melt the snow around it as it grows. Low swirling cloud had condensed to form the droplet and getting the picture demanded lying full-length in the snow. An aperture of f/5.6 provided a shallow depth of field, lifting the flowers from the background. NIKON F4, 60MM F/2.8 AF MACRO, 1/30 SEC. AT F/5.6, FUJICHROME PROVIA 100F

◄ **SNOWFIELDS, DOLOMITES, ITALY**
When photographing scenes in snow the usual advice is to over-expose and compensate for the way the reflections have fooled the exposure meter. This is not *always* necessary – here, the presence of sky and dark rocks in the picture means that the camera's own meter provides a balanced result with detail and texture in the snow. Whenever there is any doubt always bracket exposures – it is cheaper than repeating a trip. MAMIYA 645 SUPER, 45MM F/2.8, 1/30 SEC. AT F/16, FUJICHROME PROVIA 100F

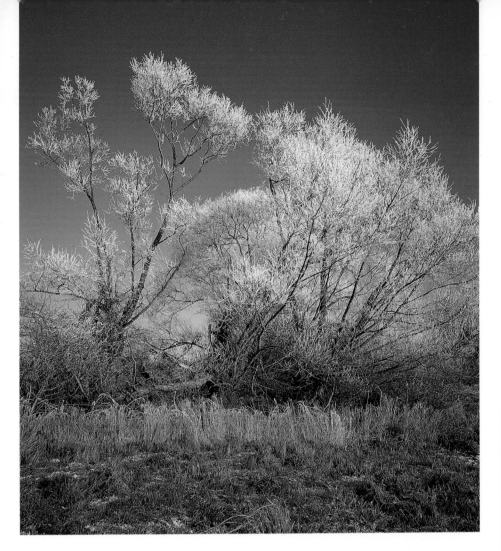

◀ HOAR FROST, OXFORDSHIRE, ENGLAND
Freezing mists create ice crystals on branches and stems, delineating them against the sky and creating a white 'foliage' that breaks up the silhouettes of the trees in winter.
MAMIYA 7 II, 80MM F/2.8, 1/30 SEC. AT F/16, FUJICHROME PROVIA 100F

Working in low temperatures
Cold conditions can affect the perform-ance of photographic equipment. Camera batteries, in particular, are susceptible to cold and can run down rapidly. Some systems have an accessory battery pack, connected to the camera by a cable, which can be kept warm in your inside pocket. Camera lubricants can become excessively viscous at low temperatures and if you are planning a cold weather expedition you should have your cameras 'winterized' with suitable substitute lubricants.

its granularity or the patterns left by animal tracks, for example – slight underexposure is required.

Incident light readings taken with a hand-held meter will produce a 'correct' exposure. You can also make reflected light exposures by taking a reading from a grey card or some other neutral-coloured object. With experience – and almost certainly with some failed frames in your collection – you can meter the snow scene and get to know, by trial and error, what exposure correction to employ. When I take a reading from snow (or from other pure white subjects such as a white flower or the feathers of a swan), I find that compen-sation of the camera reading by 1–1 1/3 stops overexposure gives the effect I want. There is still a slight underexposure to capture texture.

Most matrix meters cope very well with scenes containing a mix of sky, vegetation and snow, and do not need correction.

▼ ICE CRYSTALS ON BRACKEN
After any frosty night, leaves will be encrusted with crystals, but the first rays of the sun are often sufficient to melt the ice. Early frosts in late autumn or sudden frosts in spring catch spiders unawares and encrust their webs.
NIKON F4, 105MM F/2.8 AF MACRO, SB 21B MACROFLASH, 1/60 SEC. AT F/16, FUJICHROME VELVIA

Sea Coast

The sea is a tireless sculptor, exerting enormous forces on the land, eroding cliffs and grinding rocks to form pebbles, shingle and sand. All these distinctive natural forms make strong images, while the sea itself holds endless fascination for the photographer, from the rippling patterns it leaves in the wet sand to the drama of towering waves crashing against rocks in a storm.

As well as spectacular coastal land forms such as arches and huge rocks, the twisting and buckling of rock strata can make attractive abstract compositions. I often scan the cliff with binoculars and pick out interesting arrangements of rocks and plants with a telephoto lens.

COASTAL WILDLIFE

There is an astonishing diversity of natural habitats associated with the coast and a corresponding richness of wildlife. Rock pools (see page 76) teem with life and are replenished with each tide. Cliffs provide nesting sites for seabirds – gulls, auks, kittiwake, cormorant and shag – as well as many land-based birds, including swift, swallow, raven, jackdaw, chough, peregrine and kestrel.

Many offshore islands with colonies of nesting seabirds have accommodation and facilities run by naturalists' trusts. The larger birds are comparatively easy to photograph without disturbing them; if you visit an island reserve it is almost impossible not to get good pictures.

Salt marshes and dune systems that form at river estuaries support unique assemblages of plants. The wet slacks formed between the dunes have a slightly alkaline environment and are often rich in plant species (including orchids) and good for butterflies. Salt marshes, particularly those equipped with hides, are great places to watch and photograph visiting birds.

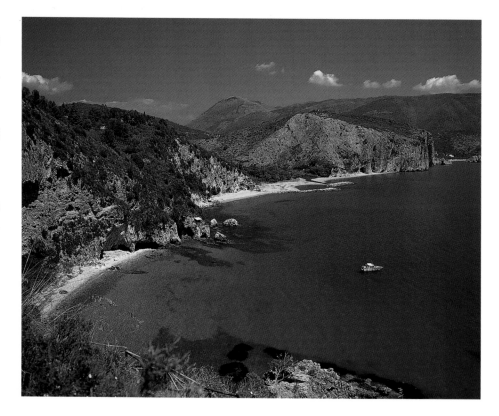

▲ PALINURO CAPE, CILENTO, ITALY
Crystal clear seas and rocky coasts are hard to resist but some thought needs to be given to the horizon: it must be absolutely level and where you place it makes a big difference to the result. If in doubt, take several shots with the horizon nearer the top or bottom, and in the centre. A polarizer is essential for balancing the colours of the sea and sky.
MAMIYA 645 SUPER, 45MM F/2.8 WITH LINEAR POLARIZER, 1/125 SEC. AT F/8, FUJICHROME PROVIA 100F

▶ CAVE MOUTH, ALGARVE, PORTUGAL
Arches and cave mouths cut by waves can serve as frames for coastal shots. The incoming tide left an area of glistening sand that reflected the rocks, and the water's edge complemented the other shapes in the picture.
NIKON F60, SIGMA 24MM F/2.8 AF, 1/30 SEC. AT F/11, FUJICHROME VELVIA, PHOTOGRAPH: LOIS FERGUSON

Salt and sand
Being close to the sea creates harsh conditions for plants and animals, and for your photographic equipment. Seawater is highly corrosive and salt-laden winds also carry fine sand particles, abrasive to lenses and ready to grind their way into focusing mechanisms.

If you intend to work with sand and sea, a protective camera covering is a good investment. Camera cases should have proper seals and, on return to base, camera bodies and lens exteriors should be given a good dusting with a blower brush before wiping with a damp cloth.

Below the Waves

You will need a heavy investment in equipment, and extensive training before you can consider underwater photography that entails diving to significant depths. Fortunately, many highly photogenic marine subjects live on and around rocks close to the shore or on coral reefs. In shallow water all you need is basic snorkelling equipment: mask, snorkel, fins, a weight belt to achieve neutral buoyancy and a wet suit if you intend spending any time in cold water. Once you are in the water – in their world – fish become inquisitive to the point of being 'tame'.

EQUIPMENT

The Nikonos was the first camera designed to be used underwater without the protection of a special housing. It has a full range of lenses and flash guns, and connections are sealed with O-rings to ensure they are fully waterproof.

Several firms make underwater camera housings, the most sophisticated of which are specially engineered for specific makes and models of camera. Ewa-Marine make flexible housings which are ideal for close-up work in shallower water and fit a range of cameras.

A TTL flash system is indispensable underwater, where there is often little light. A housing that takes a 35mm camera with 50–60mm AF macro and has small waterproof flash guns attached, is a versatile piece of equipment for close-up work. The flash reveals strong colours you did not realize were there, and you can use it exactly as you would a macro system on dry land.

You have to learn to be very careful with your camera when you begin to take photographs underwater, because accidents have dire consequences, especially with electronic equipment.

Faulty O-rings spell disaster, as does the accidental dropping of equipment into the sea. Salt water is highly corrosive and an excellent conductor of electricity capable of causing damage. The standard advice is to immerse the equipment in a bucket of fresh water as soon as possible, to wash off the salt, then get it to a repairer. This is sound, but the bills could prove astronomical and the equipment will most likely be deemed a write-off. It pays to be fully insured.

There are many simple 'disposable'

▼ **RED STARFISH, MENORCA, SPAIN**
Dramatic scenic shots are possible with ultra wide-angle lenses. This photographer has used flash to illuminate the foreground, but the combination of shutter speed and aperture captures ambient light to produce a natural background.
Nikonos V, 15mm lens, 1/30 sec. at f/11,
2 Nikon SB103 strobes,
Photographer: Carlos Villoch/imagequest3d.com

◀ **SOFT CORALS, RED SEA, EGYPT**
The rapid loss of light as you descend in the sea also suppresses colours. These corals, for example, can be viewed with an underwater lamp, but for photography most divers use electronic flash guns linked to their camera's TTL exposure system for perfect results.
NIKON N90S, 16MM LENS, 1/30 SEC. AT F/5.6,
2 NIKON SB105 STROBES,
PHOTOGRAPHER: CARLOS VILLOCH/IMAGEQUEST3D.COM

cameras on the market that can be used to experiment underwater. They give encouraging results and many people get the bug for this kind of photography after taking pictures with them.

For focusing, it is useful to have cameras with a 'high point' viewfinder – one in which you see the full image with the eye a short distance from the viewfinder. A wide-angle lens of 24mm or more allows you to take underwater landscapes with great depth of field. Just a few metres below the surface there is enough natural light to retain foreground colour. If you plan to go deeper, you will need to use a flash with sufficient coverage.

▶ **DIVER AND FISH, MOOREA, TAHITI**
Faced with shoals of colourful fish and multicoloured corals it is easy to forget the human element. Here an ultra wide-angle lens captures the observer in an alien environment that belongs to the fish. They are not at all perturbed by human presence and this makes them easy to approach, indeed they will often approach you.
NIKON N90S, 16MM LENS, 1/30 SEC. AT F/8,
2 NIKON SB 105 STROBES,
PHOTOGRAPHER: CARLOS VILLOCH/IMAGEQUEST3D.COM

Whether you want to capture shots of people at work, use boats as focal points of your landscapes, or seek out a myriad abstract designs – from reflections on water to the curves of hulls – a harbour is a marvellous source of pictures.

In and around any coastal region there are numerous people making their living from the sea, and harbours are a rich source of pictures involving human activity. For these I favour mornings, as early as possible, but for atmosphere the soft warm light of late evening can accentuate the bright colours of the painted boats. On dull days, too, the colours of boats show well though you have to choose your viewpoint to avoid including large areas of grey sky in your composition.

The day's catch of fish tends to be landed very early in a fishing harbour. People are preoccupied with their work and it is easy to get photographs unobtrusively – not just of people but of the fish and crustacea that fill the baskets and market stalls. Later in the day the fishermen linger around the harbour, mending nets, repairing and painting boats or simply whiling away the time.

Harbours that face west can provide spectacular sunsets (see page 46), with masted boats forming silhouettes and the setting sun reflected from the water – and perhaps including an island or two on the horizon.

The changeable coastal weather can sometimes produce dramatic lighting effects after a storm. As shafts of sunlight pierce the dark clouds, sharply illuminated masts and sails are set against an almost black background.

DETAIL AND DESIGN

Many boats are beautiful in themselves, both individually and in groups, and a wide-medium zoom is ideal for choosing subjects to fill the frame. Every harbour is chock full of detail. There are the inevitable chains and ropes of all thicknesses, from thin net ropes to massive hawsers wound

▲ **SAILING SHIP, LISBON, PORTUGAL**
To get the whole ship in meant including a large part of the concrete harbour side – which did not work. Often a closer view, moving in on part of a boat, will provide an effective composition. Here the rigging creates a series of lines that fit well into the frame.
NIKON F4, 24MM F/2.8 AF WITH CIRCULAR POLARIZER, 1/30 SEC. AT F/8, FUJICHROME VELVIA

▶ **LOBSTER POTS, GIGLIO, TUSCANY, ITALY**
Around any harbour there are numerous details that make good camera subjects, from nets to catches of fish, or lobster pots piled and waiting for the next trip.
NIKON F100, 28–80MM F/2.8 AF WITH CIRCULAR POLARIZER, 1/30 SEC. AT F/8, FUJICHROME VELVIA

around capstans. There are combinations of polished mahogany panels and frames, brass fittings, masthead lanterns, stacks of lobster and crab pots, masts of all sizes and hulls that range from the chunky to the downright sensuous.

As you develop an eye for shape, texture and colour, more potential abstract designs seem to appear in the harbour. You can, for example, explore the complex geometry of fishing nets and coiled ropes, where a wide-angle lens used close to the subject will often give you an unexpected

and dramatic perspective. Portions of boat hulls create slabs of bold colour, and peeling paint – in a low afternoon light that creates relief – produces endless variety as you work with a zoom lens to see what fills the frame best.

If the harbour has a jetty, by walking to the end you can often capture the whole of the waterside, with its settlement behind it. A variety of shots is essential if you want to put together a comprehensive photographic account of your harbour trip.

▼ **PESCHICI HARBOUR, GARGANO, ITALY**
I find harbours irresistible at any time of day – with the bright colours of the boats set against sky and water, it is easy to find subjects and angles for your camera.
Mamiya 645 Super, 45mm f/2.8, 1/125 sec. at f/11, Fujichrome Provia 100F

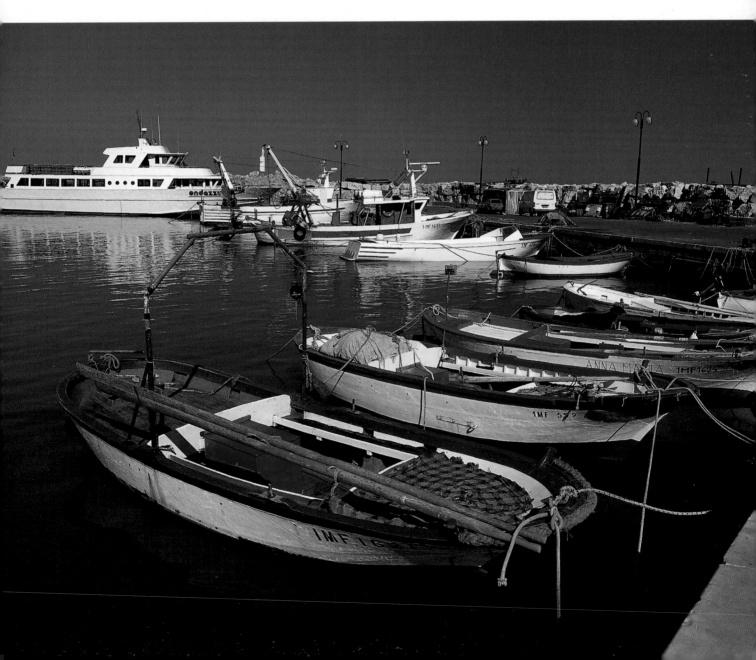

PEOPLE

A few photographers have a magical gift for seizing the moment, capturing expressions of joy, sadness, love and action in their fellow humans in a way that others would die for. Fortunately, with a little thought and practice, the rest of us can also get good pictures, and perhaps the occasional great one.

Photographs of people can be posed or candid, but you must make sure that the dignity and self-respect of the subject is not compromised. Some people are naturals: they relax in front of a lens and the camera adores them. Many of us look better when we are involved in some sort of occupation and not posing for a camera.

Reportage or photojournalism can be very much like wildlife photography, as the photographer sets out to tell a story about people and their environment. There is astonishing diversity in the way different people look, the things they do, the clothes they wear – no photographer need ever run out of ideas.

▶ **WHERE NEXT?, URBINO, ITALY**
Friends who acted as 'models' for a brochure shoot were much better subjects when left to their own devices and not posed.
NIKON F100, 28–80MM F/2.8 AF WITH CIRCULAR POLARIZER, 1/125 SEC. AT F/8, FUJICHROME VELVIA

People: Rights and Wrongs

Some people appear to think that carrying a camera gives them the right to record everything in front of the lens. But like many photographers, even those whose living depends on the pictures they take, I have always felt acutely wary of intruding with a camera. It is easy to feel self-conscious when you begin to take pictures in a public place, and this is no bad thing: it distinguishes you from those who think nothing of pushing a camera in the face of a stranger. This is something to deplore – people are not objects and their dignity and right to privacy should always be protected.

You can argue that a beggar on a street corner makes a powerful image in the hands of a photojournalist wanting to shame a government into caring. But there is something obscene about a camera-toting tourist seeing such a person as a bit of local colour – rubbing in the difference between the vastly different lots that life has dealt them.

By working in a low-key way, and by talking to people in whatever mixture of languages and gestures you can muster, it is possible to get your subject's consent for the pictures you take. Dignity is important – we should protect it at all costs.

In Western countries there are laws governing people's rights regarding published images of themselves. In France, for example, it is against the law

▼ **LADIES OF THE LAKE, APOLYANT, TURKEY**
My Turkish friends had been talking to these ladies the previous day while researching an article on the fishing community on Lake Apolyant. Using a telephoto lens I intended to be unobtrusive but I was noticed and they smiled and waved as they recognized us.
Nikon F4, 300 mm f/2.8 AF macro, 1/125 sec. at f/5.6, Fujichrome Provia 100F

◀ **LA BELLAFIGURA, VENICE, ITALY**
Sometimes people dress to be noticed: Venice at carnival time is full of far-from-retiring folk who want to be seen and photographed.
NIKON F4, 28–80MM F/2.8 AF, SB 24 FLASH, 1/60 SEC. AT F/8, FUJICHROME VELVIA

▼ **DAY'S END, TURKEY**
I had been photographing terrapins in a dirty ditch when I saw people going home from a day in the fields – these two ladies seemed so happy chatting that I took a picture from the car as it sat at the roadside.
NIKON F4, 80–210MM F/2.8 AF, 1/250 SEC. AT F/8, FUJICHROME PROVIA 100F

to publish a photograph of anyone without permission (though it is never enforced for individuals who are part of a general scene), and in Germany no child under the age of three can be photographed for commercial purposes. If you take pictures that are intended for publication, a model release form should be signed by your subject.

If you are travelling, don't shun the people – often youngsters – who offer themselves in some countries as guides. Their help will cost you little, and you will not only be giving something back by paying but often by helping them practise their English or other languages. They have far more local knowledge than any guide book, and they will know places to which you would otherwise not have access, and people who will be happy to be in your pictures.

Whereas Beefeaters at the Tower of London and the Palace Guards in Athens are accustomed to being photographed, in many countries it makes good sense not to photograph people in uniforms. Keep a low profile, otherwise you might attract the wrong kind of attention to yourself and create misunderstandings that might prove hard to resolve. All too often, paranoia seems to go hand in hand with wearing a uniform.

Markets and Crowds

Local markets draw me like a powerful magnet. All life is there and they are one of the best sources for candid pictures. My partner shares my fascination; she also happens to be a far better linguist and much prettier than I am, and talks easily with people on the stalls. Once she has established contact, people never seem to mind me taking a few pictures. While traders are setting out their stalls they are busy and are rarely bothered if you take pictures quietly – but it is always polite to ask.

An instant picture camera or a polaroid back is not only useful as a check for exposure and lighting but also allows you to produce a sample shot to show people what you are doing. This can become a gift: you get the pictures you want and your subjects get something to show their friends. You can use digital cameras with a replay facility in a similar way, although it's less easy to give away a print.

SECURITY AND DISCRETION

Being with a companion in a market is not only helpful in breaking the ice – he or she can be useful in another way, too. It is easy to become absorbed with taking pictures and not notice you are being watched: markets attract all sorts of people, including thieves. Camera bags can be snatched in an instant, and the crowd just absorbs the fleeing thief.

Your equipment will be much safer if it is unobtrusive, and you don't need to carry a great deal: you can work wonders with one camera and a 24–80mm zoom lens. Whether you use a compact, SLR or digital camera, carry it in a plain bag with the fastenings turned towards your body and the strap around your neck, not slung over one shoulder. In Arab countries people can be openly hostile to anyone with a camera; in India you will surrounded by a throng

keen to see what you are doing. Either way it is better to stay low key.

Modern compact cameras give excellent results and their leaf shutters are quiet, helping you to keep a low profile. They are also versatile, with no-nonsense exposure systems and built-in autofocus: chances are that you will get some of your best market shots with them.

Several roll-film rangefinder cameras are available in 6 x 4.5cm and larger formats. I use a Mamiya 7 rangefinder roll-film camera because I like the large transparencies (6 x 7cm), it has a shutter so quiet I often do not know it has fired, and even with a couple of lenses it is light and easy to hide in a bag. With a 43mm wide-angle I have evolved a way of holding the camera against my body and shooting while facing elsewhere. Sometimes the camera is not quite level, but the 6 x 7cm format enables me to crop to what I want.

▶ **THE FRUIT AND VEGETABLE STALL**
Markets allow you to capture pictures of people, produce, or both. Here a tele-zoom lens was used to 'condense' the perspective of the various kinds of fruit laid out on the stall. Front-to-back sharpness is not essential – you can select the plane of sharp focus. In this picture it is with the grapes, and the blurred colours lead the eye into the composition.
NIKON F801, 28–80MM F/2.8 AF ZOOM, 1/60 SEC. AT F/5.6, FUJICHROME PROVIA

▼ **DJENNE, MALI, WEST AFRICA**
The street market in Djenne with its riot of colourful people is reputed to be the biggest in West Africa. Early morning is the best time for the photographer to visit since the higher the sun gets in the sky, the harsher the light becomes. A nearby building provided the viewpoint.
OLYMPUS COMPACT CAMERA, KODACOLOR GOLD 200,
PHOTOGRAPHER: ANNA BUTCHER

In the early morning, the produce on the stalls has only just come out of the ground, off the vine or out of the sea, and it is fresh. The stall holders take great care to arrange fruit and set out their other wares to provide eye-catching displays, and will spray fruit with water throughout the day to maintain freshness. Photographers prepared to get up with the dawn are faced with the warm tone of clear morning light which accentuates the colour of fruit and vegetables. Crowds have not yet formed and people just get on with their business, largely oblivious to the camera's presence.

Often the only direct light on a stall will occur at the beginning or the end of a day, as they are positioned or shaded to avoid the effects of direct sun which quickly strips things of their freshness. The mixture of sunlight and shadow can stretch the contrast handling of any film and fool exposure meters. I tend to use a spot or matrix metering mode in order to capture shadow detail. You can also use the shapes of shadow and light areas as geometric elements in a composition.

By contrast, the end of the day is often best for capturing the glow you get in those strings of capsicums and chili peppers that adorn vegetable stalls. Low-angled direct sunlight creates a degree of backlighting, which picks up the translucency of the subjects and seems to make them glow.

VIEWPOINT

By working above the crowds you can take pictures of people interacting – arguing, trading, laughing – without impinging on their world. I take most of my overhead shots from balconies, which are common features of municipal market halls and allow you to look down on the business going on below.

You can even risk overhead shots from ground level by holding a monopod plus camera aloft. The lens must be a wide-angle closed down to give you sufficient depth of field for your guesswork to succeed. Release the shutter with a cable

◀ **MARKET AWNINGS AND STALLS, YAVLOVA, TURKEY**
Stall keepers who are anxious to keep their produce looking fresh erect awnings to create shade. For the photographer, this demands a lot from any film. The exposure used here retained the colour in the vegetables, even if the recesses contain deep shadows.
Nikon F801, 28-80mm f/2.8 AF zoom, 1/60 sec. at f/5.6, Fujichrome Provia

release – these days most cameras have an electronic release, and these can be purchased with extra long cables to give you enough reach.

WHAT TO SHOOT

Two or more bright colours juxtaposed – oranges and lemons, for example, or brilliant red capsicums next to limes so bright that they almost appear fluorescent – can make intriguing geometrical compositions when you focus closely and fill the frame. A zoom lens is ideal for this and I have sold viewfinder-filling shots of small, fresh, silvery blue fish, rows of tomatoes and mosaics of nuts, both as posters and as screensavers for computers.

Sacks of spices open at the neck to reveal colourful contents, dried peppers and a host of jars and bottles of oils and preserves create a feast for consumption and for the eyes. Foodstuffs are not the only market subjects – tropical and equatorial peoples dye their fabrics in a way which seems to reflect the joy of the sunshine. Stalls bedecked with these materials and clothes, and especially those stalls selling the dyestuffs themselves, are a veritable magnet for your lens. Assorted bric-a-brac, antiques, curios and hardware create 'still-life' compositions which you can refine in the viewfinder by choosing your position and framing with that ever-so-useful zoom lens.

▼ **THE MUD MOSQUE, DJENNE, MALI**
This extraordinary building is always surrounded by people milling in the market-place below it. First erected at the beginning of the twentieth century, it is largely rebuilt every year. A compact camera allowed the photographer to work unobtrusively, and its automatic exposure system coped with the vibrant colours and dried mud very well.
OLYMPUS COMPACT CAMERA, KODACOLOR GOLD 200,
PHOTOGRAPHER: ANNA BUTCHER

Children

Children make wonderful subjects for the camera – they concentrate so intently on what they are doing that they quickly become oblivious to your presence and you can take the candid pictures you want. This lasts until they go to school and become self-conscious, putting on a practised, cheesy grin, and it takes time and patience to get past that.

If children are aware of you trying to take pictures, you have to go along with what they want to do. Never try to force them into an activity that does not appeal to them – the resistance will clearly show – but useful props such as toys, ice-cream and sweets can stack up the odds for control in your favour.

When taking pictures of your own children or grandchildren, or those of friends and relatives, you have the advantage that you know them well and are subconsciously tuned to what they are likely to do. That anticipation is an important part of 'capturing the moment' with anyone at play or involved in sport (see page 94).

To avoid misunderstandings, don't take photographs of individual children without the knowledge and agreement of their parents and guardians. We do not live in an age of innocence and people are rightly concerned about the safety of children,

▼ **SCHOOLCHILDREN, SOUTH AFRICA**
When silversmith and inveterate Africa traveller Anna Butcher visited a charity school that she supports, her subjects queued to have their pictures taken with varying degrees of interest. Olympus Compact camera, 1/250 sec. at f/8, Kodacolor Gold ISO 200, Photograph: Anna Butcher

but even parents who have innocently photographed their own small children at play with no clothes on have found themselves being interviewed by the police when prurient individuals in processing labs have complained.

ACHIEVING SPONTANEITY

Children are at their best when they are involved in the picture-taking – digital and instant picture cameras make this much easier – and they love to 'direct' shots. Your equipment needs to be simple and quick to set up, or the spontaneity is lost and the children get bored. An AF camera with automatic exposure and a zoom lens is ideal for taking pictures of children – composition and framing are all you need to worry about, and the zoom makes that much easier. Any family snapshot can be greatly improved by framing it tightly. In too many pictures an individual or group gets lost in the frame. With a simple camera the answer is to move closer, but so many compact cameras have a zoom lens (and automatic portrait or group settings) that it is easy to fill the frame.

Family snapshots have become part of the digital revolution. The simplest of digital cameras allows you to download an image to your computer or produce a file that can be scanned to a photo disc. It is easy to produce an instant record of children in this way, and it is so simple that children can be encouraged to do it themselves. Children often see things that adults simply do not notice. The results can be assembled into slide shows on screen or converted to files and sent to relatives as e-mail attachments.

Sequences of pictures work well with children, particularly when they are finding something out and the pictures record the thrill of discovery in their facial expressions. Whenever there are children around, it's worth keeping a camera within easy reach.

▲ **DANIEL**
The promise of an ice cream was the deal that brought a smile to Daniel McNamara's face, but if you resort to bribes you must pay up: children have long memories and that unpaid-for photograph of them will be your last.
NIKON F4, 28–80MM F/2.8 AF, SB 24 FLASH AS FILL-IN, 1/125 SEC. AT F/5.6, FUJICHROME VELVIA

▶ **HANNAH AND RHODRI**
My own children, both now grown up, were asked to play giants in a model village. 'Scowl and stomp around,' was the command, but Rhodri's disdain is a bit too apparent.
NIKON F4, 28–80MM F/2.8 AF, 1/125 SEC. AT F/8, FUJICHROME PROVIA

Reportage

Almost as soon as the camera was perfected, it began to be used to record stories, and reportage or photojournalism was born. Since then, every conceivable aspect of human life has been captured on film, forming valuable historical records.

The need for a small, easy-to-carry, reliable and versatile camera for this purpose led to the design of the legendary Leica rangefinder camera by Oskar Barnack. Launched in 1925, it used the 35mm film that had been developed for motion pictures and for years it was the tool of every photojournalist. Later, the convenience of SLR cameras, and the fact that the viewfinder showed exactly what would be on film, made them favourites with many.

Modern photojournalists working on news events have to cope with insane editorial schedules, and digital cameras now enable pictures to be sent within seconds via a satellite telephone to a news desk on the other side of the world. But many photojournalists never work on news stories, instead preferring to take time to build up the story they want to get across. Often taking huge personal risks, they have made the world aware of many events that others would rather have kept hidden. We owe them a great debt.

For many, war photography is synonymous with reportage. There is an almost invisible line between pictures that show violence and death to satisfy the lust for gore that some editors feel sells papers, and pictures that bring home the horrors. Over several decades, the photographer Don McCullin's brooding images of conflict have done that better than anyone's.

GETTING THE STORY

Whatever the area, the element that links all reportage work is the story. In this field, you need to take a deep interest in people and to develop an eye for images with impact. Often, people need to be shown in relation to their surroundings.

Whether you want to use your camera to record stories for your own interest or with a view to a sale, start with events where you will not feel self-conscious or too shy to take pictures. All sorts of celebrations, parades and ceremonies will fit the bill.

With large events attended by the press it is worth trying to find a different 'angle' from which to launch your photo-essay. Walking around at a public event you might catch the behind-the-scenes preparations; as a procession passes you could concentrate on the expressions of people in the crowd.

PLANNING

Pre-planning is essential when working on any story – you need to make travel arrangements, find local sources and contacts, work out the equipment you need and the minimum you can get away with. It is never easy deciding on equipment for an assignment. Most of the time you may well use only a single camera body and a couple of lenses. If you don't have the right lens, you may have to change position and perhaps make yourself more obvious, but if you want the picture you simply have to bite your lip and get on with it.

▲ **RELIGIOUS FESTIVAL, TIMKAT, ETHIOPIA**

Every year an important religious festival is held in Timkat, Ethiopia to coincide with Epiphany. The brilliantly-coloured umbrellas are part of the priestly garb, and are not an indicator of bad weather conditions.

OLYMPUS COMPACT CAMERA, KODACOLOR GOLD 200, PHOTOGRAPHER: ANNA BUTCHER

▶ **RELIGIOUS FESTIVAL, TIMKAT, ETHIOPIA**

Here a small group of people has been isolated by moving inwards from the 'bigger picture' to details of the individuals' clothes. In telling any story it is important to capture both general and more specific views. At the time you usually have no idea which shots will be used for the complete story at a later stage. This often only becomes clear when they are all viewed on a lightbox.

OLYMPUS COMPACT CAMERA, KODACOLOR GOLD 200, PHOTOGRAPHER: ANNA BUTCHER

People at Work

Most of us are fascinated by other people's special skills. Glass-blowers always draw crowds when they display their craft, we marvel at a chef rapidly cutting cucumber and keeping all his fingers intact, or watch transfixed as fishermen quietly mend their nets between tides.

The work people do provides endless opportunities for stories and also creates chances for good portrait shots. Any activity that involves several stages can make an interesting series of pictures: sequences have long been an important part of photojournalism.

People engrossed in their work are far too busy to worry about posing for your camera – even if they are aware initially, the activity soon takes over: their faces relax and their gestures become more natural. Always ask permission before taking photographs of people at work – if your interest in what they are doing is clear, you will seldom be refused. Most people take a great pride in what they do, and they don't mind others seeing it.

◀ **ARTIST, ZANZIBAR**
The colourful work of this street artist contrasts strongly with his surroundings.
OLYMPUS COMPACT CAMERA, KODACOLOUR GOLD 200,
PHOTOGRAPH: ANNA BUTCHER

▶ **ON ASSIGNMENT, SANT ANTIMO, TUSCANY, ITALY**
A freelance photographer always has to be on the lookout for opportunities to get pictures and articles. I started picturing fellow photographers in action not just to use as illustrations in talks but also because it adds interest to familiar tourist destinations and buildings.
MAMIYA 645 SUPER, 45MM F/2.8, 1/30 SEC. AT F/8,
FUJICHROME PROVIA 100F

◀ **POWERED SAW, KNOWLE HILL STEAM RALLY, READING, ENGLAND**
Traditional working practices always have an appeal for onlookers – here the use of a saw powered by a traction engine was being demonstrated at a steam fair.
NIKON F100, 28–80MM F/2.8 AF, 1/30 SEC. AT F/5.6, FUJICHROME VELVIA

SHOWING THE WORKPLACE

When you set out to show a workplace, the people in it – singly or in groups – become elements in the design of the picture. Machinery, materials, parts of the building or stacked pieces of work can all become subjects that you can use in the foreground of your picture, leading the eye into the frame.

A wide-angle lens is ideal for this kind of subject – which one depends on how much perspective distortion is acceptable. If people's faces are close to the lens no one will thank you for the exaggerated noses and lips that the foreshortening produces. (Various photojournalist friends have profitably used this effect on politicians – when they fall out of favour there suddenly seems to be a demand for unflattering shots.)

SHOWING THE WORK

Any experienced craftsperson develops special skills and by moving in close on the work (perhaps with a zoom or with a telephoto lens) the photographer can make its quality the main focus of attention, though hands and perhaps the maker's face (even slightly out of focus in the background) add to the picture. Hands can add greatly to a portrait of someone at work – I often move in to isolate hands busy with a piece of work or involved in some activity. There is astonishing variety

in human hands – the hands of metal-workers, carpenters, boxers, climbers and musicians – and myriad uses to which these astonishing appendages can be put. Hands that might seem huge and clumsy can be photographed involved in the most delicate of work.

Musicians often have expressive hands and a portrait that involves hands and just part of a face can show a lot in terms of emotion and concentration.

▲ **ART GALLERY, ZANZIBAR**
It was the colours that drew the photographer to this shop, but its owner sitting quietly outside is an essential part of the scene.
OLYMPUS COMPACT CAMERA, KODACOLOUR GOLD 200
PHOTOGRAPH: ANNA BUTCHER

People at Play

The classic image of the sports photographer involves massive telephoto lenses and several motor-driven cameras. For some purposes that is still what is needed – but if you have not got this kind of equipment there is still much you can do.

Touchline places at major sports events are jealously guarded and are usually reserved for accredited photographers. Local friendly (and not so friendly) team events will not have the same restrictions and you can position yourself closer to the action. Lower level amateur games also have the advantage that they are slower and easier to follow with the lens. There is the same need for anticipation – being ready to record a rugby try or a dispute as the referee holds up a card – but it is not so pressing.

If you do get some good pictures, you might want to try showing your work to the management of the sports ground: you could be given access to future sporting events, with more opportunities for your camera.

ANTICIPATION

Outstanding sports photos, the ones we all wish we had taken, such as those by the British photographer Eamonn McCabe, show an uncanny ability to capture the essential moment. This comes from a thorough knowledge of the sports that are covered, but also from a deep sense of how people behave.

In many sports there are long periods of inaction followed by sudden periods of rapid action. Apart from learning to handle a camera with complete familiarity, this means you need to be able to recognize the build-up of tension and action, then shoot around the period of activity using a motor drive. With your 'rapid' motor drive working at six frames per second, this will

eat a 36-exposure film in six seconds: it is an expensive way to learn.

Even if you cannot get close to the action at a major sports event, you can still get worthwhile pictures, such as candid shots of the crowd. Expressions of elation, gloom and desperation can follow one another in seconds as a football match develops. If you spot a friend in the crowd, an effective technique is to use the shallow depth of field of a telephoto lens at maximum aperture to single out his or her face in a sea of blurred heads.

PARTICIPATION

Many sports offer great opportunities for pictures. As with any other area of photography, if you have a particular interest and inside knowledge it will show in your pictures. If you take part in a sport such as sailing, you can get where the action is – in this case, wide-angled lenses are useful for showing the crew, the boat and the weather in one shot.

Some of the best photographs of extreme sports – downhill racing, sky-diving, climbing – are those taken by the participants themselves, carrying a camera on a body harness. It is not something for the faint-hearted and to wield the camera you have to be even more competent than those doing the sport without it.

▶ **CAROUSEL, KNOWLE HILL STEAM RALLY, READING, ENGLAND**
The blurring was created deliberately, using a shutter speed too slow to freeze the action. If everything is sharp the subject can appear static – which is not why people go to fairs.
MAMIYA 7 II, 43MM F/4.5, 1/30 SEC. AT F/11, FUJICHROME PROVIA 100F

▼ **KITE FESTIVAL, NATIONAL BOTANIC GARDEN, WALES**
Kites have universal appeal for young and old. I wanted to include kites, kite fliers and the remarkable glasshouse all in the same shot.
MAMIYA 645 SUPER, 45MM F/2.8, 1/60 SEC. AT F/11, FUJICHROME PROVIA 100F

Outdoor portraits tend to fall into two broad groups. In the first you move in close and let the head and shoulders of the subject fill the frame, which works well with faces full of character. The second type of portrait includes more background and shows the environment of the person – this is good for people at work and can give additional insight into the subject's personality.

The camera seems to love some people who immediately adopt a natural pose and can look directly at it. Others look better when they are doing something, or in conversation with someone else.

LENSES

Whichever approach you take it is a good idea to avoid wide-angle lenses, which distort perspective and can make faces look unnatural. A zoom lens providing the range 80–200mm is ideal for portraiture. It gives a flattering, more acceptable perspective and lets you include as much or as little of the background as you want.

When using longer lenses, the depth of field can be shallow, especially in low light where the lens needs to be used wide open. And if depth of field is limited, make sure that the subject's eyes are the part of the face that is in sharp focus.

LIGHTING FOR OUTDOOR PORTRAITS

Diffuse light, such as hazy sunlight, gives the best results with portraits. Bright sunlight creates harsh shadows and overhead light creates unflattering shadows in the eye sockets and accentuates 'jowls'. A portable reflector held to one side of the face, making sure it is out of the field of view, can soften these shadows. Try to position subjects so that the sun does not make them squint.

Flash can be used with care as a fill-in (see page 56) by setting it a stop or more below the ambient light exposure. In recent years, a fashion has developed for flash to be the main light, with the ambient light a stop or so lower. This creates well-lit faces against a darkened background, but one with lots of detail.

FILTERS

Warm-up filters accentuate tanned faces and in black and white a yellow-green

▲ **IN A TURKISH GARDEN**
On an assignment for a Turkish magazine we visited several traditional walled gardens, none more peaceful than the one tended by the ladies pictured here.
NIKON F4, 80–200MM F/2.8 AF, 1/125 SEC. AT F/5.6, FUJICHROME VELVIA

filter does the same; spots and other blemishes can be reduced by a red filter. Wrinkles, crows' feet and other signs of ageing and an outdoor life create character, however if your subject does not feel that way about them, you can use either a diffusing filter, or the thinnest possible smear of petroleum jelly on a piece of glass in front of the lens. This will soften wrinkles and also produces a 'flattering' portrait, though the ruse will be easily detectable.

SKIN TONES

There is a great difference between the exposures needed to capture Caucasian and black skin tones accurately on film. In terms of a standard grey card with its 18 per cent reflectance (see page 36), the average Caucasian skin is about a stop lighter; black skins are often several stops darker and cover a much greater range of tones. An incident light meter is useful with skin tones – or you can make a few bracketed test exposures with different people and keep a record of the corrections needed.

◀ HANDS
Hands and feet make subjects for a different kind of portrait – one that concentrates on an activity rather than a person. Here grapes are examined before picking for wine-making.
MAMIYA 645 SUPER, 80MM F/4 MACRO, 1/60 SEC. AT F/8, FUJICHROME PROVIA 100F

▲ I LIKE ICE CREAM
This little girl at a fair was oblivious to everything except her large ice cream, which seemed to be going everywhere . . .
NIKON F4, 80–200MM F/2.8 AF, 1/125 SEC. AT F/8, AGFA SCALA 200

Carnivals and Parades

Everyone, they say, loves a carnival. There are several known internationally for their extravagance, and thousands of others that are much more modest but which also provide endless opportunities for photography. People go to be seen, and willingly perform for the camera – no one tells you not to take pictures at carnivals. Whether you take your camera to Notting Hill in London, to Rio de Janeiro or to your local fair, a mid-range zoom lens and a single flash will see you through the occasion and let you stay reasonably unobtrusive. These pictures were taken at the Venice Carnival, which catapults the Venetians, and thousands of visitors, out of winter despondency with a riot of colour and activity.

▶ **THE MASK MAKER'S SHOP**
Some papier maché masks may be cheap imports, but there are a number of mask makers in the back streets of Venice, away from the Grand Canal. On a dull day the vibrancy of colour on this stand had an unusual force.
NIKON F60, 28–80MM F/2.8 AF, F/8 AND CAMERA'S INTERNAL FLASH, FUJICHROME VELVIA

▲ **CARNIVAL MASK, VENICE**
The traditional characters of the carnival in Venice are well-defined and an industry exists to make the ornate masks for this annual event. The masks themselves are often striking – whether filled by a human head or, as with this one, just hanging outside a shop in the back streets.
NIKON F60, 28–80MM F/2.8 AF, F/8 AND CAMERA'S INTERNAL FLASH, FUJICHROME VELVIA

◀ **LADY IN A MASK, VENICE**
There is no shortage of subjects willing to pose for photographers during Carnivale – after all, many have taken immense trouble over every detail of their costumes. People are there to be seen as well as to join in the spectacle. Colours are bright, costumes fascinating and the whole event is great fun for those with or without a camera.
NIKON F4, 80–200MM F/2.8 AF, F/5.6 AT 1/125 SEC. WITH SB 25 FLASH GUN AS FILL-IN, FUJICHROME VELVIA

STRUCTURES & ENGINES

The built environment demands a lot of any photographer, for there is much room for interpretation. It helps to spend time wandering around structures, exploring different views and trying to understand what the architect intended. Was a building designed to be imposing and stand alone, for example, or was it intended to blend with existing architecture? Your conclusions will affect the viewpoint you adopt.

To photograph a city or town properly you need to spend several days there. This is not just to get a feel for the architecture but also to decide on the best times of day to give your pictures impact. Frontal lighting creates saturated colours while side lighting brings out textures and creates relief. Ornate towers and buttresses can be emphasized by viewing them as silhouettes against the light, and this can be extremely effective at twilight when the available light defines the outlines of buildings.

▶ **LOGGIA AND CHURCH OF SANT'ANDREA, CAMPI VECCHI, UMBRIA, ITALY**

Those who start out with a 'purist' approach to natural landscape photography soon find that much of what they see is actually influenced by centuries of human activity. From there it is a short step from turning the camera to the wealth of villages dotting a landscape, to individual buildings, and then on to the multiplicity of architectural features and decoration that give them character.
MAMIYA 645 SUPER, 45MM F/2.8 WITH LINEAR POLARIZER, 1/30 SEC. AT F/16, FUJICHROME PROVIA 100F

A dictionary definition of a village is 'a settlement of houses and associated buildings larger than a hamlet and smaller than a town'. It is a convenient catch-all term for an astonishing diversity of small human settlements throughout the world.

The word can evoke a number of classic images, from a picturesque cluster of thatched cottages, or the narrow cobbled streets of an Italian mountain settlement, to groups of grass or reed buildings in equatorial and tropical regions.

SECRET CORNERS

Whatever the village, it offers the photographer the chance to explore interesting nooks and crannies with a camera. Buildings are often crowded together, constructed to fit into the available space and brightened with flowers, artlessly but charmingly planted in any available container. Although some village houses will boast neat window boxes, old olive oil cans may be pressed into use by other residents – it is the flowers that are important, and some striking vignettes can be created of tiny courtyards bedecked with geraniums, bougainvillea and morning glory. Domestic animals – goats, chickens and cats – will be unconcerned by your presence and easy to photograph.

Try to avoid being a gawping tourist and show your respect for, and interest in what is, after all, a place where people live. In a Turkish village I was once surrounded by children who started pulling at my arm – so I went with the flow and was taken to all sorts of little corners they knew and which they thought I might find interesting. The ministrations of locals wanting to be guides can be a pest – but more often than not you'll be taken to places that you might not otherwise see, and other would-be guides will leave you alone to take photographs.

Beautifully manicured villages are often popular tourist destinations. The brilliant white buildings of the Greek Cyclades, for example, with their blue-painted doors and window frames, are familiar the world over. During the day the villages are filled with sightseers, but by early evening the day trippers' boats have departed, the light is far less harsh, and you can then take photographs to your heart's content.

On holiday there is no substitute for staying in a village, where your presence quickly becomes accepted and all sorts of unexpected opportunities for photographs can arise: people working, talking together or children playing.

▼ **DESERTED VILLAGE, ROMAGNO AL MONTE, BASILICATA, ITALY**
The village of Romagno al Monte was evacuated following an earthquake. When we visited, no birds sang there and a child's shoes had been left in a doorway. There was something profoundly unhappy in the atmosphere of this abandoned ruin, a feeling not easy to capture on film.
MAMIYA 7 II, 80MM F/2.8, 1/125 SEC. AT F/8, FUJICHROME PROVIA 100F

◀ **CERAMIC SHOP, GIGLIO CASTELLO, ITALY**

On sunny islands throughout the world village life has changed dramatically, as many now depend on an influx of summer visitors. For the photographer the result is brightly coloured displays of local wares which make eye-catching subjects.

MAMIYA 645 SUPER, 45MM F/2.8 WITH LINEAR POLARIZER, 1/125 SEC. AT F/11, FUJICHROME PROVIA 100F

ANGLES AND VIEWS

Wide-angle lenses can be put to good use in a village since you can incorporate foreground interest in the bigger picture. A medium-range zoom enables you to switch from wide-angle views to details.

Many villages have narrow streets that receive direct sunlight for only a short time each day. You can use a sun compass to work out the height and direction of the sun, but the patterns of light and shadow that might make a sensational picture are difficult to guess in advance.

If you live near attractive villages, repeat visits at different times of the year and in varying weather conditions will produce an interesting portfolio of pictures.

Distant villages often make an evocative element of a landscape. They need not even be in sharp focus in your composition – just the suggestion is enough.

◀ **BAGNO VIGNONI, TUSCANY, ITALY**

Few village squares boast a Renaissance thermal pool – a feature captured countless times on film and also used as a movie set. The problem was how to create foreground interest: there were balconies and steps around the square decorated with flowers, so we chose one that gave the best view of the pool.

NIKON F4, 24MM F/2.8 AF WITH CIRCULAR POLARIZER, 1/60 SEC. AT F/8, FUJICHROME VELVIA

Cities, large and small, never lose their appeal if they have a history. In this case, a telephone call on a December evening offered an assignment – producing photographs to illustrate a guide book – and we found ourselves in Florence just two days later.

WHEN TO PHOTOGRAPH

Florence in high season can be a problem for the would-be photographer. The city lies in a wide 'bowl' and becomes unbearably humid in late summer when the skies are often a featureless harsh white – not the best for great shots. If you cannot choose the time of year, you need to rise early and take pictures in the soft light of the hour or two it takes for the city to wake and for visitors to congregate.

Winter weather can be unpredictable, but clear bright days offer a clarity and crispness which adds bite to your pictures. Even those grey days can be turned to advantage, for not only can you concentrate on details rather than expansive landscape shots, but you can also explore the city. Time taken to get a 'feel' for a city, looking for angles from which to shoot and thinking about the best time of day for light direction, is never wasted.

WHAT TO SHOOT

Look at postcards and books to see what local photographers who know their territory tend to focus on. They can pick and choose their weather and light conditions. But try to plan your own shots and photograph known sites in a way that puts your stamp on them. Statues, for example, can be given impact by using a wide-angle lens and a low viewpoint. For a high viewpoint there are often balconies – although getting access to them may depend on your powers of persuasion.

Don't avoid the 'obvious' shots altogether, however: clichés arise because a view is popular and that is the view people want to see. For commercial sales, these views must be well lit, pin-sharp and composed so that they can be cropped to fit a layout. Travel shots date – styles of dress, hair, makes and models of cars change. This means that agencies need new pictures of popular subjects every two or three years.

In many cities, courtyards and arched cloisters provide you with ideal framing for your pictures. Ceilings within arches can be a wonderful source of patterns. In Istanbul there is the fascinating geometric arrangement of tiles. In Florence there are wonderful, whimsical paintings – with animals, plants, humans and numerous phantasmagorical denizens of heaven and hell chopped and changed.

▼ **DETAIL OF BAPTISTERY DOOR, FLORENCE, ITALY**
Just west of the Duomo façade lies an octagonal baptistery. Its doors, with their cast bronze scenes by Lorenzo Ghiberti, are without doubt the most impressive in Florence. We guessed that the low-angled late afternoon sun would impart the greatest relief to the bronze door castings and were not disappointed.
Mamiya 645 super, f/4 macro with linear polarizer, 1/15 sec. at f/8, Fujichrome Provia 100F

Italians are often regarded as the most communicative people on earth. Every conversation is accompanied by hand and whole body movements which convey nuances of meaning. For those who love to sit in cafés and simply watch, cities offer rich photographic pickings.

LIGHT AND WEATHER

Light direction in cities needs careful consideration. I tend to avoid the harsh overhead light of midday for it does not create the shadows that give character to architectural shots. But in narrow streets with overhanging balconies, that overhead sun may bring the only direct light of the day. On this assignment, late in the year, we had to watch the direction of the light carefully and make sure the sun's rays cleared surrounding roofs.

There are days when even the most stalwart of outdoor photographers might be forced inside; though tripods and flash are forbidden in churches and museums everywhere. However, many churches and other buildings with vaulted ceilings have massive pillar supports against which you can lean in order to support your camera. Alternatively, use a beanbag on a seat-back in order to get a rock-steady support.

Exploring the Duomo

The construction of Florence's great cathedral, the Duomo, spanned some 150 years from the 13th to the 15th century. Although it must be one of the most photographed buildings in the world, there are innumerable close-up details to be taken as well as the more 'obvious' shots of the whole building. Even if your time is limited, try to explore surrounding streets and squares to see what other subjects you can find. These shots become important in fleshing out a subject when you write an article or give a slide show.

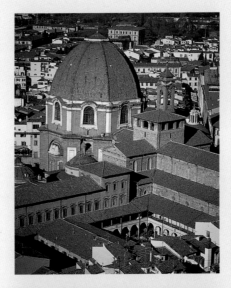

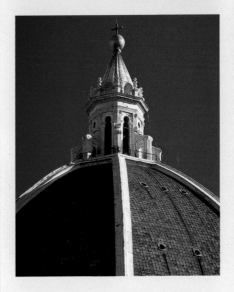

EXPLORING THE DUOMO, FLORENCE, ITALY
From top to bottom: A general view over the city from the Campanile; the Duomo; the cupola on top of the Duomo; a close-up detail of the Duomo's massive wooden doors; the copy of Michelangelo's statue of David in the Piazza della Signorina; the statue of Neptune and attendants.

Windows and Doors

The architectural detailing of doors and windows is astonishingly varied, and can make a fascinating theme for a photographic essay, as many visitors to regions such as Provence or Tuscany have discovered.

DECORATION AND DETAIL

Massive carved doors are a feature of many old palaces and churches. Panels might be carved in weathered wood, or depict whole scenes cast in bronze (see page 104). I like to move in very close with a zoom lens and fill the camera frame with a small portion of the design. An early morning or afternoon sun will provide the side lighting that creates surface relief (see page 44).

Door knockers and hinges come in a great variety of shapes and sizes, from simple cast-iron bars to ornate lions' heads. The patterns of heavy square-headed nails in old doors make interesting compositions, and so does the heavily aged and worn wood – often with layers of peeling paint showing centuries of redecoration. If you have a macro lens you can make very small portions fill the

▼ **DOORS OF DIFFERING SIZES**
However much reading you do before visiting a location it is fun just to get there and then wander to make your own discoveries. These doors were set into a wall close to the harbour and cried out to be photographed.
MAMIYA 645 SUPER, 80MM F/2.8 WITH LINEAR POLARIZER, 1/125 SEC. AT F/8, FUJICHROME PROVIA 100F

frame – though a good close-up facility on any zoom will work well. The built-in flash in many modern cameras will also work well if your subject is in shade. Better still, if you have a connecting cable that allows the flash to be removed from the camera, you can create a degree of side lighting to produce relief and enhance the texture.

It is surprising what you find when you start to look at the detail in buildings. Houses in Greek and Turkish villages built near ancient sites sometimes include ancient stones recycled in past centuries. The massive lintel over a house door may first have adorned an ancient Greek temple, and I have seen parts of column capitals and many other bits and pieces given new 'life' in these old houses.

Window boxes are an important part of the ornamentation around windows, and a display of bright scarlet geraniums or blue lobelia provides a brilliant contrast with the greys and browns of weathered wood and stones. The containers themselves may be brightly painted or traditional lead or stone; others have an altogether rougher and more rustic charm. Many narrow streets receive direct sunlight for only a short time during each day, so if you want brightly lit flowers you have to make an intelligent guess about where the sun will be and when.

ANGLES AND FRAMING

If you want a door or window to appear 'square', it must be photographed face-on – the slightest tilt of the camera up or down will introduce distortion of the vertical frame edges, making them converge or diverge. The further back you can stand the better.

Arrangements of windows and doors can themselves become 'frames' within the frame of your picture. A zoom is very useful for quick adjustments to achieve satisfying proportions – it is a question of what looks good to you.

▲ AN OXFORD DOORWAY
Perhaps as a result of reading *The Secret Garden* as a child, doors in garden walls have always intrigued me. I saw this one near the Oxford Botanic Garden.
NIKON F100, 28 -80MM F/2.8 AF WITH CIRCULAR POLARIZER, 1/60 SEC. AT F/8, FUJICHROME VELVIA

▶ DOOR KNOCKER, FLORENCE, ITALY
Ornate knobs and hinges may go unnoticed when a door is photographed as a whole, but as soon as your eye becomes tuned to the possibilities it is astonishing what you notice.
NIKON F60, 28–80MM F/2.8 AF, CAMERA'S INTERNAL FLASH, 1/125 SEC. AT F/11, FUJICHROME VELVIA,

PHOTOGRAPH: LOIS FERGUSON

Ornamentation

It is easy to be overwhelmed by the sheer scale of some buildings. At such places you may find you reach saturation point, just recording without stopping to enjoy what is in front of you. That is the time to put away your camera for a while and just look for photogenic details – they are easy to miss when you are still reeling from the big picture.

Other photographers may have taken the definitive large-scale views, especially if they live nearby, but details are things you

▲ **CARVED VALANCE, GARGANO, ITALY**

The carving looks as if it might belong on the canopy of a railway platform, but it adorns the roof of a ruined hunting lodge. The late afternoon sun emphasized the weathered grain of the wood.

NIKON F4, 80–200MM F/2.8 AF WITH CIRCULAR POLARIZER, 1/125 SEC. AT F/8, FUJICHROME VELVIA

◀ **STONE CARVING, ALHAMBRA, SPAIN**

Ornamentation remains a viable subject when the weather does not favour views. The first time that I visited this great Moorish palace, on a grey winter's day, I used a macro lens to concentrate on small portions of the carved walls.

NIKON F4, 60MM F/2.8 AF MACRO, 1/60 SEC. AT F/8, FUJICHROME PROVIA 100F

◄ **NEPTUNE, VILLA LANTE, VITERBO, ITALY**
Statues adorn many buildings or appear as garden features. This lichen-encrusted reclining figure of the god Neptune is part of a fountain in the villa gardens.
Mamiya 645 Super, 45mm f/2.8, 1/125 sec. at f/8, Fujichrome Provia 100F

can make your own, capturing them in a way that emphasizes their geometry, texture and pattern.

FOCUSING ON DETAIL

The choice of lens is dictated by what you want to record: parts of inscriptions will benefit from a macro lens, while arches and door panels need a wide to telephoto zoom; and gargoyles stuck tantalizingly high on eaves will demand a telephoto lens, possibly boosted by a teleconverter.

Many details in stone, wood or metal are essentially monochrome subjects. To emphasize texture, shape or pattern it is worth using monochrome film, in a second camera body for 35mm or in another film back if you use roll film.

Architectural details have filled books by themselves, so the following suggestions are just a few starting points for looking closely at buildings.

Door handles and panels on old doors, with carving, metal strapwork and hinges, or ornate knockers, make excellent camera subjects. In Italian cities great use is made of ornamental door panels in wood and metal (see page 106).

Roofs can have interesting shapes just in themselves, or allow you to create patterns by choosing groups of roof and ridge tiles. Looking down on any large collection of rooftops from a distance, they form vistas of pattern, colour and texture.

Tiles decorate many buildings in the Islamic world, with wonderful geometric patterns created in just a few colours.

Many of the designs are built up from divisions of circles or by using proportions which were believed to have special significance as perfect ratios. The shapes interlock and tessellate – extending and repeating to fill the space. If you try to photograph tiles in shade it is tempting to use flash, but a built-in flash or a unit on top of your camera will create 'hot spots' of reflected light on the glazed surface – the answer is to use the flash on an extension cable.

Mosaic, with its unpolished surfaces, can look dusty and dull, but the difference when it is sprayed with water is dramatic. For guide books and art books, mosaics are often sprayed and photographed wet, using side lights and a polarizer to cut reflection and retain colour intensity. Unless you can persuade or cajole the authorities, or have friends in high places, you won't be able to achieve this richness of colour, but a rainy day can provide lovely pictures of open-air mosaics.

Inscriptions, particularly those using an unfamiliar alphabet, can form intriguing patterns.

Gargoyles – fanciful small figures of animals, demons and humanoid figures – adorn many buildings but are not always easy to get close to.

Grotesquery of all kinds can be found on many Renaissance buildings, which often have painted roofs both inside and out. In Italian cloisters it is easy to miss the weird and wonderful animal and plant forms painted on the ceilings.

▼ **CHURCH OF SANTA CROCE, LECCE, APULIA, ITALY**
The soft Leccese stone in Italy's far south hardens after carving and thus lends itself to intricate designs. In bright sun the stone can be highly reflective and an 81B or 81C warm-up filter is needed to give a soft glow.
Nikon F4, Sigma 300mm f/4 apo macro 81B filter, 1/250 sec. at f/8, Fujichrome Provia

Texture and Pattern

The standard to aim for with pictures showing texture is for people to want to reach out and touch the material in your photograph, whether it is fur, feathers, rock or wood. It is a tall order because to achieve this level of realism the subjects need to be well lit and to appear as sharp as possible.

LIGHTING AND DETAIL

Sharpness is not just a question of using a fine-grained film and high resolution lenses. A picture will appear flat unless the subject is lit so that relief is created. It does not matter whether you are looking close up at the surface of a single stone, or at a whole wall – light from the side picks out all the ridges and depressions by creating tiny shadows that emphasize the edge of each detail. The late afternoon is ideal for this – especially with some light cloud cover. Although you want shadows, it is better if they have soft edges; the diffuse but directional light provided by hazy sunshine produces this effect.

Details in materials produce strong, almost abstract effects. Weathered wood on old doors and window frames has a lovely texture, particularly in monochrome. Worn, peeling and faded paint can be made to fill the viewfinder with your zoom lens. What it covers does not matter: it is the pattern, colour and texture that will create the picture. Also building materials such as stone and brick can be shown to advantage by late afternoon light, when the shadows cast by each course of bricks become more pronounced, as does the surface texture of each brick. Carved limestone blocks look their best in a warm, acute-angled light.

For texture in the landscape, winter is the ideal time, since the low angle of the sun enhances relief. Snow, for example, appears granular with strong side lighting. Bare ploughed fields, photographed with a wide-angle lens from close to the ground, show strong relief, as do dried grasses, pebbles, rippled sand and rocks. For outdoor still life shots the same low-angled lighting is ideal. If the shadows are too hard-edged, a portable reflector can be used to provide some fill-in light and to soften the shadows.

You can only create the best sense of texture if your subjects are properly exposed – in fact I often slightly underexpose with transparency film to get greater saturation in colour. This reproduces a wider range of tones, enhancing texture.

▲ **TILED WALL, ALHAMBRA PALACE, GRANADA, SPAIN**
The Moors were masters of repeating geometrical patterns. Tiles and mosaics have a reflective glaze which creates 'hot spots' if a camera-mounted flash gun is pointed at them. These reflections can be cut by avoiding direct light and either photographing them in shadow or using a flash gun well to the side. A polarizer can be useful, too.
NIKON F4, 60 MM F/2.8 AF MACRO, SB 24 FLASH HELD TO SIDE, 1/60 SEC. AT F/16, FUJICHROME VELVIA

▲ **ENLARGED INSCRIPTION, ALHAMBRA PALACE, GRANADA, SPAIN**
What caught the eye in these inscriptions was the sheer elegance of the lettering and the way it stood out from an intricate background. A macro lens was used to isolate small portions of the scene although any lens with a close-focus facility would have been adequate.
NIKON F4, 60MM F/2.8 AF MACRO LENS, 1/60 SEC. AT F/8, FUJICHROME VELVIA

▶ **FLAKING PAINT, GARGANO, ITALY**
Many years of scorching sun and winter wind and rain had peeled back layers of paint on an old building. Details like this are often small and the trick is to isolate them with a zoom or telephoto lens so that they fill the frame and create an abstract pattern.
NIKON F4, 80–200MM F/2.8 AF WITH CIRCULAR POLARIZER, 1.125 SEC. AT F/8, FUJICHROME VELVIA

Places of Worship

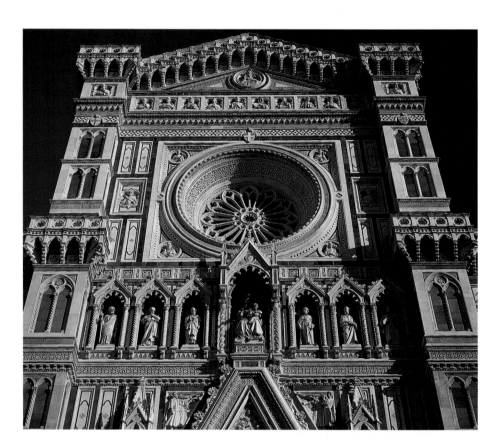

Many of the world's most glorious buildings are churches, temples or mosques or other places of worship. Your interest may be purely in their architectural splendour, but all sacred buildings should be treated with respect for those using them.

The exteriors of religious buildings are often replete with domes, bell towers and steeples – all of which make attractive subjects, whether as part of the whole or as details. Flying buttresses supporting the walls sometimes create natural frames through which other architectural details can be photographed. Decorative gilding on the outside of a church will only appear to shine at certain times of day, depending on the sun's orientation. You also have to be aware of light direction when you are photographing wall paintings (both inside and outside), statues and carvings. A side light brings out details in statues and also creates fewer surface 'hot spots' on painted surfaces.

INTERIORS

Sunlight creates photogenic scenes within churches and temples, so there is some justification for discussing their interiors in a book on outdoor photography. Lofty church windows set between massive stone columns create shafts of light, picked out by motes of dust in the air, which form pools of light on the floor, and the sun brings stained glass windows to life in vivid colour. Care must be taken with exposure to read mid-tones, so that bright areas appear bright on film.

Without exception, members of the clergy I have known have been affable and tolerant. If you ask before trying to photograph a church interior you may get permission to use a tripod – in small

RUINED CHURCH, NINFA, ITALY
These 14th-century ruins are part of the wonderful garden at Ninfa, south of Rome. A low viewpoint often suits buildings: if you don't have a plate camera with movements, or a shift lens to correct converging verticals, then the answer is to make them part of your compositions.
NIKON F60, 80–200MM F/2.8 AF, 1/250 SEC. AT F/8, FUJICHROME PROVIA, PHOTOGRAPH AT RIGHT: LOIS FERGUSON

◀ DUOMO FAÇADE, FLORENCE, ITALY

Churches and temples usually say much more about their builders than they do about the god they are dedicated to. The front of the Duomo in Florence dates from a period where complexity was everything.

MAMIYA 645 SUPER, 150MM F/3.5 WITH LINEAR POLARIZER, 1/25 SEC. AT F/8, FUJICHROME PROVIA 100F

churches you will seldom be refused. It helps to make a suitable donation to the church upkeep fund, so that you and others can continue to enjoy the interior.

The Catholic church has a great deal of commercial acumen, and in large European churches tripods and flash are forbidden. Tripods, it is true, can get in the way and may scratch floors when used carelessly. Flash, it is argued,

damages pictures, but these restrictions have far more to do with the commercial sales of guide books and postcards. And this is fair enough: churches are extremely expensive to keep in good repair.

If you cannot use a tripod, there are walls, pillars and seat backs, all of which can support a camera held against them. The mixture of natural and artificial light from windows and tungsten lamps produces a pleasant, warm effect. In order to photograph painted ceilings I sometimes adopt a suitably pious posture, reposing on a chair, camera plus wide-angle lens pointing upwards beside me on the timed exposure setting.

The wonderful geometric displays of wall tiles in Moorish buildings and mosaic floors in basilicas make good photographic subjects (see pages 108–9). Often a better picture can be created by moving in to take details – carefully arranging tiles or mosaic elements in the viewfinder. The soft light in a mosque courtyard sets off tiles perfectly.

◀ SHAFTS OF LIGHT, SAN MINIATO AL MONTE, FLORENCE, ITALY

Although this book is about outdoor photography, it is unlikely you would stay outside a beautiful church like this, and the essential feature of this picture – the shaft of light – does after all come from without.

MAMIYA 645 SUPER, 45MM F/2.8, 1/8 SEC. AT F/11, KODAK EKTAR 100

Castles and Forts

Castles were built to dominate. Their designers chose commanding, strategically sensitive positions and constructed them on a massive scale. It is their sheer size that has enabled these buildings to survive the ravages of the centuries and repeated sackings.

As well as providing you with a powerful focal point in the landscape, and architectural studies of towers, arches and battlements, a castle is often the perfect vantage point from which to view the surrounding country. It is usually not difficult to find windows, battlements and arches that are ready-made frames through which you can depict the scene beyond. The walls of ruins form an interesting habitat for flowers. Wallflowers sometimes still grow at windows where they were once planted to counter the smell of the middens below. Birds of prey such as kestrels and peregrines may choose high walls as nesting sites with good vantage points.

CORRECT PERSPECTIVE

Castles are usually on open ground, so you can stand far enough back to avoid perspective distortion. But in castle courtyards, as with many churches, the walls of nearby buildings may be so close that you are forced to use a wide-angle lens to capture a scene. The resulting converging verticals may not be a problem, as the distortion can give a sense of sheer size. But if you don't want them, you have to use some form of lens or camera movements.

In 35mm, the simplest solution is a shift lens. This provides a larger image circle than normal, so that there is space for one of the elements in the lens to move up. As a result, the image moves down, changing the angles made by the verticals. Most camera manufacturers

include a shift lens in their systems (see Appendix). If architectural work is your particular interest, it may be worth investing in a tilt and shift lens in 35mm.

In larger formats, a bellows with movements can extend the capabilities of a roll-film camera, but for occasional use a shift lens works extremely well. If you create digital files, it is easily possible to change the geometry of a picture to correct for converging verticals – after all, the problem only arises because we try to capture images of three-dimensional objects on two-dimensional film.

LIGHT EFFECTS

A castle or fort can be made to look more dramatic by using light to your advantage. Early mornings or late evenings can bring warmth to otherwise cold, grey stones, and colourful skies offset the inevitable monochrome of the stone building. In the evening, a building with complicated castellations, crenellations and turrets makes an attractive silhouette. The sight of castle walls and towers looming from a grey mist creates a sense of foreboding, whereas a castle 'growing' out of a ground mist on a fine morning has a completely different feel.

▼ **KANTARA CASTLE, NORTHERN CYPRUS**
Few castles can match the position of the three crusader castles on the Kyrenia Range. Kantara is my favourite because of the distant views it offers, both west across the mountains and far out along the Karpas Peninsula. There is a tremendous feeling of being on top of the world, especially when peregrine falcons scream and plummet around you.
Mamiya 7 II, 80mm f/2.8, 1/125 sec. at f/11, Fujichrome Provia 100F

Columns and Colonnades

We associate columns most readily with the classical architecture of the ancient Greeks and Romans, though it was the Egyptians who first used massive columns in their temples and palaces. Classical sites offer numerous opportunities for the creative photographer, especially in spring, when a brief profusion of flowers seems to bring life into the dry stones. At this time of year, and in the autumn, the light has a noticeable clarity, and when the blue sky is broken with a few clouds, conditions are ideal for photography.

The different orders of Greek columns can be distinguished from the ornamentation on their capitals: Doric are the earliest and simplest, Ionic have characteristic curled tops and Corinthian are ornamented with curves and acanthus leaves. The Romans took such decoration a stage further, and in Byzantine, Moorish and Renaissance designs the patterns and carvings are extremely complex, both on the capitals and the columns themselves.

PERSPECTIVE AND FRAMING

Groups of columns forming a colonnade make very attractive subjects, taken from a position to the side of the colonnade. You can choose a lens to give the perspective you want – a moderate telephoto will condense the perspective of the row. A shift lens or camera with movements helps to avoid converging verticals, but this effect can be used to advantage – wide angles will make columns soar above you and exaggerate their immensity. When there are fallen columns on a site, a section can be used in the foreground to lead the eye into the picture.

Many classical sites are shrouded with scaffolding, so it will take some ingenuity on your part to find an angle of view which excludes modern metalwork. The

◀ **TEMPLE OF NEPTUNE, PAESTUM, ITALY**
Every time I have visited this temple its columns have been clad in scaffolding – a common problem with ancient ruins. The slightest movement to the right in this frame would have revealed structural supports.
NIKON F100, 28–80MM F/2.8 AF WITH CIRCULAR POLARIZER, 1/125 SEC. AT F/8, FUJICHROME VELVIA

▼ **GYMNASIUM, SALAMIS, NORTHERN CYPRUS**
In spring Salamis is overgrown with giant fennel plants: this might not be to everyone's taste but it does bring colour to the scene. This is a site for wandering – there are no restrictions on photographers and visitors are few.
MAMIYA 7 II, 43MM F/4.5, 1/125 SEC. AT F/16, FUJICHROME PROVIA 100F

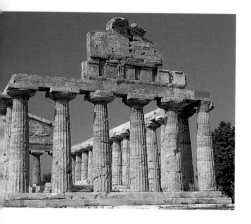

◄ TEMPLE OF CERES, PAESTUM, ITALY

The temples at Paestum are aligned from east to west which means that the front (shown here) is illuminated in the morning, whilst the rear gets its light later in the day. This sort of information is hard to glean from maps – but you can sometimes deduce it from guidebooks and postcards.

MAMIYA 645 SUPER, 80MM F/2.8 WITH LINEAR POLARIZER, 1/125 SEC. AT F/8, FUJICHROME PROVIA 100F

▼ VILLA ADRIANA, TIVOLI, ITALY

Other visitors are the problem with popular archaeological sites such as Hadrian's villa near Rome. The only option is to wait until the viewfinder is people free, and on a day when small clouds race to obscure the sun, that the light is right.

MAMIYA 645 SUPER, 80MM F/2.8 WITH LINEAR POLARIZER, 1/125 SEC. AT F/8, FUJICHROME PROVIA 100F

answer might be to crop later, choosing a narrow format that emphasizes a column's length and excludes the periphery.

I often make a couple of visits to a site. The first, on arrival, is to get a feel for what is there and mentally to log the angles and vistas that might be incorporated in photographs. On second and subsequent visits I go armed with a list of the pictures I wish to take. In conditions with flat lighting, I work on detail and finding interesting shapes. Late afternoon light, which makes the stones glow and also brings out the relief, is ideal when photographing ancient sites.

The Golden Mean and the rule of thirds

The ancient Greeks recognized the principle of the 'Golden Mean' as a way of calculating proportions that the human eye found pleasing, and used it in their buildings. In photography, the same approach produces the 'rule of thirds'. If you divide the picture area vertically and horizontally into thirds, at or near any of the points where the lines intersect is a good place to create a point of interest. If you place the centre of a flower here, for example, it leads the eye into the frame. Rules of composition are not a set of commandments to be used slavishly, but provide good starting points for arranging objects in the frame or placing horizons (see page 60).

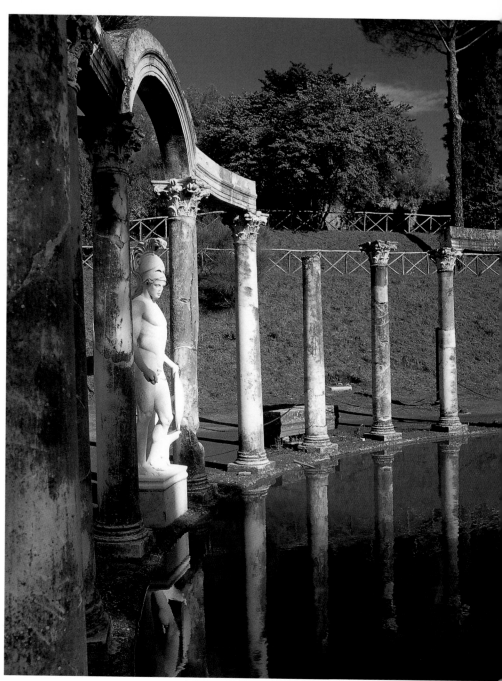

Arches

The structural use of the arch is probably as old as humankind itself – dating back to the first branch bent over to form a shelter. There are plenty of examples in nature, too, wherever water has eroded rocks to form caves, or wind and waves have hollowed out a natural arch which will eventually crumble into the sea. Countless generations have appreciated the way that weight is distributed along an arch and how the stones are, in effect, pushed together by the construction. They have also seen that there is something intrinsically beautiful about arches and groups of arches.

For the photographer, arches just in themselves make interesting photographic subjects, but they can also become frames through which small corners of the world can be revealed. The shape – whether it is part of a circle or an ellipse, or is modified at the top and sides in some way – can convey a sense of period and place, since distinct forms and decorative styles have emerged throughout history.

LOGGIAS AND COURTYARDS

Countless architects have used series of arches to create loggias and courtyards – providing shelter or shade while leaving an interior open to the air. Your camera position can make a great deal of difference to the impact made by the final photograph. A series of arches can be photographed face on from some distance away and provide a perfectly acceptable shot. But by moving to the side and then photographing along the row of columns a more interesting effect is produced.

A medium to telephoto zoom can control the degree to which the arches will become condensed in your photograph – the longer the focal length the more they appear pulled together. When choosing where to focus it is useful to remember that you have about one-third of the available depth of field in front of the plane of focus and two-thirds behind. By looking through the viewfinder and using the stopped-down preview, you can achieve a row of arches in sharp focus from beginning to end.

SHADOW AND SILHOUETTE

Arches set around courtyards create strong patterns of light and shadow, particularly later in the afternoon. The shadows may reflect or distort the shapes of the arches, according to the angle of the light. By standing within or behind the arches you can take views of the courtyard, groups of

▲ **CHURCH OF ST BARNABAS, NORTHERN CYPRUS**
Though this church is now an icon museum following the Turkish invasion and partition of the island in 1974, it is the cool arched cloisters that provide the photographic opportunities. The arches have pointed tops – a style dating from Byzantine times – and create interesting frames depending on where you happen to be standing. MAMIYA 7 II, 43MM F/4.5, 1/125 SEC. AT F/11, FUJICHROME PROVIA 100F

people and the world beyond inside a ready-made frame.

When the light level within the arch is much lower than that outside, the arch becomes a silhouette at the edge of the frame. You can experiment with how much of that dark frame encroaches into a picture or where the arch will be positioned in the viewfinder. Depending on the time of day, the light might illuminate part of the interior of the arch, creating a different kind of frame with some visible detail around the edge. For centuries, painters have used the device of a figure placed in an archway, looking out on to a landscape or as a silhouette, to create a sense of wistfulness or even mystery. Some very effective outdoor portraits or groups can be created in this way using an arch as a frame or a prop.

▲ TOWER OF BELEM, LISBON, PORTUGAL

The ornate arches of the Belem Tower make an ideal frame for seascapes but there is little room to move back on the balcony. A wide-angle lens – 24mm or wider – lets you include part of the inside of the arches, though a bright day and at the wrong time those interior surfaces might prove too dark. Sometimes it takes repeated visits to get what you want.

NIKON F60, SIGMA 28MM F/2.8 AF WITH CIRCULAR POLARIZER, 1/30 SEC. AT F/11, FUJICHROME VELVIA, PHOTOGRAPHER: LOIS FERGUSON

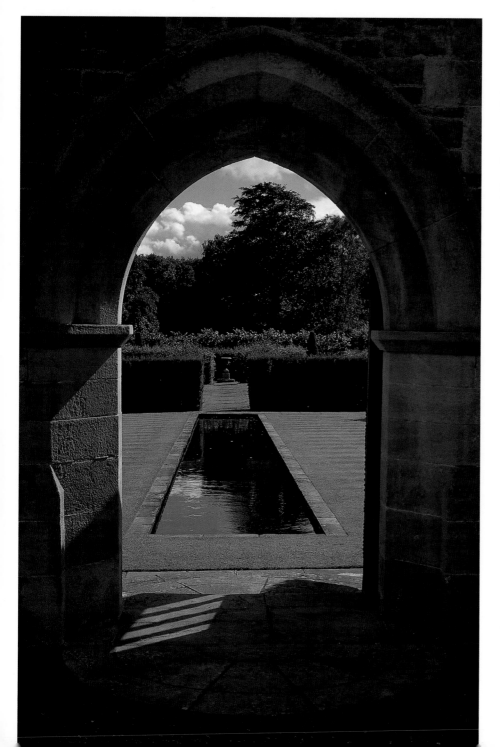

◀ PREEN MANOR GARDENS, MUCH WENLOCK, SHROPSHIRE, ENGLAND

There is a great contrast between the brightness of the scene beyond the arch and that within it – by exposing for the scene beyond, much of the frame appears dark, though some highlights remain to give it structure.

MAMIYA 7 II, 80MM, F/2.8, 1/125 SEC. AT F/11, FUJICHROME PROVIA 100F

Bridges and Viaducts

Bridges come in all shapes and sizes, from tiny footbridges, little more than a log across a stream, through single spans and multiple arches to those magnificent suspension bridges where the imagination of engineers and architects has been given full rein.

Sweeping bridges are ideal for leading the eye into a picture – a wide-angle lens enables the bridge to be captured in the foreground at one side of the frame while giving plenty of depth of field for the rest of the landscape.

The space below any bridge, whatever its shape, can provide you with an ideal frame to view the world beyond. Coupled with its reflection in the water below, a bridge makes a striking double image.

SUSPENSION BRIDGES

When a chain or steel hawser hangs under its own weight it forms a curve, that is called a 'catenary'. These curves have very pleasing shapes and they form part of any suspension bridge, since the road or rail deck is suspended from the catenary.

A camera capable of giving a wide landscape format is ideal for photographing a whole suspension bridge. Given the expanse, the result will be better if you can capture interesting cloud conditions, too. Many bridges are painted in light colours so that they look good frontlit against a stormy sky. Alternatively, the shape of the bridge gives a pleasing silhouette against a dawn or evening sky. The vantage point

▲ **COASTAL BRIDGE, BISCOITOS, TERCEIRA, AZORES**
It is asking a lot of any film to cope with a white wooden bridge set against black volcanic rocks. The result shows the sophistication of modern metering systems that evaluate different segments of the viewfinder in order to achieve a compromise.
Nikon F4, 24mm f/2.8 AF with circular polarizer, 1/30 sec. at f/11, Fujichrome Velvia

◀ **BALLYDEHOB VIADUCT, WEST CORK, IRELAND**
This viaduct spanning an estuary once carried an old tramroad. I took the picture as much for the reflections as for the series of arches.
Mamiya 645 Super, 45mm f/2.8, 1/125 sec. at f/16, Fujichrome Provia 100F

and lens used make a huge difference to the way the bridge will appear. A long telephoto at one end of a suspension bridge condenses the perspective of the catenary and far pillar. A wide-angle lens below one of the support pillars will convey a sense of how massive the structure is – the strongly converging verticals will ensure this.

RAILWAY BRIDGES

Long railway bridges are often constructed using cantilevers – each section is supported by a pillar at one end and the other end is free. The free ends are joined to one another by girders. Many bridges from the great age of steam railways incorporate ornate ironwork. Recently, many of these have been painted with pastel colours which enhance the design and produce highly photogenic structures.

American railroads, in particular, made great use of timber trestles to span large distances. The same principles were later used with steel girders and both timber and metal versions can still be seen in use on preserved lines.

VIADUCTS

Arches in bridges tend to be parts of a circle or an ellipse. Roman engineers built aqueducts in Provence with multiple arches, stacked and staggered above one another. In industrial areas of Britain, Victorian engineers thought nothing of spanning whole valleys with high viaducts – arches 50m (165ft) or more high that from below seem far too thin to convey heavy coal trains. In France, Italy and Switzerland, sweeping curved viaducts were built to carry railway lines from one tunnel to the next.

▼ **PONT DU GARD, PROVENCE, FRANCE**
After several hazy days we were due to leave, so a picture had to be taken. Towards evening, things improved – the low light with a high yellow content bringing out relief on the stones as well as intensifying colour. A polarizer will accentuate any blue in the sky as long as it is away from the sun.
NIKON F4, 80–200MM F/2.8 AF WITH CIRCULAR POLARIZER, 1/125 SEC. AT F/8, FUJICHROME VELVIA

Modern Architecture

There are huge differences in public opinion about modern architecture. Whether you think it is pushing back boundaries or just an ego trip for today's architects, modern buildings provide some startling images to be captured on film.

Colour, pattern and texture are all important elements in a picture and these are abundant in modern buildings that mix glass, metal, concrete and other materials. A mixture of ancient and modern architecture in a city offers tremendous scope for photographic essays and documentary work. The variety of stairways, atriums, walkways and towers becomes unlimited when you start looking at all the possibilities.

Complex curves in roofs – from domes to hyperbolic surfaces – can pose a challenge in trying to find a viewpoint to explore the shape. Pressure on space in a city and the costs of land make it difficult to stand back and take a look. The results you get with a telephoto lens used some distance away will flatten perspective, and when you use a wide-angle lens, perspective distortion giving converging verticals becomes a problem. However, the strength of the images can turn this distortion into a virtue. If you want to eliminate converging verticals, the easiest way is to use a shift lens (see page 114).

Lighting is as important in modern architecture as anywhere – whether you intend to capture the whole building or concentrate on a part. The time of day is crucial, not just because it affects the light quality but also because nearby buildings may cast shadows on your subject.

Modern architecture can look particularly good at twilight and in afterlight, when reflective glass and metal surfaces make the most of the available natural light and the artificial lights around the building (see page 48).

REFLECTIONS

Many modern city blocks use mirrored glass, which can produce a kaleidoscope of images as it reflects the nearby buildings, street scenes and the sky. The viewpoint you select will make a huge difference to what you see reflected.

From a distance, you might see a recognizable image in the camera viewfinder, with both building and reflections in focus, but by moving in and cropping tightly you create an abstract series of shapes and colours. Focusing needs care – the reflection, as with any plane mirror, appears behind the surface, so you need a small aperture to give sufficient depth of field to capture it and the building sharply. Alternatively, it is worth experimenting with either the building or the reflection out of focus.

The sun itself just creates dazzle when reflected – except at sunset – but a blue sky with light clouds looks particularly good in reflection. With mirrored buildings it's useful to work out when interesting buildings nearby will be lit by the sun (architects and designers will have taken this into account). A polarizing filter is essential because the light reflected from a non-metallic surface is partly plane-polarized – by rotating the filter you can adjust the balance between the reflected image and the building.

▲ **BARCLAYS BANK, CITY OF LONDON, ENGLAND**
Photographers used to worry a great deal about 'converging verticals' but with today's buildings soaring high above city streets, perspective distortion can be a positive factor in composition. Converging verticals convey a sense of the buildings towering over the viewer – exactly as they do in reality.
Mamiya 7 II, 43mm f/4.5, 1/125 sec. at f/16, Fujichrome Provia 100F

▶ **THE LONDON EYE, LONDON, ENGLAND**
When an object has been photographed as often as the London Eye which was built for the millennium celebrations, it is hard – impossible even – to do something new, but you can experiment. This picture was one of a series that explored parts of the structure using an ultra-wide angle lens to create a dramatic perspective. There is no polarizer – the lens design brings the rear element close to the film in a rangefinder camera with excellent contrast handling as a result.
Mamiya 7 11, 43mm f/4.5, 1/125 sec. f/16, Fujichrome Provia 100F

Industry

Many authors have written of landscapes 'blighted' by industry. In the pursuit of wealth, little thought was given to aesthetics, or to the impact on the lives of those who lived and worked nearby. Ironically, those industrial 'eyesores' can become powerful, dramatic elements in a landscape, and also provide a host of more abstract images of pipes, columns and chimneys.

To facilitate bulk transport of ore, oil and metals, many heavy industries are sited near the sea, on flat ground that sets them against the sky. Oil refineries, in particular, have complex chimneys, tanks and pipework; steelworks have blast furnaces, cranes and gantries, all of which look marvellous in silhouette. At twilight and in the afterlight, they are lit with a host of lamps that delineate the shapes of their structures and walkways. In the early evening, both natural and artificial light have the same intensity (see page 48). The smoke emitted from stacks of all sorts looks dark against the light and can impart a sense of mood to pictures.

GAINING ACCESS

You will need permission to work within any industrial complex – some industries, sensitive to adverse publicity and criticism on environmental grounds, are reluctant to allow access to any photographer they have not commissioned. But smaller industries – such as potteries, boatyards, winemakers and brewers – can often be more obliging. Many of them offer a host of opportunities for 'detail' shots, with surprising patches of bright colours or highly polished pipework in otherwise drab surroundings.

CHOICE OF LENSES

Oil refineries have extremely complex pipework and latticed walkways. With these an ultra-wide lens, such as 20mm in 35mm format, will create dramatic perspective distortion when used to shoot towers, and will accentuate foreground subjects such as wheels and gearing.

Power stations often have hyperbolic cooling towers (the name derives from the curvature of their sides). These can be made

▶ COOLING TOWERS, DIDCOT, ENGLAND

For a staunch conservationist to admire the shapes and patterns of industry might seem a bit of a contradiction, but then I grew up in an area where industry and wild landscapes were found close together.

MAMIYA 7 II, 80MM F/2.8, 1/125 SEC. AT F/8, FUJICHROME PROVIA 100F

▼ DIDCOT POWER STATION, ENGLAND

Industrial complexes often produce waste rich in fine dust particles. Unacceptable though this is in terms of pollution, those fine particles scatter light and create superb sunsets. At the same time the power station makes an interesting silhouette across the skyline.

MAMIYA 7 II, 43MM F/4.5 WITH 35MM LANDSCAPE ADAPTOR, 1/60 SEC. AT F/11, FUJICHROME PROVIA 100F

Forms of Transport

Forms of transport sometimes play an important part in pictures that try to tell a story about people and places. Trains, planes and boats are obvious subjects, but there are many other means of transport, from dog sleds in Arctic wastes, to rickshaws on a Beijing street or Mediterranean farmers riding donkeys – and leaving their wives to walk. All the different forms are highly photogenic, none more so than steam trains. It is an irony, given the pollution they caused, that so many conservationists (and I am one of them) love old trains.

STEAM ENGINES

To depict a steam train as an element in the landscape you need to do some research to find a good line-side vantage point. The chances are that you will be visiting a 'preserved' steam railway, unless you are in China or Cuba where steam locomotives are still in service.

The harder a locomotive has to work the more smoke it produces, so setting up near an incline is good practice since the engine will also be going more slowly. Locomotives in more unusual situations, such as crossing bridges or trestles, create

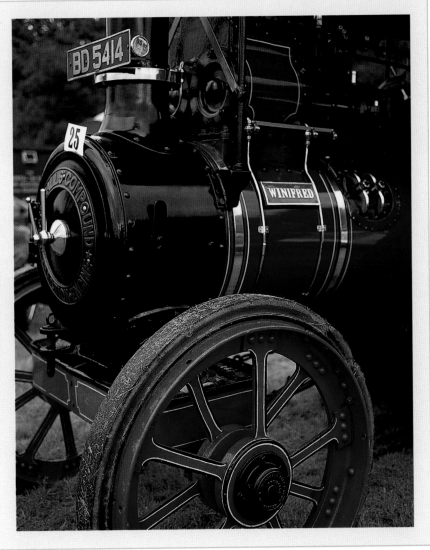

TRACTION ENGINE, KNOWLE HILL STEAM FAIR, READING, ENGLAND

The combination of polished brass and steam-driven engines can prove irresistible. The engines themselves, and also details such as handles, wheels, boilers and levers, always make interesting compositions.

MAMIYA 7 II, 80MM F/2.8, 1/60 SEC. AT F/8, FUJICHROME PROVIA 100F

to soar above you using a wide-angle lens, and forests of chimneys and pylons can be treated in the same way against a blue sky or set in silhouette at sunset. Telephoto lenses come into their own to isolate details or – when used at a distance – to compress perspective and perhaps superimpose foreground objects like figures and houses against industrial background elements.

THE CHANGING LANDSCAPE

The industrial landscape changes rapidly, and industrial archaeology offers a wealth of interesting possibilities. I grew up in an area where conical spoil heaps from coal mines dotted the hills and the valley bottoms contained numerous sets of giant wheels – pithead gear marking the tops of coal-mine shafts. All have now gone in a couple of decades. But old mine workings and buildings, waterwheels and mills are being restored and preserved as people realize they are an important part of a country's heritage.

The demands of industry and domestic users have created another legacy in the landscape: electric pylons. They can scar a natural scene, but parts of their lattice framework isolated against the sky, or a view from immediately below, can create dramatic pictures. Wind farms have also begun to proliferate in many countries – a medium telephoto condenses perspective along a ridge and creates interesting effects by compressing an array of these structures together.

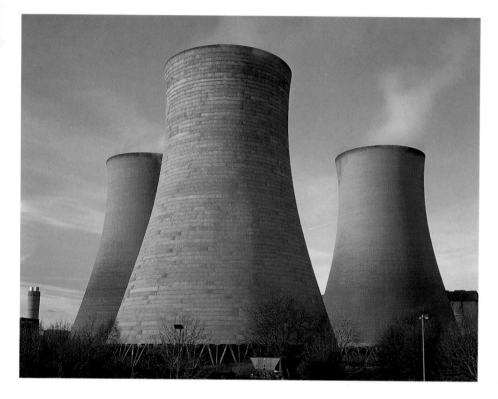

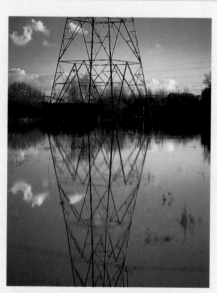
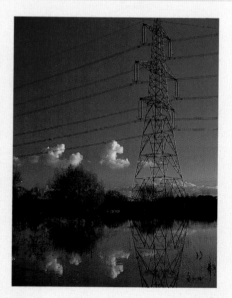

From left to right: These three pictures were taken at a time of extensive flooding, when a lake appeared beneath this pylon. In late afternoon it was silhouetted against the sky and a polarizer was used to control the amount of reflection. The first two frames (with 150mm lens) show a different ratio of pylon to reflection; the third shows the whole pylon after a change to a wide-angle lens (45mm).

them to lead the eye into a scene. And don't forget portraits of other enthusiasts, drunk on the nostalgia that the smell of engine smoke seems to induce.

Railways have left behind a vast legacy of interesting and photogenic items, such as ornate old station buildings, yards with water towers and tanks, and maybe an old coaling stage. Many of these have disappeared from the landscape at large but some have been lovingly restored by groups of enthusiasts. Many preserved lines run special photographers' days – some even have an 'evening steaming', when you can capture night-time shots from a bygone era.

Traction engines evoke the same passion as steam trains. Enthusiasts hold annual fairs where beautifully restored museum pieces are on display, and they can also be seen at work ploughing, sawing, driving fairground rides and in other occupations – a mirror of their past usefulness.

A tripod is always useful, particularly if you want to take photographs in the evening, but you can capture a great variety of scenes with a couple of zoom lenses (24–80mm and 80–210mm) or a single lens that embraces the range.

AIRCRAFT

If you want to photograph aircraft, air shows allow you to get close to the machines and capture details or full views. With aircraft in flight you inevitably have to pan with the subject (see page 94) and use a moderate telephoto zoom lens.

Shooting against the sky has its own problems because the film may not be able to handle the contrast range between subject and background. Take the reading from the aircraft to get correct exposure. If it is highly reflective, open up a stop or so in order to avoid underexposure (see page 36).

▲ **AUSTIN SEVEN, KNOWLE HILL STEAM FAIR, READING, ENGLAND**
With a featureless white sky I moved in close to cut out as much background as possible.
MAMIYA 7 II, 80MM F/2.8, 1/30 SEC. AT F/8, FUJICHROME PROVIA 100F

greater interest in a picture. A whole locomotive can be photographed without perspective distortion using a moderate telephoto lens, standing slightly to one side to capture the smoke box at the front. Wide-angle lenses produce distortions that if used carefully can produce dramatic effects, making a locomotive seem even more massive than it is, for instance, by taking a low-angle shot.

Interesting details abound, such as pipework, wheels, coupling rods and a host of brasswork. You can make these the main subjects of photographs or use

Farms and Farming

Over the millennia, farming practices have shaped much of the world's landscape. The diversity of many apparently natural habitats is entirely due to human intervention.

THE LARGE FARM

It may be depressing to photograph vast areas of unrelenting monoculture created by modern industrial farming practices, but good photographs with impact can convey the impression of a sterile environment. Large farms have machinery on a scale to match the size of their fields, and like other industrial equipment this can provide dramatic images.

Environmental photographers often make use of a wide-angle lens and low viewpoint so as to photograph combine harvesters (with permission and also by arrangement) to get a sense of their immense size. Other activities, such as ploughing, seed planting and tilling, can be shown in the same way, setting the practice in the context of the landscape.

THE SMALL FARM

Traditional farming practices can still be found on small farms, echoing a rural idyll of a former age, even if the reality is a struggle for survival. People never seem to tire of bucolic scenes that evoke idealized bygone days of sunny summers, featuring haymaking or cows in a meadow, with a distant church and green hills in the background. As you look you can almost hear the church bells carried on the breeze.

Wherever they are, smallholdings offer rustic vignettes, with chickens, geese and ducks housed in makeshift coops and children playing in the yard, oblivious of you as you take pictures. Some farm

▲ **GOAT, AGROS, CYPRUS**
When you are visiting smallholdings and farms, the residents often find you an object of curiosity – I feel the goat's central dilemma is, can it eat the camera?
NIKON F801, 28–80MM F/2.8 AF, 1/30 SEC AT F/11, FUJICHROME PROVIA

◀ **NEAR COLLE DE VAL D'ELSA, TUSCANY, ITALY**
Vast areas of the Tuscan landscape are put to the plough each year. A low angle of view lets you use the broken lumps of soil in the foreground – a useful device for leading the eye into the frame – and late in the day the longer shadows create a greater sense of modelling.
MAMIYA 645 SUPER, 45MM F/2.8 WITH LINEAR POLARIZER, 1/60 SEC. AT F/8, FUJICHROME PROVIA 100F,
PHOTOGRAHER: LOIS FERGUSON

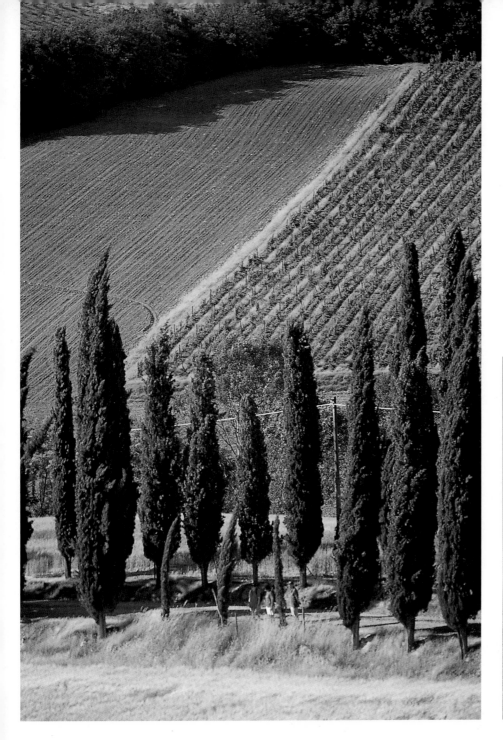

◄ **CYPRESS TREES AND VINES NEAR SAN GIMIGNIANO, ITALY**
Many photographers are drawn to the Tuscan countryside, a landscape shaped by varied agriculture where it is possible to capture ploughed fields, vines and the characteristic Cypress trees all in the same frame.
NIKON F4, 80–200MM F/2.8 AF WITH CIRCULAR POLARIZER, 1/125 SEC. AT F/8, FUJICHROME VELVIA

▲ **WINDMILL, FAIAL, AZORES**
This windmill is disused but with a working mill a slight blurring of the sails (with the body sharp) using a shutter speed of 1/15 sec. or more helps to give a sense of movement.
NIKON F4, 80–200MM F/2.8 AF WITH CIRCULAR POLARIZER, 1/125 SEC. AT F/8, FUJICHROME VELVIA

animals will approach inquisitively if you stop to photograph them. I know to my cost that young bulls can be a bit too enthusiastic. It helps to have a companion who can hold some hay or sugar lumps, while you concentrate on getting images.

FIELDS AND MEADOWS

Haymaking on any scale is a photogenic activity. Traditionally, the hay was cut with scythes, and this practice still survives in many parts of the world. Bales of hay will be left dotted about the fields, and with low-angled light they become interesting elements in a landscape.

Crops planted in regular rows make an interesting geometric contrast with the more random elements in the landscape. In areas where cultivation follows traditional practices, there will be displays of poppies and cornflowers in the cornfields, bringing splashes of brilliant colour to a landscape. Hay meadows in mountain areas, cut after flowers have set seed, are a haven for numerous species of flowers and insects, especially butterflies.

CHAPTER 6
THE NATURAL WORLD

Most people begin to photograph nature because of a love of living things. There is so much diversity that to do it justice you need to acquire the skills of portraiture, landscape and close-up photography. The natural world is an endless source of inspiration and enjoyment.

The more you learn about your subjects and their behaviour the more insight you gain, learning to anticipate animal behaviour, and this gives a real edge to your photographs. In this field, care for your subject should always come first. However tempting it is to make a good photograph, you should never remove surrounding vegetation to expose a rare plant to unscrupulous collectors, or reveal the whereabouts of nesting birds.

Great good can be done by presenting images that convey the beauty of the natural world. Being close to nature – watching a butterfly emerge, a bird tirelessly feeding its young, or bees on a flower – revives a childlike sense of wonder in all of us.

▶ **TREE FROG (*HYLA ARBOREA*)**
You will hear tree frogs easily, because they make extremely loud sounds for such small creatures. In trees they are difficult to spot, but at breeding time they come to water and then are easier to photograph.
NIKON F4, 105MM F/2.8 AF MACRO, MACROFLASH, 1/60 SEC. AT F/16, FUJICHROME VELVIA

Mammals

Organized safaris are often the way in which most of us get the opportunity to photograph large animals in the wild, though a general excursion with a lot of vehicles may not be what you want. In some countries, such as South Africa, there are good firms closely linked with conservation organizations who work with small groups and have a fund of knowledge of animal behaviour. Large mammals get used to vehicles and tend to ignore them – until people venture out of them. But the back of a truck or four-wheel-drive vehicle is an ideal viewing platform, and you can easily set up a tripod or use a bean bag for support, resting it on a rail or the truck side or back.

Game lodges that have their own water-holes are a special delight, for here you can just sit quietly and photograph at dawn or dusk, when the light has an extraordinary quality, or visit at night.

LONG LENSES

Getting close to wildlife owes more to thought and technique than owning a long telephoto lens, and even with a 500mm lens, smaller animals can still look remote in the viewfinder. A 500mm lens at 50m (165ft) produces the same sized image as a 50mm lens at 10m (33ft). If mammal or bird photography becomes your passion, a 500mm or 600mm lens would be ideal, but to be useful these must have a wide maximum aperture to allow you to use fast shutter speeds to freeze subject movements and eliminate blur due to vibration.

A 300mm f/4 lens can be useful – many are apochromatic and have good close focus – and a x 1.4 converter turns it into a 420mm f/5.6 objective. This is not perfect but a good compromise in bright conditions. With longer lenses

some support is essential, and balance is better if the lens has a built-in tripod mounting ring (see pages 16–17).

ANIMALS IN CAPTIVITY

There is nothing wrong with photographing well cared-for animals in a zoo or on a ranch where they are kept 'semi-wild'. This is a great way of getting close and obtaining portraits of animals in prime condition. A good photograph is a good

▲ **GIRAFFE**

Many people photograph large animals in wildlife parks or zoos long before they get the chance to do so on safari. To avoid intrusive surroundings, try using a telephoto and a wide aperture to produce a portrait with shallow depth of field. Here the trees were definitely not African but when they are reduced to a soft blur that is not obvious.

Nikon F4, Sigma 300mm f/4 AF apo macro, 1/250 sec. at f/5.6, Fujichrome Provia

photograph, so there is no need to pretend such a picture was taken in the wild. Any such deception devalues the work of the few dedicated individuals who spend months planning and following creatures like snow leopards, taking great pains to get photographs. The superb wildlife photography we see on film and in books makes it tempting to imagine it is easy: it is not. The same goes for picture manipulation. There is nothing inherently wrong in changing images in order to create a picture, but we must preserve integrity and not hide the fact that it has been done.

▶ GREY SQUIRREL

When grey squirrels set up home in my garage roof I thought it would be easy to get pictures at leisure, but I had to lay bait for them and set up in advance – here the camera was inside the house pointing through a window.

NIKON F4, SIGMA 300MM F/4 AF APO MACRO, 1/250 SEC. AT F/5.6, FUJICHROME PROVIA

◀ COYPU, TUSCANY, ITALY

The quarry in a small Italian lake was pond tortoises, not coypu. I had half noticed burrows in the soft, sandy soil but had not guessed at their occupants. Towards evening, we hid and watched as family members came out, swam a bit and then walked off. The problem was shade – a lot of it by that time – so as soon as an individual showed any sign of moving into the sun its picture was taken.

NIKON F4, 80–200MM F/2.8 AF, 1/125 SEC. AT F/5.6, FUJICHROME VELVIA

To freeze the motion of birds in flight requires fast shutter speeds, though in order to suggest movement in a photograph you might prefer to compromise a little and use a speed that freezes body movement but leaves the wing tips slightly blurred.

Fast flyers such as auks, ducks and waders need a shutter speed of 1/1000 sec. For geese, herons and storks 1/500 sec. is fast enough, while swans and many birds of prey have a slower wing speed and need 1/250 sec. to freeze movement.

SUPPORTS

When you are hand-holding a lens you should never use a shutter speed that is slower than 1/focal length in millimetres: with a 500mm lens this means 1/500 sec. So unless you have an expensive large-aperture lens, or you feel happy using medium- to fast-speed films, you have to use some sort of support – although this

▲ NORTHERN GANNETS (*SULA BASSANA*), GRASSHOLM, PEMBROKESHIRE, WALES

The boatman's skills took us close enough to the island to photograph groups but not individuals. I thought that the contrast between the birds and rocks might be a problem but the matrix meter triumphed again. The rocking of the boat made it difficult to hold a lens still; fortunately, the engine was cut, since the vibration travels easily through a tripod or monopod.

NIKON F4, SIGMA 300MM F/4 AF APO MACRO, 1/500 SEC. AT F/4, FUJICHROME PROVIA

◀ FLAMINGOES, SLIMBRIDGE, ENGLAND

I had often photographed flamingos as a distant pink raft in Cyprus, but here, where they are inured to the attentions of photographers, it was a simple task to catch groups of birds in superb breeding plumage.

NIKON F100, SIGMA 180MM F/3.5 AF APO MACRO WITH CIRCULAR POLARIZER, 1/125 SEC. AT F/8, FUJICHROME VELVIA

needs to be flexible enough to allow you to follow the birds' flight.

Some bird photographers work with a shoulder support or chest pod and a follow-focus lens, panning with a moving subject. This gives a sharp subject and a blurred background, which suggests movement. A monopod may provide sufficient support (see page 26) but I prefer to rest the lens barrel on a bean bag, placed on top of a rock, car roof or car window ledge for firm support.

AUTOFOCUS

Modern AF systems let you decide on several different points of focus, so that you can position a bird off-centre in the frame to improve composition. Many systems will predict the position of a moving object and adjust focus by a tiny amount when the shutter is fired. Lens motors are now whisper-quiet and very fast. Some lenses even have stabilizing, allowing you to shoot hand-held at twice the shutter speed you would normally need for a sharp result.

FILMS

Many photographers like to use slow films to capture maximum detail. With nesting birds this is possible with the aid of flash, but with birds in flight you simply cannot get a working combination of shutter speed and aperture.

The answer is to use faster films, with speeds from ISO 100–400. On really dull days it may be necessary to uprate to ISO 800 or 1600. The results you get will show obvious grain, but this can be effective in some compositions.

BIRDS IN THE LANDSCAPE

Large groups of migrating birds congregate in wheeling flocks towards evening, and the clouds they form create attractive silhouettes. Flights of cranes, geese, swans and ducks can also become elements in a landscape picture, especially against a spectacular dawn or dusk sky. Seabirds such as gannets nest in such large colonies that they and their guano-spattered site become the principle landscape feature, covering the top of an island.

Many water birds are large enough to allow you to use a moderate telephoto or zoom lens and still get something that is recognizable in the viewfinder. In some seabird colonies you may be able to get close enough to use a wide-angle lens to fill the frame with a single gannet or albatross while including many other nesting birds in the background.

Using a hide
Building a hide takes skill. Good commercial ones are available but they need to be established over a few days and a close watch kept to make sure that birds are not agitated or away from the nest for too long. You will often need a companion, or even two, to enter the hide with you and then leave again, in order to convince the birds that they have been left in peace.

▼ **GRASSHOLM, PEMBROKESHIRE, WALES**
Often visible in the far distance as its gannets and guano-covered top catch the light, Grassholm is the most remote of the islands off the Pembrokeshire coast. Landing is not permitted, but the aerial display as you approach is unforgettable. Diesel fumes, the stench of guano and the rocking of the boat make for a stomach-churning trip.
NIKON F4, SIGMA 300MM F/4 AF APO MACRO, 1/500 SEC. AT F/4, FUJICHROME PROVIA

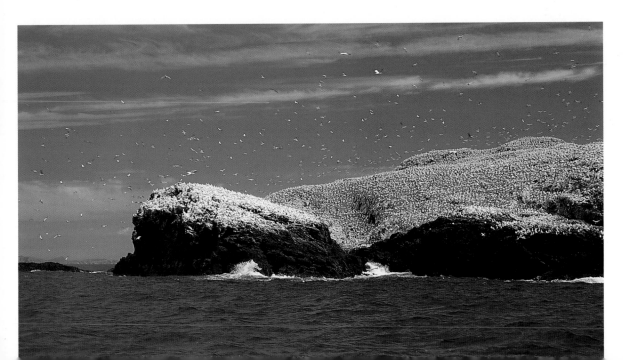

If you can encourage a variety of birds to visit your garden by putting out food and water, it is possible to take 'portrait' shots using the close-focusing facilities of a zoom lens or prime telephoto, with or without an extension tube. Modern 300mm lenses have a useful close-focus facility, thanks to a design that uses internal movement of elements rather than lens extension (see page 16).

WHAT TO INCLUDE

Some photographers like to fill the frame with the whole bird, while others prefer to include some of the surroundings to give a sense of place. Moving in even closer to produce head and shoulder portraits can also be useful as part of a series or in order to show some point for identification, such as use of the beak.

The addition of a single extension tube can turn a 300mm lens into a close-focusing portrait lens capable of frame-filling shots of birds' heads at a distance of a few metres, showing details such as plumage patterns or beaks. The lens is focused either on a bird table moved within range or on various perches 'baited' with suitable food. On dull days I use a Nikon SB25 flash on an extension lead so as to provide a main light and a catchlight in the bird's eye. An old Metz CT1 gun is triggered by a slave to illuminate the greenery in the background.

TRAP FOCUS AND TRIGGERS

Some cameras have a trap focus facility which allows them to make an exposure

▼ **NEST OF CIRL BUNTING (*EMBERIZA CIRLUS*) WITH EGGS, UMBRIA, ITALY**
No photographer should do anything to cause a bird to desert its nest, but we found a female bird dead, a short distance from this nest where we had noticed activity a few days earlier. The eggs were freezing cold.
Nikon F4, 105mm f/2.8 AF macro, SB 21B macroflash, 1/60 sec. at f/16, Fujichrome Velvia

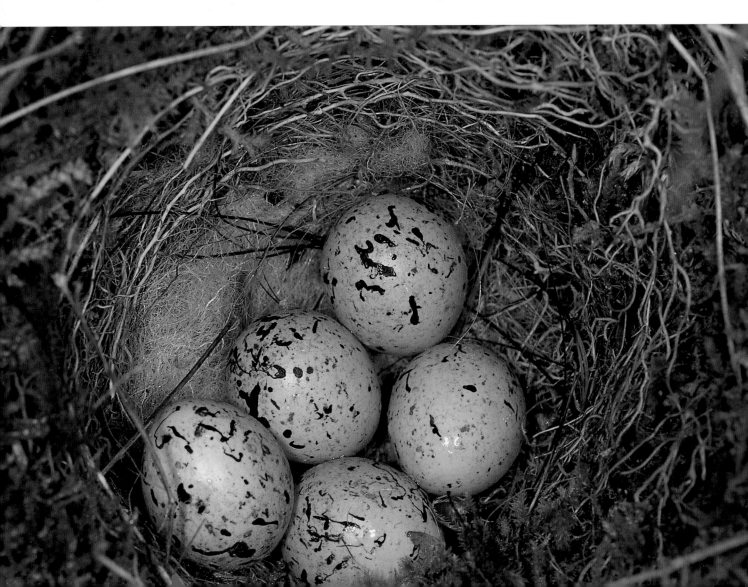

(with or without flash) when the quarry comes into a predetermined position set by pre-focusing the lens. In principle, this should provide marvellous pictures, but small creatures move quickly and inherent delay in the system means you get a lot of pictures of insect tails and wing tips.

A better bet for triggered photography is to use commercially available infrared units with a fast response time. They employ crossed beams and the flash is triggered by an AND gate only when the subject breaks both beams simultaneously. The same principle can be extended to capturing insects in flight, where true macro photography is exceedingly difficult because of the restricted field of view. Anyone interested in this area should read the work of the wildlife photographer Stephen Dalton. Some flash guns permit a manual mode where you can obtain a fractional power output, giving a burst of around 1/20,000 sec. rather than the usual 1/1000 sec. flash duration. The intensity is not great enough for small apertures, but it is fine for experimentation.

THE LEGAL SIDE

In many countries you need a permit to take photographs near a nest. If birds sense a threat they will desert nest, eggs and young, so even where no permit is needed you should use the utmost care

and consideration, which may mean just walking away. In some countries, building a hide is an invitation to hunters to come and shoot – the last thing you want.

BIRDS IN CAPTIVITY

Many aviaries, and bird sanctuaries that rescue injured birds and return them to the wild, raise funds by allowing photographers special access on open days or by private arrangement. This is a great way to obtain portraits of subjects such as owls or birds of prey, which are impossible to obtain in the wild without great luck.

▲ **EMPEROR PENGUIN (*APTENODYTES FORSTERI*) IN CAPTIVITY, ENGLAND**
Of course, I would rather show a scene with thousands of penguins on an ice floe but have yet to see the spectacle.
NIKON F4, 80–200MM F/2.8 AF, 1/60 SEC. AT F/8, FUJICHROME PROVIA

◀ **PUFFINS, SKOMER ISLAND, PEMBROKESHIRE, WALES**
I never tire of watching puffins and on Skomer, a national nature reserve, paths run close to the colonies – the birds land quite unperturbed and waddle to their nests. Puffins give you time to think and compose, which many birds do not: the photographer had never tried her hand at bird photography before.
NIKON F60, SIGMA 300MM F/4 AF APO MACRO, 1/250 SEC. AT F/5.6, FUJICHROME PROVIA, **PHOTOGRAPH:** LOIS FERGUSON

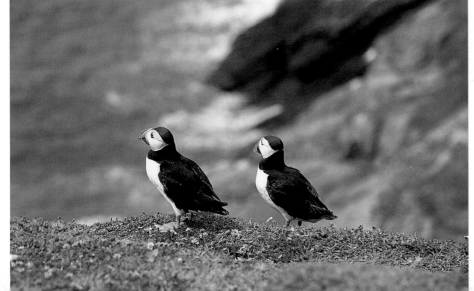

Cold-blooded creatures, such as lizards and snakes, like to bask in the sun. No matter how slowly you approach them, as soon as you get a millimetre within their circle of fear they move rapidly for cover. Towards the end of the day when the sun is low they are more reluctant to move, and this is a good time to photograph them.

A 300mm telephoto lens with a close-focus facility, or a long-range macro lens (180–200mm), is ideal as it gives a reasonably large image with sufficient distance between you and the subject. If you are planning to photograph venomous snakes you need expert knowledge and advice, as much distance as possible between you and the subject, and must be careful not to make any sudden movements.

RAINFOREST SUBJECTS

Frogs and toads make wonderful camera subjects. Tree frogs in particular are highly photogenic and can be posed on vegeta-tion if you are quick. Many tropical frogs are gaudily coloured as a form of warning coloration. They can be highly venomous, secreting neuro-toxins that can be absorbed by your skin. They are not aggressive but should never be handled by anyone without experience. These small frogs thrive in low light conditions, living on epiphytic plants or on the forest floor, and after rain they appear from nowhere in large numbers. You will need flash and a macro lens to photograph them.

Their skin can be surprisingly reflective, so diffusers should be used on the flash heads. Beware when using a twin flash, because it produces unnatural-looking twin highlights in the subject's eyes. You can avoid this happening by changing position slightly – or cheat later and remove one highlight with Adobe Photoshop.

VIVARIA AND AQUARIA

Many reptiles and amphibians have fascinating heads and eyes that make them ideal for portraits if you can get close

▲ SLOW-WORM (*ANGUIS FRAGILIS*) DORSET, ENGLAND
This baby slow-worm was just a few centimetres long and seemed to have a penchant for tying itself in knots.
NIKON F100, 105MM F/2.8 AF MACRO, SINGLE SB 23 FLASH MIXED WITH DAYLIGHT, 1/60 SEC. AT F/8, FUJICHROME VELVIA

▶ BABY CHINESE WATER DRAGON
This small lizard was extremely active and needed to be photographed from outside its circle of awareness. A flash gun was used because the creature was in shade.
NIKON F4, 180 F/3.5 AF MACRO, SB 24 FLASH AND SLAVE, 1/125 SEC. AT F/16, FUJICHROME PROVIA

enough. The skin texture and patterns of many species can produce interesting abstracts if you move in close to isolate patches in the viewfinder.

The easiest way to photograph small reptiles and amphibians, as well as small mammals, is to make an outdoor set – which need be no more than an aquarium tank with a removable side. Small creatures will quickly settle down after they have been transferred into it, and they can then be released as soon as possible afterwards. If you use an aquarium tank to photograph newts (or small fish) in water,

reflections from the glass front are a problem. I use a large 'lens hood' made from a plastic water collector intended for the top of a drainpipe, sprayed inside with the mattest black enamel I could find.

I either use overhead natural light, when the sunlight is diffused, or a pair of flash guns directed through the sides of the tank or from above. A hole cut in a piece of black velvet or black flock paper allows you to push the camera lens through. If this is set in front of the tank you will not get reflections that interfere with the viewfinder image.

▼ **LEOPARD GECKO (*EUBLEPHARIUS MACULARIUS*) IN CAPTIVITY**
Many lizards have a distinctive texture to their skin, though you have to move in close to capture it on film. This leopard gecko was kept as a pet and photographed in an outdoor set.
NIKON F4, 105MM F/2.8 AF MACRO, SB 21B MACROFLASH, 1/125 SEC. AT F/16, FUJICHROME VELVIA

Insects

Photographing the diversity of shapes, sizes and forms within the insect world can keep any outdoor photographer occupied for a lifetime.

INSECT LARVAE

Caterpillars and grubs tend to be inactive since their main function is to feed. This makes them convenient subjects on which to hone your close-up skills.

You can arrange the food plant with the larva on it to make an attractive shape in the viewfinder. This is something which will become second nature to you and enable you to work more speedily when faced with their much more active parents – butterflies, moths and beetles.

BUTTERFLIES AND MOTHS

Many butterflies have a circle of fear: as long as you stay outside it, they will feed happily, but as soon as you move closer there is a flick of the wings and they are gone. If you locate plants that butterflies favour – such as buddleia or sedum – you can just station yourself and wait, though they will usually already be there. This is where a set-up with a macro flash is ideal,

▲ **INDIAN MOON MOTH LARVA (*ACTIAS SELENE*) IN CAPTIVITY**
Moth and butterfly larvae – especially large ones like this – make excellent subjects on which to perfect your close-up techniques because they go on happily feeding. Indian moon moths are easy to raise in captivity, feeding on hawthorn.
NIKON F4, 105MM F/2.8 AF MACRO, SB 21B MACROFLASH, 1/60 SEC. AT F/16, FUJICHROME PROVIA

◀ **ORANGE TIP (*ANTHOCARIS CARDAMINES*), COWBRIDGE, WALES**
Male orange tips emerge in spring and frequently settle to feed: that is the easiest time to photograph them. The females can be photographed as they lay a single egg on a flower stem of lady's smock (*Cardamine pratensis*).
NIKON F4, 105MM F/2.8 AF MACRO, SB 21B MACROFLASH, 1/60 SEC. AT F/16, FUJICHROME PROVIA

because the flash freezes movement.

Decide how much of the frame you wish the creature to occupy and adjust your lens to give the approximate magnification. Set the aperture to, say, f/16, to maximize depth of field. Approach the butterfly with the camera held to your eye, so you can watch it carefully, move forward and then gently tilt your whole body to focus: when the image is sharp press the shutter. This method of focusing takes a little practice, but you will often get two or more chances because you have avoided creating movement that alerts the insect.

Alternatively, you can work with daylight and use a longer focus lens that has a good close-focus capability. This necessitates using a tripod to avoid camera shake, so to minimize movement it is easiest to set up the camera near nectar-rich flowers and wait. I often use a long-focus macro lens of 180mm focal length, occasionally with a matched multiplier which allows me to get life-size magnification when almost 1m (3ft) from an insect.

INSECTS IN FLIGHT

Taking photograps of flying insects presents a whole set of challenges. It is not something you can just do spontaneously, unless, for example you spot one of those species of hawkmoth, such as the humming bird or convolvulus hawkmoths, which sometimes hover near flowers with proboscis outstretched. By stalking these insects carefully it is possible to capture them on film.

With most flight pictures, the first task is to get the insect to fly where you want it, so that it interrupts a pair of crossed infrared beams that trigger the camera shutter plus flash. Several commercial units enable you to do this, but it is much easier to set up a controlled environment in the studio.

◀ **TWO-TAILED PASHA (*CHARAXES JASIUS*) ARDECHE VALLEY, FRANCE**
Some large butterflies can be attracted to bait such as rotting fruit, animal carcasses or urine. The two-tailed pasha is highly territorial and will sometimes reveal its presence by dive-bombing you.
Nikon F4, 105mm f/2.8 AF macro, SB 21B macroflash, 1/60 sec. at f/16, Fujichrome Provia

▼ **BRIMSTONE (*GONEPTERYX RHAMNI*), BETWS, WALES**
You will rarely see a brimstone with its wings open, but occasionally you can find them settled with their wings against the light, revealing the veining and orange spots.
Nikon F4, 105mm f/2.8 AF macro, SB 21B macroflash, 1/60 sec. at f/16, Fujichrome Provia

Insects at Close Quarters

In the field it is impractical to take pictures of insects and other small creatures at more than a few times life-size magnification. Fortunately, equipment you may well have already can be adapted to give excellent results when you need to photograph small insects such as ants or to show details of larger insects. See the Appendix for further information on the methods briefly described below. You can buy adaptors or make your own for unusual lens sizes by lining up two Cokin filter adaptor rings back to back, secured with superglue.

Supporting a lens is never easy as magnification increases, since every tiny movement is exaggerated – ways of doing this and of using flash to freeze movement are discussed on pages 134–7.

REVERSING LENSES
(magnification range x 1 – x 6)
A simple ring with a filter thread and lens mount will enable you to reverse lenses on to an extension tube or even lightweight bellows. This allows you to get up to x 6 magnification with a 24mm wide angle, for example. The disadvantage of this set-up is the loss of automatic diaphragm control and all exposure coupling, unless you use the Canon system and purchase a Novoflex adaptor.

▲ **BEE ON FLOWER, OXFORDSHIRE, ENGLAND**
It takes some practice to move to focus when the depth of field is tiny. It helps to brace the set-up: in this case the plant grew on top of a wall and the lens front rested on my hand.
Nikon F4, Sigma 180mm f/3.5 apo macro with x 2 multiplier, homebuilt twin flash set-up, 1/125 sec. at f/16, Fujichrome Velvia

◀ **PEACH-POTATO APHIDS (*MYZUS PERSICAE*) ON SWEET PEA**
To work at around x 6 magnification you have to take the studio outdoors. I use a portable optical bench; subjects are brought to the camera and illumination is provided by three TTL flash guns.
Nikon F/4 with Olympus 38mm f/3.5 bellows macro, Nikon TTL flash guns, 1/125 sec. at f/oo, Fujichrome Velvia

SUPPLEMENTARY LENSES
(to life size with non-macro lenses and zooms)

Supplementary lenses can be screwed into the filter thread of your prime lens or zoom. Importantly, no light is lost using this method, because the lens does not move away from the film as it does with extension tubes.

COUPLING LENSES
(magnification range x 2 – x 6)

My preference in the field is for coupled lenses. By reversing a camera lens and attaching it to the front of another you create a high quality supplementary lens. All it takes is a small adaptor ring with a thread to fit the filter thread of each lens. It is advisable to choose lenses that are

around the same thread size to avoid the problem of vignetting (darkening at the edge of the image).

The magnification of the combination is obtained by dividing the focal length of the prime lens by the focal length of the added lens. The wider the aperture of the added lens the better, so it can give a new lease of life to a 50mm f/1.8 standard lens that might have been pushed to the back of your cupboard.

This is my favourite method because it is quick and easy, no light is lost and all the functions of the camera are retained. It works even with wide-angle lenses, though vignetting may occur.

TELECONVERTERS
(magnification range x 1.4 – x 2)

At close quarters, converters act as magnification multipliers: you are using small apertures and light rays close to the centre of the lens so that they perform well optically. A converter magnifies the image while your distance from the subject stays the same. For example, using a x 2 converter your macro lens will give you twice life size at its closest focus and 1:1 where it gave you half life size. You lose light – one stop with a x 1.4 and two stops with a x 2 converter – but a x 1.4 converter is especially useful in giving an extra 'boost' to your usual macro lens.

◀ HOVERFLY (*MILESIA CRABRONI-FORMIS*) ON SUNDEW, OXFORDSHIRE, ENGLAND

Several sundews are kept outside during the summer near a garden pond; the hoverfly had become entangled and I used a coupled lens set-up with a 135mm f/3.5 prime lens and a 50mm f/1.8 lens at maximum aperture reversed on to it. The total magnification was 135 ÷ 50 = 2.7.
NIKON F4 135MM F/3.5 WITH 50MM F/1.8 AS SUPPLEMEN-TARY, SB 21B MACROFLASH, 1/125 SEC. AT F/16, FUJICHROME VELVIA

Many aquatic creatures, both marine and freshwater, can be photographed without expensive underwater housings and scuba gear. The techniques described for rock pools (see page 76) can just as well be employed in ponds and streams.

Avoid windy days as they are hopeless for rock pools and ponds: surface ripples make it impossible to get clear views of the occupants. Extra care with equipment is needed when working at the coast (see page 74) and if you are intending to do a lot of beach work it might be worth purchasing a housing for your camera or a waterproof cape to protect it.

THE OVERHEAD VIEW

One method of capturing underwater life involves photographing down into the water from above the surface. The simplest way to start is to set the camera on its tripod looking vertically down into the water. The camera back needs to be parallel to the surface. By leaning over it wearing dark clothes, you cut out virtually all upward reflection from the water surface. Check for reflections appearing in the corners of the frame if you move.

On cloudy days there is no strongly directional light, and surface reflections become more awkward to control. You can use a flash gun (with a diffuser to spread its light) held away from the camera at an angle of at least 45 degrees to the water surface, so that none of its light is reflected into the lens. When I am using a TTL flash system I find that I need to increase exposure by about 2/3 stop to compensate for light absorption in the water.

The camera can be used from the side with a polarizer to make surface reflections disappear – the effect is most pronounced when the camera is held at an angle of about 54 degrees to the surface.

PERISCOPES AND VIEWING TUBES

The small animals in rock pools – hermit crabs, shrimp, sea anemones and small fish – are intriguing subjects but the vertical view can prove restrictive. One answer is to build a periscope with a sealed end to go in the water. Only a single mirror is needed but it must be front-silvered and of good optical quality, obtained from an optical

▼ SHORE SEA URCHIN (*PSAMME-CHINUS MILIARIS*), RHOSILI, WALES
This small sea urchin was spotted when some weed was moved in a shallow rock pool. Any movement creates a cloud of debris in the water and you have to wait until it settles. It is essential to keep looking through the viewfinder as particles can drift into the field of view.
NIKON F4, 105MM F/2.8 AF MACRO, SB 24 FLASH, 1/60 SEC. AT F/16, FUJICHROME VELVIA

supplier or ex-army equipment dealer. An even simpler solution is to place the camera inside a small fish tank immersed in the water. Great care is needed to make sure no water rises up over the sides, and the maximum depth is therefore limited by the depth of the tank.

It is very easy to disturb bottom material in a rock pool. As you watch through the viewfinder a cloud seems to drift over the subject. In coastal rock pools each successive tide brings a change in water, so clarity is generally good. If the water appears full of tiny planktonic forms, darting about like tiny motes, a viewing tube can be used to reduce the depth of water between you and the subject. This is easy to make from a length of plastic drainpipe, painted matt black inside, with a glass window cemented and sealed with silicone cement at the lower end. A flashgun can be used off camera and held to the side to provide a light source on dull days.

▼ **OPELET ANEMONE (*ANEMONIA SULCATA*), WALES**
This purple-tipped anemone is common in rock pools. A single flash provided the illumination on a calm day when there were no surface ripples on a shallow causeway exposed at low tide.
NIKON F4, 105MM F/2.8 AF MACRO, SB 24 FLASH, 1/60 SEC. AT F/16, FUJICHROME VELVIA

Plants in the Landscape

Groups of flowers can be used to create foreground interest in landscape pictures. Conversely, when a plant is the main subject, setting it in the landscape always conveys useful information about its habitat, shape and growth requirements.

A wide-angle lens used at close quarters gives a degree of perspective distortion that makes human faces look peculiar, but with plants the effect is almost an advantage: when we look at plants we usually notice the flowers first and in the mind's eye they are exaggerated.

DEPTH OF FIELD

To set a plant in the landscape you need to understand depth of field – how to make the best use of it and the limits it imposes on you. There is a common misconception that the longer the focal length of a lens the smaller is the depth of field (the range over which things appear in sharp focus). If you stand at a particular point and use a range of lenses from wide to telephoto, all set to the same aperture, then depth of field will decrease (see page 14). But it is because the magnification increases that the depth of field is reduced, and this is especially noticeable in close-up and macro work.

If you are serious about landscape photography, at least one of your SLR cameras should have a depth of view preview. This is a lever which stops down a lens to its taking aperture – the view darkens, but if you give your eye time to

▼ **POET'S NARCISSUS (*NARCISSUS POETICUS*), PIANO GRANDE, UMBRIA, ITALY**

There are views elsewhere in this book of the Piano Grande – this picture shows its appearance early in the year. The low angle of view created the sense of richness I wanted.

Mamiya 645 Super, 45mm f/2.8 with linear polarizer, 1/15 sec. at f/16, Fujichrome Velvia

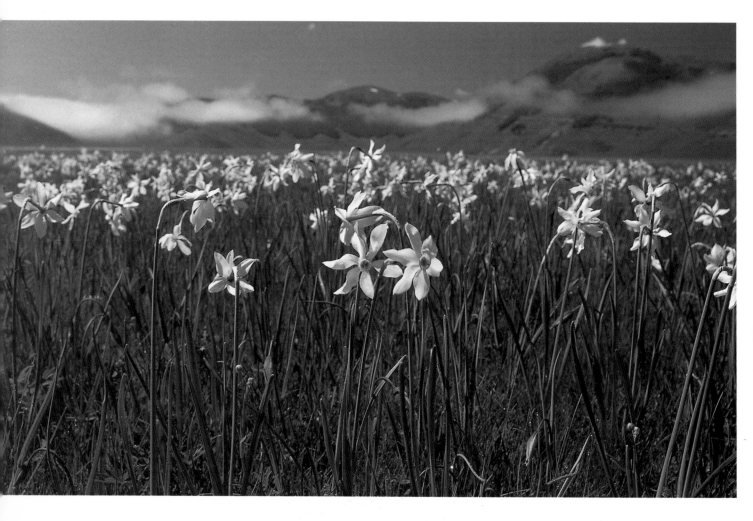

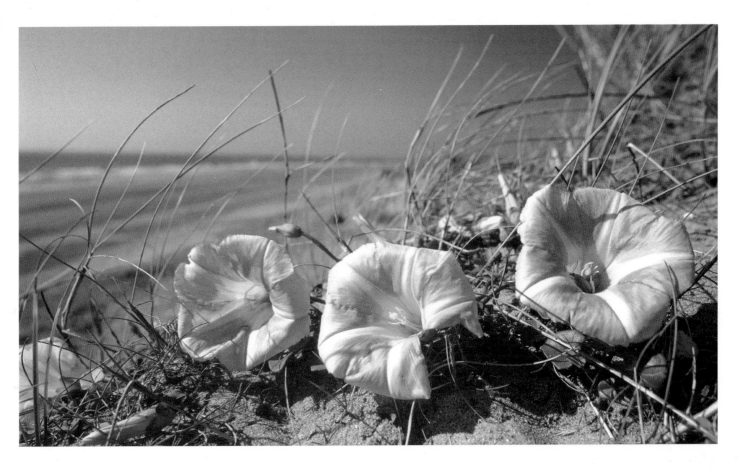

accommodate you will see more appear in focus in front of and behind the subject. Often, careful use of the depth-of-field preview is all you need to choose the right aperture to get both subject and background in focus.

If you want everything in your viewfinder, from subject to infinity, to appear in focus, an understanding of the idea of hyperfocal distance is essential. When the subject is at the hyperfocal distance, everything from infinity to a point halfway between you and the subject will be in focus (see Appendix).

In practice a background does not have to be pin sharp. With snow-capped mountains or forest trees, there is no doubting what they are, and a slight softness in the background can accentuate the sharpness of the subject.

LENS CHOICE
I find that manual focus lenses are better for landscape shots with plants, simply

because they have a more generous focusing thread and allow you to get closer – typically about 10cm (4in) with a 24mm or 28mm wide-angle when used with 35mm.

The 28mm is my favourite for this work in 35mm format, and the 45mm does the same job in 6 x 4.5cm format. This is a personal choice – I like the perspective it produces better than that of wider lenses.

▲ **SEA BINDWEED (*CALYSTEGIA SOLDANELLA*), SKER BEACH, WALES**
The location is always windy. In June and July the sea bindweed flowers amongst the marram grass on the dunes, and the bent stems evoke the wind and convey the atmosphere of the location. Patience is essential for you have to wait for a lull between gusts of wind.
Mamiya 645 Super, 45mm f/2.8, 1/15 sec. at f/11, Fujichrome Provia 100F

◄ **POPPIES, UMBRIA, ITALY**
I wanted the low-angled evening light to illuminate the poppies from behind and make the scarlet cups glow. When metering, take readings from a flower that is not backlit – this ensures that those that are, will glow in the final result.
Mamiya 645 Super, 45mm f/2.8 with linear polarizer, 1/30 sec. at f/11, Fujichrome Velvia

Flower Portraits

To take good flower portraits you can use any lens that has the close-focus capability to produce the size of image you want. For larger flowers such as roses, or for flower groups, a mid-range zoom will do the job. For smaller flowers you will need a macro lens. Your choice may rest with the way you want the background to appear – wide-angle lenses can be used to set a flower in the context of its background (see page 146) while telephotos can isolate a flower from the background against a soft blur.

It is important to vary the way you take flower portraits, especially if you are going to use your work in slide shows, otherwise your shots begin to show a definite sameness. Single flower pictures can look dramatic: it is worth adjusting the viewpoint to fit the field of view and then, for a second view, moving closer so that the frame is over-filled, perhaps placing the flower centre according to the rule of thirds (see page 117).

SHAPES IN THE VIEWFINDER

You can often create a more interesting portrait by framing to include two or more flowers: one might be face on, and another offer a side or partial side view. Not only do you offer more information about the flowers this way, but the shapes and patterns created are an important element in your composition. Flowers, unlike birds and other active creatures, give you time to experiment and your compositional skills increase quickly.

If a flower group makes a shape – a circle, ellipse or triangle – or flows through the picture in an 'S' shape, along a diagonal or in a curve, there will be greater visual impact. Anything arranged along a diagonal imparts a sense of movement, even with static subjects.

When creating a picture you need to place the subject to best advantage in the viewfinder. With practice you develop an 'eye' for doing this automatically, but as a useful starter you can use the rule of thirds and place a point of interest where the theoretical lines dividing the picture into thirds meet.

If you intend your pictures to be used for identification you should include other parts of a plant, such as leaves, buds and tendrils, as well as the open flower.

LIGHTING

A sky with light cloud cover gives a uniform light with soft shadows that is ideal for flower photography. On bright sunny days, portable reflectors are useful for throwing light into areas of shadow and reducing contrast in the image. Similarly, a fill-in flash set a stop or so below the ambient light level can reduce the contrast range. Rainy days can produce delightful plant portraits. Raindrops glisten attractively on the flowers, and the colours seem to sing out.

Many flowers – and especially those which have a cup or globe shape – lend themselves to backlighting and are best photographed early or late in the day, when the sun is low in the sky.

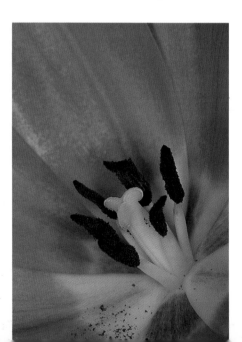

▲ **POPPY BUD (*PAPAVER ORIENTALIS*), OXFORD, ENGLAND**
Backlighting often brings life to plant portraits by delineating hairs on stems. If the sun's disc is too close to the field of view you may create flare from reflections on the lens surface. This can be eliminated with a lens hood or even a hand held out of view to act as a shade – the difference in the viewfinder tells you when it's working.
NIKON F4, SIGMA 180 MM F/3.5 AF APO MACRO, 1/250 SEC. AT F/5.6, FUJICHROME PROVIA

▶ **WATER LILIES (*NYMPHAEA SPECIES*), MADEIRA**
These water lilies are the subject of the picture being taken on page 26. A telephoto lens was used to provide a large enough image in the viewfinder since the plants were not very close to the edge of the pool. A polarizer is useful for controlling reflections, both from shiny leaves and from the water.
NIKON F60, SIGMA 300M F/4 APO MACRO WITH CIRCULAR POLARIZER, 1/60 SEC. AT F/8, FUJICHROME VELVIA, PHOTOGRAPH: LOIS FERGUSON

◀ **LILY STAMENS**
A flower portrait does not need to show the whole flower. In fact, moving in to overfill the frame can create a dramatic composition. I tend to do both, for you never know which view a client will prefer, or what might sell to, say, a magazine. The long focal length macro provides a flat perspective and focus falls off quickly into the background.
NIKON F4, SIGMA 180 MM F/3.5 AF APO MACRO, TWIN FLASH, 1/60 SEC. AT F/8, FUJICHROME PROVIA

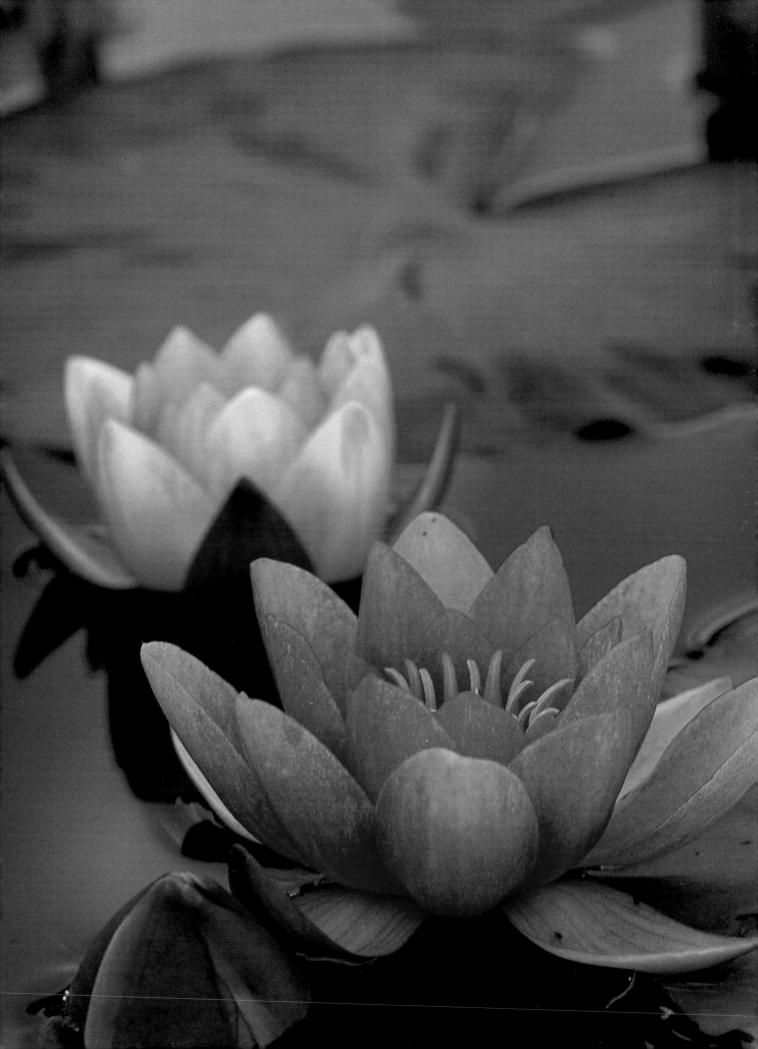

Trees

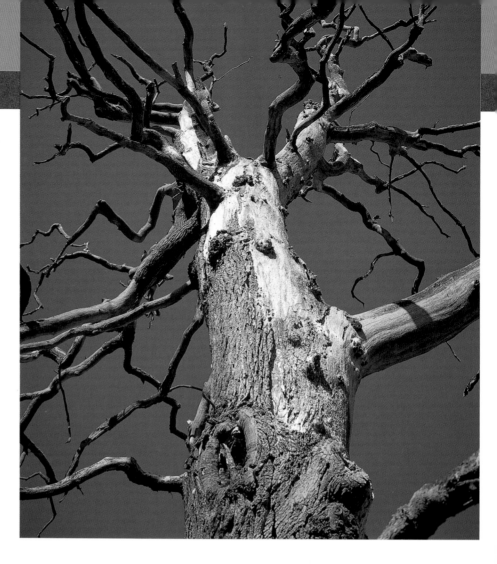

Trees are guaranteed to provide photographic challenges to suit all lenses and scales, from wide-angled views of individual specimens to telephoto views of flowers and fruit, or macro shots of bark and creatures for whom the tree is home.

Old trees with their gnarled trunks and holes can become abstract subjects. Ancient olives, in particular, offer an endless challenge to the imagination. At high altitudes where growth rates are slow, the ravages of wind, snow and lightning strikes produce painfully distorted dwarf pines and cypresses.

Many trees, particularly those in the tropics, produce spectacular flowers. Jacarandas, bauhinias, flame-orange Spathodea and many other species grow in parks, streets and gardens, as well as in the wild. The flowers and fruits are often formed well out of reach and, short of climbing the tree, can only be reached with a telephoto lens.

TEXTURE AND PATTERN

Tree bark generates a monochrome feel in colour pictures and is well suited to monochrome film. The various surface textures, from the smooth polish of a birch to the deep ruts of a venerable oak, look good in black and white or as tinted prints. With a macro setting on a zoom lens, or with a macro lens itself, small portions of bark are easily isolated and individual patterns emphasized. If possible use side lighting, employing a reflector if necessary, since this emphasizes the texture.

SPECIMEN TREES

Trees are an essential element in many landscape photographs, either as objects or for the framing effect their branches create. Winter is a good time for viewing

▲ DEAD ELM, OXFORDSHIRE, ENGLAND

A dead tree creates a framework of branches against the sky. Both sky and tree are lit from the same direction, and normally I would use a polarizer to intensify the sky colour; but the inconvenience of doing so with a rangefinder camera led me to take an exposure reading and shoot using the camera's meter.

MAMIYA 7 II, 43MM F/4.5, 1/125 SEC. AT F/16, FUJICHROME PROVIA 100F

▼ BOSNIAN PINE (*PINUS LEUCODERMIS*), LUCANO, ITALY

Above the snowline, high in the hills of the Lucano in southern Italy, grow ancient Bosnian pines. Their fallen trunks decay very slowly and lie around, possibly for centuries. A wide-angle lens was used to capture the shape and lead the eye into the picture.

NIKON F60, SIGMA 24MM F/2.8 AF, 1/15 SEC. AT F/16, FUJICHROME PROVIA, PHOTOGRAPH: LOIS FERGUSON

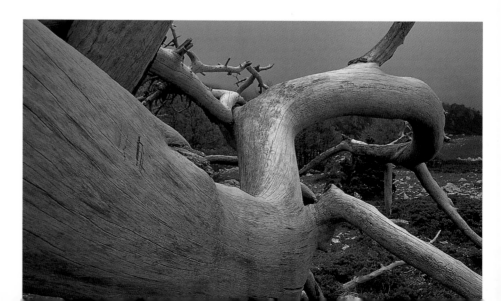

the structure of deciduous trees, when, with the leaves gone, just the skeletons of twigs and branches remain. But to capture an individual tree takes some thought and a fair degree of selection. Unless you can find a large clearing in a forest, individual trees will be part of a confused scene. This is certainly true in tropical forests, where any clearing quickly becomes filled by other plants seizing the opportunity to grow. Arboretums and parks will often provide you with the best specimen trees.

Viewpoint is important. A single tree can fill the viewfinder when it is photographed with a wide-angle lens near to the tree, or with a telephoto much further away. The results are quite different and produce contrasting perspectives. Sometimes the exaggeration of the parts of a tree close to a wide-

angle lens makes the tree crown recede unnaturally, though this can also result in a dramatic photograph. There is no one 'right' way – the answer is to walk all round the tree and view it in relation to its surroundings.

LIGHT

Good frontal lighting will reveal the bark and other details, but when a tree is set against a bright sky, it becomes a silhouette. A dull, overcast day with flat lighting can prove ideal for photographing the patterns, shapes and colours of leaves and branches, free of the confusion created by the harsh shadows that are cast in sunlight.

Trees looming out of fog and mist provide atmospheric shots, though early morning conditions change quickly and it does not pay to wait around for too long before taking such pictures.

▼ **JUNIPER (*JUNIPERUS FOETIDIS-SIMUS*), BUFFAVENTO, NORTHERN CYPRUS**
Patterns not only exist in bark but also beneath it. The trunk of this ancient juniper tree had been eaten by insect larvae, producing a pattern that was worth recording.
Nikon F100, Sigma 24mm f/2.8 AF, 1/60 sec. at f/16, Fujichrome Provia

Fungi

Fungi are non-flowering plants containing no chlorophyll. What we see above ground are the fruiting bodies produced by the mycelia, or fungal threads, that pervade the soil. They show a huge range of size, form and colour – from microscopic slime moulds to large bracket fungi – and are highly photogenic.

Small fungi and tiny slime-moulds are easily overlooked, yet they make attractive subjects for the macro lens. They can be found in cracks in rotten wood, on rotting fruit and on dead animals.

Many larger species grow out in the open on dune lands and in meadows, in short, well-grazed turf. But in temperate countries woodlands in autumn are the best places to find fungi, and each woodland 'type' – such as beech, oak or birch – has its own characteristic species of fungi. In tropical forests, fungi are everywhere, quickly digesting all dead organic material.

LIGHTING AND ANGLES

The light level in woodland is usually low. However, most fungi have strong stalks and sheltered habitats, so that subject shake is not a problem at slower shutter speeds. Fungal colours and tints are subtle and I find they are best captured using natural light or with, at most, a fill-in flash when the light is too low (see page 56). Bear in mind that fungi can be highly reflective and pictures taken with flash can usually be recognized by specular reflections – 'hot spots' – on the fungus surface. But in a tropical forest, flash may be the only practical light to use, and you can reduce surface reflections by using a diffuser over the flash.

Fungi look particularly impressive when viewed from below with a wide-angle lens, so you need a tripod capable of reaching low positions (see page 26). In pale-coloured fungi the caps of the fruiting bodies are translucent and you can use backlighting to emphasize the gills beneath the cap.

Treetrunks often host large bracket fungi that can only be photographed with a telephoto lens. In winter, when the leaves have disappeared from the trees, you will inevitably include the sky when photographing them from below. Some form of fill-in flash will therefore be needed to balance the exposure of the sun and the background.

▶ **BRANCHED OYSTER (*PLEUROTUS CORNUCOPIAE*) NEAR HENLEY, ENGLAND**

To accentuate the translucency of this group of fungi I decided to use natural light with flash as a fill. The shutter speed was set on manual to give about 2/3 stop underexposure to the background at the taking aperture. The flash was switched on and the camera exposed the foreground through its TTL meter.

Nikon F100, 60mm f/2.8 AF macro, 1/4 sec. at f/16, SB21B macroflash, Fujichrome Provia

◀ **HONEY FUNGUS (*ARMILLARIA MELLEA*), BLACKMILL, WALES**

There is often so little light where fungi grow that there is no alternative but to use flash. To avoid specular reflections use a diffuser – such as tracing paper or tissue over the flash tube.

Nikon F100, 60mm f/2.8 AF macro, 1/125 sec. at f/16, SB21B macroflash, Fujichrome Provia

▼ **PUFFBALLS (*VASCELLUM PRATENSE*)**

Even in the gloom of a wood these fungi were easily visible. I took pictures both by natural light and with diffuse flash. The latter, shown here, had slightly more relief and showed up the texture of the surface better.

Nikon F100, 60mm f/2.8 AF macro, 1/4 sec. at f/16, SB21B macroflash, Fujichrome Provia

Small Plants and Details

L ichens and mosses are slow-growing organisms that often create patterns as they spread, and these can be captured with any camera with a zoom lens that has a close-focus facility. Late afternoon light has a low angle that creates relief in lichens encrusting coastal and mountain rocks and ornamenting old gravestones.

Lichens and mosses are often at their best in winter when other subjects are hard to find. This is the time of year when they produce their fruiting bodies – such as the scarlet-tipped cups of some lichens or the delicate spore capsules of mosses.

To reveal the delicate beauty of these tiny plants you need to enter the realm of macro photography. The degree of magnification you need can be achieved using the techniques discussed on page 142.

MAKING BEST USE OF DEPTH OF FIELD

With magnifications above life size the depth of field is just a few millimetres or less, even at small apertures. To make best use of this, make sure that your camera back – the film plane – is as near as possible parallel to the subject plane you have chosen. It helps to look at the camera on its tripod from the side, or to adjust your position carefully if you are hand-holding a macro flash.

FLASH

When working at life size and greater magnifications I abandon natural light and use flash. The tiniest vibration of subject or camera can soften the final image, but flash is so fast (about 1/1000 sec.) it freezes most movements. I have used a commercial macroflash unit for years. These units are underpowered with longer focal length macro lenses unless you are working at life size, but work well in the

▼ COASTAL LICHENS ON ROCK, WEST CORK, IRELAND

The clean air of west Cork encourages lichen gardens to form on rocks. Rain often brings out colours in a saturated way on film, and cuts the contrasts you get in bright sunlight which can wash out some tones completely.

MAMIYA 645 SUPER, 45MM F/2.8, 1/125 SEC. AT F/8, FUJICHROME PROVIA 100F

▶ COASTAL LICHEN (*XANTHOREA AUREOLA*) PEMBROKESHIRE, WALES

Late afternoon light makes some colours sing and the low angle creates tiny shadows on this crustose lichen to give it a great sense of relief. Lichens are great subjects – they don't move and are unaffected by wind.

NIKON F4, 60MM F/2.8 AF MACRO, 1/60 SEC. AT F/11, FUJICHROME VELVIA

range x 1 – x 6. At close quarters, flash becomes a wall of light, like a small umbrella flash, and gives a pleasing quality of light. Modelling is good because the light comes from an angle of 30–45 degrees to the axis and this creates relief. Some units allow you to adjust the relative outputs of guns to give different lighting ratios. With a ratio of 1:2 or 1:4, for example, one light becomes a fill-in. You can achieve the same result using a diffuser or neutral density filter.

POSITIONING THE CAMERA

Small subjects can be photographed *in situ* by getting down to their level and resting the lens barrel on a bean bag. Focus by moving the whole camera unit. If the moss or lichen is on a twig or stone, it is easier to set your camera firmly on a tripod and gently move the subject. I use a small gadget with a heavy base and an arm with two crocodile clips to hold a twig steady. This is the simplest possible optical bench, but it works.

▶ TENDRIL, WHITE BRYONY (*BRYONIA CRETICA*)

Parts of plants such as stems and leaves also show great variety and demonstrate the art and design elements in nature. The coiled springs made by tendrils are one example: with a macro lens you can isolate them and they stand as subjects in their own right.

Nikon F4, 105mm f/2.8 AF macro, macroflash, 1/60 sec. at f/16, Fujichrome Velvia

TECHNICAL APPENDIX

APERTURES AND IMAGE SHARPNESS

SHARPNESS AND DEPTH OF FIELD

By closing down the diaphragm you can restrict light rays passing through a lens to those near the axis. Apart from being better corrected near the axis, this procedure increases depth of field.

An image is, in theory, made up of points. A circle of 0.03mm (1/850in) or less (the blur circle or circle of least confusion) appears as a sharp point to the eye, so there is some latitude in the position of the film plane. As the light moves further in front of or behind the film it spreads out, and the distance over which it stays within the limits of the blur circle is the depth of focus. At the subject, a slight movement either side of the plane of sharp focus (within the depth of field) will also produce a circle of 0.03mm (1/850in) or less on film. The image on film is made up from small, overlapping images of the lens diaphragm.

Landscape photographers using old 10 x 8in plate cameras would use lenses that stopped down to f/64 and smaller – here an inescapable wave property of light upsets things: diffraction. Light

can spill around the edges of a very small aperture or grid to create softening. The advantages you get from increased depth of field begin to be outweighed by softening due to diffraction. See the author's *Complete Guide to Close-up & Macro Photography* for ways in which this affects close-up and macro work.

DIAPHRAGMS – THE NUMBER OF BLADES

In recent years, the number of blades in a diaphragm has been used as a selling point by manufacturers boasting about their lenses. An image on film is a series of tiny overlapping images of the aperture. The better the circle the smoother the transition between these tiny images, and the more crisply an image seems to snap in and out of focus. Highlights are also rendered as natural-looking circles. When a diaphragm has few blades (or is badly lubricated) it closes to form a polygon or even a star shape – this shows in the highlights and lack of crispness.

LENSES

HYPERFOCAL DISTANCE

With cameras other than 35mm SLRs, such as rangefinder, roll film and all larger format cameras, lenses have a depth-of-field scale engraved on the lens barrel. To either side of the sharp-focus mark you can read off the limits of the depth of field at different apertures. If you want everything to appear in focus, understanding the idea of hyperfocal distance is essential. If the subject is set at the hyperfocal distance, everything from infinity to a point halfway between you and the subject will be in focus.

To find the distance, move the infinity mark on the lens until it is opposite the aperture you want – say f/16. The focus mark will be at the hyperfocal distance. This point of sharp focus can be set a short way beyond your subject – as long as it lies between the hyperfocal distance and half that distance from your lens, the subject will be in focus. With any SLR or large-format camera you

◀ **BRIDGE AND REFLECTION, VENICE, ITALY**
We saw this bridge on our way to buy carnival masks. This is the kind of picture this book is all about: seeing opportunities wherever they are and choosing your lens and camera angle to get pictures with freshness and impact.
MAMIYA 645 SUPER, 80MM F/2.8, 1/30 SEC. AT F/8, FUJICHROME PROVIA 100F

can check this before taking the picture. Lens scale and reality may not quite match, so work out the distance for the next stop wider – in this case, f/11 – to give a margin for error.

SHIFT LENSES AND IMAGE CIRCLES

The image produced by a lens is a circle that gets fuzzier and less bright towards the edges. All 35mm lenses make use of the central area of the image, 36 x 24mm, which is uniformly bright and sharp.

Shift lenses cover a bigger area and make use of parts of the circle outside the normal field. By moving lens elements at right angles to the lens axis, the image is moved the opposite way. The perspective changes, correcting converging verticals.

Lens tilt makes a 35mm camera act like a miniature view camera and is great for getting depth of field that seems to go on forever. Canon has led this field in 35mm photography, with superb tilt and shift lenses of 24mm, 45mm and 90mm focal length – for many people I have met this has been the single deciding factor when it came to changing outfits. Most other manufacturers tend to make only a shift lens in 35mm and roll-film formats. Hasselblad tackle the problem with their FlexBody.

CLOSE-UP AND MACRO PHOTOGRAPHY

'Macro' is a term that is much misused by manufacturers. Many zoom lenses and telephotos boast a macro facility that, although useful, is really just a close focus. 'Macro' should be confined to lenses that achieve life-size magnification and beyond. Several manufacturers (Olympus, Canon, Leica, Zeiss and Minolta) manufacture 'true' macro lenses that do this but they are best suited to studio use on a bellows.

REVERSED LENSES

One way of getting magnified images in the range x 1 – x 6 involves reversing lenses and fitting them backwards on to a bellows or extension tube. Most lenses are corrected to deal with a large subject at the front element and a small image at the rear. In close-up and macro photography, the subject is small and the image is life size or larger, so by reversing the lens you make best use of the lens corrections. Some zoom lenses work well when reversed and give you a 'zoom' macro lens. You have to experiment with the equipment you have to make sure than there is no vignetting – usually, the more pricey the lens the better it works this way.

SUPPLEMENTARY LENSES

These can be screwed into the filter thread of your prime lens or zoom. You lose infinity focus but get much closer and also retain TTL metering and automatic diaphragm coupling. Importantly, no light is lost because the lens does not move away from the film, as it does with extension tubes. Single element lenses should never be used at apertures wider than f/8 unless you deliberately want soft focus – they are not well corrected for light rays away from the centre of the lens. Much better are the two-element 'achromats' that come with a higher price tag.

COUPLED LENSES

You can reverse a lens such as a 50mm objective on to the front of a 100mm lens, for example, using an adaptor ring that screws into both filter threads. The lens you have added acts like a brilliantly corrected supplementary lens. To avoid vignetting, choose lenses that are around the same thread size; the wider the aperture of the added lens the better. You end up with a magnification given by the focal length of the prime lens divided by the focal length of the added lens. All the functions of the primary lens connected to the camera are retained and, unlike methods involving lens extension you do not lose light.

FILM AND EXPOSURE

RECIPROCITY FAILURE

As exposure times increase, many films show reciprocity failure. For normal daylight exposures, the principle of reciprocity means that if light intensity doubles the shutter speed can be doubled or the aperture cut to half its area (closed down by one stop) and the film will be perfectly exposed. To expose film properly at shutter speeds that run into minutes, much more light is needed than expected. Exposure times have to be increased and apertures opened up. Each film behaves differently and manufacturers can provide precise details. Kodak recommends that you do not use Kodachrome films for exposures longer than 10 sec. The newer Ektachrome films (Elite Chrome 100/200/400 and Ektachrome E100S/E and E100SW) are more tolerant and can be used for exposures of up to 1 min.

Fujichrome emulsions (Astia, Sensia and Provia) are reasonably tolerant: for exposures up to 10 sec., no compensation or colour correction is needed. Velvia needs correction by +2/3 stop (overexposure) between 1 and 10 sec. With longer exposures, many films also show colour shifts and these must also be corrected if you want colour accuracy.

THE ZONE SYSTEM

The landscape photographer Ansel Adams invented the 'zone system' to make the best use of a film's contrast handling.

If you expose for the bright areas in a scene, the shadows will be too dark to retain detail; expose for detail in the shadows and the highlights will be burned out. The zone system classifies the tonal range on a ten-point scale, from black (zone 0) to pure white (zone IX). Each step in the scale is one stop from the next. For example, middle grey falls in zone V, average Caucasian skin in zone VI.

In practice, you fit key areas of a scene to appropriate zones to discover how wide a spread it encompasses. This is usually around seven zones in an 'average' subject. The exposure is set to embrace this range from light to dark.

EXPOSURE VALUES (EV)

Exposures are sometimes quoted in EV – you usually see this when a camera specification tells you its metering range is 0–21 EV, for example. A change of 1EV is equivalent to a one-stop change in light intensity.

POLARIZERS AND POLARIZED LIGHT

Visible light occupies a very small portion of a map called the electromagnetic spectrum, which arranges electromagnetic waves according to wavelength. Radio waves lie at the long wavelength end, and wavelengths decrease through microwaves, infrared, visible light and ultraviolet light to X-rays and gamma radiation.

Associated with light waves is an electric field that varies at right angles to the direction of travel – a transverse wave. In normal light the variation is in all directions perpendicular to travel. When light passes through a polarizing filter, however, just one direction is selected by the polarizer to produce plane-polarized light. The filter is a kind of molecular grid or gate through which the light passes. When the grid and the electric field are aligned, everything passes through; when they are at 90 degrees (crossed) no light gets through.

When light is scattered or reflected it is partly polarized and filters can be used to select or cut this light.

THE BREWSTER ANGLE

When a light ray hits a water surface at an angle, part enters and is transmitted and part is reflected from the surface and polarized. If you set the camera so that the lens axis is at about 54 degrees to the vertical (the Brewster angle) this is where the highest degree of plane polarization occurs and you can eliminate it with a polarizer.

COLOUR TEMPERATURE

The colour content of 'white' light from all sources, including artificial lights such as tungsten lamps, can be described in terms of 'colour temperature'. Imagine a light bulb: as you increase the electric current through the filament, it glows dull red, red, orange, red, yellowish white, white, and eventually bluish white. Colour temperature is the temperature, measured on the Kelvin scale, to which you would have to heat a theoretical 'black body' to emit light of a particular colour.

COLOUR TEMPERATURE

Light source	Colour temp (°K)	Conversion filter for daylight balanced film	Exposure increase in stops
Clear blue sky	10,000–15,000	Orange 85B	2/3
Open shade in summer sun	7,500	Warm-up 81B or 81C	1/3
Overcast sky	6,000–8,000	Warm-up 81C	1/3
Sun overhead at noon	6,500	Warm-up 81C	1/3
Average daylight 4hrs after sunrise to 4 hours before sunset	5,500	None	none
Electronic flash	5,500	None	none
Early morning or late afternoon	4,000	Blue 82C	2/3
One hour before sunset	3,500	Blue 80C	1
Tungsten photo pearl	3,400	Blue 80B	1 2/3
Quartz bulbs	3,200–3,400	Blue 80A	2
Tunsgten photoflood	3,000–3,200	Blue 80A	2
Household lamp 100W	2,900	Blue 80A + 82C	2 2/3
Golden sunset	2,500	Blue 80C + 80D	
Candlelight or firelight	2,000	Blue 80A + 80B	

INDEX

Acknowledgments

This book would not have been possible without the help and encouragement of Lois Ferguson who gave generously of her time, her skills in Photoshop, much constructive criticsm, as well as photographs. To Anna Butcher, of Asimi, skilled silversmith and inveterate traveller, I also owe a debt of gratitude for her 'eye' for a good picture. Thanks to Peter and Chris Parks, and Lucy Siveter at Imagequest 3, and to Steve Young. I am grateful to Mark Langley of Mamiya cameras, to Paul and Joey Simms at Colourbox Technique, to Fi Lowry of Kudu Travel, and to many friends who put up with this writer's angst as deadlines approached. Last but not least my thanks to the team at David & Charles with whom it is always a pleasure to work: Sarah Hoggett, Freya Dangerfield and Beverley Jollands; and to Paul and Steve at Paul Cooper Designs for patiently putting up with constant changes!